Sex Work Politics

AMERICAN GOVERNANCE: POLITICS,
POLICY, AND PUBLIC LAW

Series Editors
Richard Valelly, Pamela Brandwein,
Marie Gottschalk, Christopher Howard

A complete list of books in the series
is available from the publisher.

Sex Work Politics

From Protest to Service Provision

Samantha Majic

PENN

UNIVERSITY OF PENNSYLVANIA PRESS

PHILADELPHIA

Published by
University of Pennsylvania Press
Philadelphia, Pennsylvania 19104-4112
www.upenn.edu/pennpress

Printed in the United States of America
on acid-free paper

10 9 8 7 6 5 4 3 2 1

Library of Congress Cataloging-in-Publication Data
Majic, Samantha.
 Sex work politics : from protest to service provision / Samantha
Majic. — First edition.
 pages cm. — (American governance: politics, policy, and public
law)
 Includes bibliographic references and index.
 ISBN 978-0-8122-4563-9 (hardcover : alk. paper)
 1. California Prostitutes Education Project. 2. St. James Infirmary.
3. Health facilities—California—Case studies. 4. Prostitutes—
Services for—California—Case studies. 5. Prostitutes—Political
activity—California—Case studies. 6. Prostitutes—Health and
Hygiene—California—Case studies. 7. AIDS (Disease)—California—
Prevention—Case studies. 8. Prostitution—California. 9. Nonprofit
organizations—California—Case studies. 10. Social action—
California—Case studies. I. Title. II. Series: American governance.
 RA643.6.C2M35 2014
 362.19697'92009794—dc23
 2013036900

For John Rasmussen, always

CONTENTS

ABBREVIATIONS

ACPHD	Alameda County Public Health Department
AWARE	Association for Women's AIDS Research and Education
CAL-PEP	California Prostitutes Education Project
CAP	Community Action Program
CDC	Centers for Disease Control and Prevention
CHAC	California HIV/AIDS Advocacy Coalition
COYOTE	Call Off Your Old Tired Ethics
DEBI	Diffusion of Effective Behavioral Interventions
GPRA	Government Performance and Results Act
IRC	Internal Revenue Code
IRS	Internal Revenue Service
MORE	Mobile Outreach and Recovery for Ex-Offenders
NGO	nongovernmental organization
PEMS	Program Evaluation and Monitoring System
PERB	Program Evaluation and Research Branch
SAGE	Standing Against Global Exploitation
SAMHSA	Substance Abuse and Mental Health Services Administration
SFDPH	San Francisco Department of Public Health
SISTA	Sisters Informing Sisters About Topics on AIDS
SJI	St. James Infirmary
SOEI	semi-structured, open-ended interview
SWEAT	Sex Work Environmental Assessment Team
SWOP	Sex Workers Outreach Project
TVPRA	Trafficking Victims Protection Reauthorization Act

Institutional Negotiation: Sex Workers and the Process of Resistance Maintenance

One afternoon, in the fall of 2006, I sat across from Tasha in the Oakland office of the California Prostitutes Education Project (CAL-PEP), an organization that offers HIV/AIDS prevention and education services to sex workers and members of other street-based populations, including persons recently released from prison, substance users, and parolees. When I first met Tasha—a pleasant, soft-spoken African American woman in her early forties, dressed in a pale-blue pantsuit and with neatly cropped hair—she told me that when she was fifteen she dropped out of school, ran away from home, and started working in prostitution to support herself and her cocaine addiction. CAL-PEP's mobile HIV-testing van was present in the community where she worked; when she was in her thirties, they provided the test that confirmed she was HIV positive. Although Tasha no longer works as a prostitute, she did not express regret or a sense of victimization about her participation in prostitution. Instead, she stated, prostitution "was a good thing" for her because it meant she "didn't ask for no handout." She went on to tell me that prostitution should be legal because then it would be less dangerous. "Girls are dying out there," she said (Interview, 1 December 2006).

On another afternoon that fall, across the bay in San Francisco, I sat with Monica at the St. James Infirmary (SJI), the world's only occupational health and safety clinic for sex workers (Interview, 24 October 2006). Monica, a Native American transgender woman in her late thirties, is a regular client here. Talkative, striking, and extremely confident, Monica told me how she worked as a street prostitute in San Francisco for ten years. Like Tasha, she also spoke openly to me about how she struggled with substance abuse and worked as a prostitute until she discovered she was HIV positive. Despite

having experienced these challenges, she also expressed no sense of victim-
ization or regret about her work in the sex industry. Instead, she explained,
"Prostitution should be legalized to let girls make money to survive because
it's hard enough to make money as a trans [gender person]: sex work is the
only way sometimes." She then told me about the banner in the SJI's commu-
nity room that reads "Outlaw Poverty, Not Prostitutes." She thought the SJI's
staff and clients "should take it to a rally."

 As I listened to Tasha's and Monica's stories, I was struck by how openly
they referred to and supported legally recognizing prostitution as *work*. Af-
ter all, despite their location in one of the more sexually liberal regions of the
country, they are still in the United States—the only Western industrialized
nation that almost universally criminalizes prostitution (Jolin 1994) and one
where the mainstream media is replete with stories of prostitution involving
coercion, violence, and human trafficking. Yet at CAL-PEP and the SJI, persons
like Tasha and Monica, who participate in prostitution and other forms of sex
work, not only receive free, nonjudgmental health services, but express views
of prostitution that oppose mainstream conceptions of it and support efforts to
change how society views sex workers.[1] These organizations therefore raise the
following broad question I explore in this book: how did they develop and sus-
tain themselves as spaces that offer services *and* support oppositional political
stances (in this case, recognizing prostitution as legitimate work)?

 At first glance, the answer appears rooted in a broader story of activists
capitalizing on particular political and resource mobilization opportunities
to facilitate such a project. But a closer examination indicates this answer is
not sufficient, particularly for explaining how these organizations foster and
sustain contentious issue positions in a political-institutional environment
that presents seemingly intractable obstacles. In particular, their nonprofit
status, grant agreements, and a broader political-legal climate that evinces
hostility toward noncriminalizing approaches to prostitution significantly
limits their capacity to maintain and promote an understanding of prostitu-
tion as legitimate work. But all of this does not necessarily preclude political
opposition and claims making. This book draws on CAL-PEP's and the SJI's
experiences to argue broadly that activists may in fact negotiate institutional
constraints and advance oppositional political claims as nonprofits. Through
what I label *resistance maintenance*, their founders and leaders strategically
use the process of building and sustaining nonprofit health- and social-ser-
vice organizations to continue opposing state policy, minimizing cooptation,
and pursuing broader social-change goals.

Changing Political-Institutional Arenas?
The Evolution of a Social Movement

CAL-PEP and the SJI were created by women who were active in Call Off Your Old Tired Ethics (COYOTE), the nation's first prostitutes' rights group. Formed in 1973 by Margo St. James, after she was arrested and tried for a prostitution offense in San Francisco, COYOTE initiated a social movement that sought to reshape social and legal understandings of prostitution from an immoral, criminal activity to a form of legitimate work. In so doing, Valerie Jenness wrote, COYOTE offered "a radical critique of popular views of prostitution by substituting a new ethic affirming prostitutes' behavior as sensible and moral" (Jenness 1993: 4). To this end, as social-movement scholars term them, COYOTE employed repertoires of "collective action" or "contention" (Traugott 1995; Tilly 1978; Tarrow 1989, 1998). A frank and well-written newsletter, *COYOTE Howls*, provided a simple, inexpensive way to communicate with its membership and the public. And COYOTE was visible through protests and the media. Holding placards reading "Hookers Unite: You have nothing to lose but cop harassment," "My ass is mine," and "The trick is not getting caught" (Jenness 1993: 49–52), COYOTE followed the lead of the city's gay community, which had successfully organized years earlier to protest against police harassment and for the right to participate in private consensual sex. COYOTE's collective actions soon came to the attention of the national news media. St. James was a guest on *Donahue*, and Gloria Lockett, CAL-PEP's current executive director, who joined COYOTE in 1984 after her own series of prostitution arrests, also appeared on *Geraldo*. Both women spoke on television (and in other media) of the need to legitimize prostitution as work in order to end the stigma and harms against women in the sex industry.

By the early 1980s, COYOTE's collective actions succeeded on many fronts, albeit mainly in San Francisco. The San Francisco Barristers' Club invited St. James to speak about prostitution law reform, and for COYOTE's annual Hooker's Ball (the organization's major fundraising event from 1973 to 1979), COYOTE gained the solidarity and support of other workers in the city when, as Margo St. James stated, "even the fire department helped us hang banners" (Interview, 26 October 2006). COYOTE also provided crisis counseling, support groups, legal counseling, and testimony at government hearings; served as expert witnesses in trials; helped the police investigate

crimes against prostitutes; and provided sensitivity training to government and other nonprofit agencies that serve prostitutes (COYOTE 2003).

Even with these gains, the COYOTE-led prostitutes' rights movement, like many other social-movement organizations, eventually faced a new set of political opportunities.[2] In particular, the advent of the AIDS epidemic marked a transitional point for many COYOTE members. As Lockett stated, "We knew that in the very near future prostitutes would be scapegoated for AIDS. At the time, all the attention was on gay men. [But] anyone with any sense whatsoever knew that [since the disease] was sexually transmitted . . . the next group of people they would target would be prostitutes" (Lockett 1994: 209). Lockett was correct: when the first heterosexual males tested positive for AIDS, public-health officials assumed these results were due to their interactions with prostitutes, representing the historically familiar pattern of scapegoating prostitutes for the spread of disease (Cohen and Alexander 1995). And so with over fifteen years' experience challenging the public's perceptions of prostitutes, COYOTE began its own HIV prevention efforts. On a shoestring budget, the organization handed out condoms and informational fliers about HIV/AIDS, and it held discussion groups to inform prostitutes about the virus (Stoller 1998).

In 1985 the Centers for Disease Control and Prevention (CDC) began a multisite study of HIV infection rates among female prostitutes in the United States (Darrow 1990: 22).[3] The agency knew from experience with other stigmatized communities, such as drug users and gay men, that prostitutes would also be more likely to trust their peers than government officials, and so the CDC would have to work with this community to conduct the study and convey health information. COYOTE's HIV prevention efforts thus came to the attention of researchers at the CDC's San Francisco site, which was run by the Association for Women's AIDS Research and Education (known as Project AWARE). Project AWARE teamed up with COYOTE in 1984, hiring three sex workers from its active membership, training them about HIV/AIDS transmission and risk reduction, and certifying them as phlebotomists (Cohen, Derish, and Dorfman 1994). They named their team the California Prostitutes Education Project.

Although COYOTE activists assumed CAL-PEP was temporary, government health authorities provided resources that would allow the agency to continue community-based health-service provision. CAL-PEP received its first grant from the San Francisco AIDS Office in 1987 and registered as a charitable nonprofit under Section 501c3 of the Internal Revenue Code (IRC)

to obtain more funding and broaden its service repertoire. Further opportunities for COYOTE members to continue health-service provision emerged in 1999, when they discovered sex workers held in jails were having their blood drawn illegally for syphilis testing. They presented the San Francisco Public Health Department's division of Sexually Transmitted Infection Prevention and Control (also known as City Clinic) with a plan for a clinic that would provide much-needed services to the sex-worker community and a site from which prostitution research would be conducted and disseminated (Alexander 1995a). The health department's new director at the time, Dr. Jeff Klausner, was open to this project and provided the initial resources (namely, office space and clinic staff) to begin work. The St. James Infirmary, the world's only occupational health and safety clinic for sex workers, opened on 2 June 1999 as a 501c3 charitable nonprofit offering HIV/AIDS prevention and other health services to sex workers, by sex workers, after hours in the City Clinic offices (it moved to its own office space in 2002).

CAL-PEP and the SJI as Social Movement–Borne Nonprofits

To some, CAL-PEP and the SJI may appear as little more than obscure, regionally specific organizations that serve a marginalized constituency. However, this book takes a broader view by situating them in a genealogy of what I term social movement–borne nonprofit organizations, which were created by activists involved in oppositional social movements that capitalized on resource incentives to continue "the work" of their movements through service provision. As such, they offer important insights into how activists continue their resistance efforts once their protest subsides.

Examples of social movement–borne nonprofits are wide ranging, including but not limited to women's health clinics formed by reproductive-rights activists to challenge male-dominated, doctor-asserted control over women's bodies (Morgen 2002); social-service organizations created by welfare-rights activists that involved and empowered welfare recipients in and through service delivery (Orleck 2005); AIDS service organizations like Gay Men's Health Crisis, established by members of the gay community to create a safe, stigma-free space where persons with AIDS could gather, without harassment, and receive services from their peers (Kayal 1993); homeless-service organizations that involve and serve members of the community in direct services and policy advocacy (Cress 1997); and rape crisis centers formed by feminist

activists who opposed violence against women (Maier 2011; D'Emilio and Donat 1992). Despite the range of issues this category of organizations covers, they all have in common registration as nonprofits and funds from government sources to offer health and social services to constituents represented by their activist interests (Cress 1997).

While capitalizing on resource opportunities may explain CAL-PEP's and the SJI's emergence—and that of many other organizations in this category—it does not explain how they continue supporting and advocating for the broader goals of their movement. In particular, it does less to explain how CAL-PEP and the SJI have continued supporting struggles for prostitutes' rights by creating spaces where sex workers like Tasha and Monica may gather—not as criminals or victims who must be "rescued" from an immoral activity but as individuals who can develop and express a consciousness of themselves as *workers* with occupational health and safety needs. In fact, one may assume government patronage (in the form of grant agreements) would create institutional incentives to the contrary by forcing them to sacrifice such political-oppositional claims-making activities for "don't-bite-the-hand-that-feeds-them resource dependence" (Chaves, Galaskiewicz, and Stephens 2004: 295). Although there is certainly truth in this assessment, my observations of and experiences with CAL-PEP and the SJI lead me to believe it is also a static understanding of many government-nonprofit relationships.

Instead, I explore how CAL-PEP and the SJI are shaped by and interact with their institutional environment, which I understand broadly as "relatively enduring collection[s] of rules and organized practices . . . that create capabilities for acting" (March and Olsen 2006a: 3). These may encompass both formal, state-oriented institutions (such as laws, policies, and administrative agency rules and practices) and informal institutions that are "created, communicated, and enforced outside of officially sanctioned channels" (Helmke and Levitsky 2004: 725), including dominant ideational structures, social norms, and cultural practices, among others. Informal institutions here are not simply norms and practices, however, because—like formal institutions—they are also communicated and enforced by state and societal actors (Banaszak and Weldon 2011). And so, as Guy Peters writes, the broad range of formal and informal institutions are unified by the fact that "they are in some way a structural feature of a society and/or polity" that is stable over time and constrains individual behavior (2005: 18).

Through my research with CAL-PEP and the SJI, I identified two institutional arenas that provide the stable yet constraining structures that influence

the behavior of these organizations, their leadership, and their constituents. The first is more formal, encompassing the laws and rules governing nonprofit organizations' capacity for and engagement in political activities, defined broadly to include indirect activities (such as empowering a constituency) and direct involvement with formal political institutions (such as lobbying legislators or participating in political campaigns and policy development). The second is issue related and includes the formal and informal historical, legal, and ideational institutional structures that shape dominant societal and political understandings of prostitution.

Nonprofit Organizations

While adopting a nonprofit health and social-service organizational form may risk activists' capacities to maintain and advance oppositional political commitments, Mary Fainsod Katzenstein writes that this formalization mirrors a long-standing tendency observed on the American political landscape since the writings of Alexis de Tocqueville to create associations (1998a: 12). Nonprofits, as a specific associational form, have a long, varied history in American service delivery, policy advocacy, and social movements (Jackson-Elmoore and Hula 2001) dating back to the English Poor Laws of 1601 (Block 2000).[4] The early colonial settlers in America adopted and applied their ethos, delegating responsibility for the poor to church and county officials, commonly through local, voluntary charitable organizations (Block 2001). Charitable giving and nonprofit formation grew even further at the beginning of the twentieth century, when such wealthy families as the Carnegies and Rockefellers created foundations to protect their wealth from taxation (Incite! Women of Color Against Violence 2007: 3).

Even with the ascent of the New Deal and Keynesian economic policies, Americans' misgivings about excessive government power limited the scope of government social protections and left ample room for the charitable, voluntary nonprofit sector to grow (Salamon 2003; Sokolowski and Salamon 1999). President Lyndon B. Johnson's War on Poverty extended government service provision through nonprofit organizations. Theda Skocpol writes that in the mid-1960s the federal government began to engage more in administration "by remote control" by using grants and contracts to induce nonfederal actors to pursue desired goals (2004: 6). In particular, amendments to the 1967 Social Security Act (Title IV-A) provided heavy inducements to encourage states to

enter contracts with private agencies to provide services (Morgen 2002; Skocpol 2004). In turn, state and local governments often designated private nonprofits to run social programs, making the nonprofit sector the "theatre of operations for the enlarged welfare state" (Morgen 2002: 161).

Many critics argue that government-nonprofit (and also, by extension, foundation-nonprofit) partnerships have served to coopt social-change efforts (see, for example, Kivel 2007), but a closer examination reveals that a major goal of these collaborations was not (entirely) to dampen the visible, disruptive activism of the era but to foster political participation. The Community Action Programs (CAPs) developed as part of President Johnson's War on Poverty provided an important example of how community-government partnerships may foster political participation and social change. Funded by the Economic Opportunity Act of 1964 to encourage the "maximum feasible participation" of residents in local areas, CAPs were formed based on the rather paternalistic view that the poor lacked a tradition of community organizing.[5] By providing the poor with collective-action structures and strategies, CAPs would theoretically help them become more politically efficacious, empowered, and able to harness resources to benefit their community and combat poverty (Banks et al. 1996). CAPs thus emerged in such poor communities as Harlem to serve youth, through such organizations as the Mobilization for Youth and Harlem Youth Opportunities Unlimited Associated Community Teams project (Cazenave 2007). CAPs also served African Americans, to develop community and political leadership (Banks et al. 1996), and women (Naples 1991a, 1991b, 1998).

Although various authors have dismissed the War on Poverty as largely a well-intentioned but poorly executed set of programs that failed to eliminate poverty (Stricker 2007; Quadagno 1994), if one looks closely, the CAP element created an institutional environment that provided opportunities for marginalized groups to develop civic and political skills and engage in the broader political realm. CAPs that served and involved poor women provide one of the most notable examples here. Nancy Naples's extensive studies collected focused life histories of women employed by various CAPs in Philadelphia and New York City between 1964 and 1974 and found that the CAPs politically empowered these women in a number of ways (Naples 1991a, 1991b, 1998). The first was internally: by providing spaces, within the state, for these women to not only gather and meet others in their community with similar concerns but also to receive pay for work performed on behalf of their communities. Although many of these women did not see themselves as political

activists, they ensured their community's interests were served and were paid for this work, by the state, thereby inadvertently challenging the separation of paid employment and nurturing activities for women. Second, CAPs also provided opportunities for the women to gain political skills and efficacy externally. As "street-level bureaucrats" (Lipsky 1980), these women identified how the state was not meeting their community's needs, and they resisted the oppressive structures of the state to redirect and rechannel social policy. And so in addition to engaging in the day-to-day administrative and service-oriented tasks required of them, many participated in political activities and made claims on the state outside of their organizations. Although none of the women Naples interviewed ever went as far as running for political office, they variously challenged the authority of city and state agencies, developers, landowners, police, and public-school officials to ensure their community's interests were served (Naples 1991a, 1991b, 1998).

As CAPs declined, however, the government-nonprofit nexus continued growing. By 1975, government funding replaced private donors as the largest source of nonprofit revenue (Dobkin-Hall 1987: 143). Nonprofit-sector growth continued in the 1980s with the rise of the New Right and Ronald Reagan's election on a platform advocating a major retreat from government intervention in social policy and the economy and an ideological opposition to social spending (Abramovitz 2000; Eisenstein 1994). To the Reagan administration and others on the right who decried government involvement in the economy, nonprofit organizations' small budgets and dependence on contracts made them seem more efficient, accountable, and flexible for offering and delivering new service ideas, and they were a means for bringing unaddressed problems to public attention (Berry and Arons 2003; Salamon 2003; Gilmore 2007).

Activists concerned with health and welfare issues also saw the nonprofit sector as an arena where they could provide services and draw attention to the emergent AIDS epidemic, especially since government agencies at the federal, state, and local levels responded slowly to the mounting prevention and care needs of those affected. Unlike other communicable diseases among urban populations, many public and political officials understood AIDS as a disease of social pariahs that was associated with immoral conduct (Cohen and Elder 1989; Armstrong 2002; Penner 1995). The gay community quickly realized that they would have to help themselves: they engaged in intensive political protest through such organizations as the AIDS Coalition to Unleash Power (Chambré 2006), and they formed community-based nonprofit

organizations, such as the Gay Men's Health Crisis in New York City and the San Francisco AIDS Foundation in California to serve persons with AIDS more immediately.

To government officials, these local, grassroots service organizations appeared inexpensive, and they offered flexibility and new ideas for delivering information and services to persons considered at risk for HIV (Berry and Arons 2003; Salamon 2003). And as indirect measures seemed to indicate, these community-based efforts successfully discouraged unsafe sexual behaviors (Bailey 1991; Wolitski et al. 2006), while their small budgets and highly localized programming aligned with the Reagan administration's devolutionary agenda. Of course, this approach was not unique to HIV/AIDS prevention: collaboration between government agencies and community-based organizations with access to hard-to-reach or stigmatized populations has been a public-health tradition in the United States. Indeed, as early as 1937, the Surgeon General declared that the best hope for eradicating syphilis lay in community-based voluntary organizations, and so federal and state leaders offered concrete help to these organizations to support their efforts (Bailey 1991). And since the 1970s, community-level interventions have been useful in addressing other health issues, such as smoking cessation and control and prevention of coronary heart disease (CDC AIDS Community Demonstration Research Group 1999).

Consequently, by the mid-1980s, the relationship between community organizations and government agencies like the CDC was largely reciprocal. The community organizations became laboratories, in a sense, for the CDC to observe and learn about different HIV prevention interventions (Bailey 1991), and by 1988, the CDC was delivering the bulk of their HIV/AIDS prevention services through them. According to the CDC (2002), its Division of HIV/AIDS Prevention is in charge of reducing incidences of HIV infection and HIV-related illnesses and deaths, in collaboration with community, state, and national partners. Sixteen percent of the CDC's $6 billion budget is for HIV/AIDS prevention, nearly 80 percent of which is distributed externally through cooperative agreements, grants, and contracts to state and local agencies (Department of Health and Human Services 2010, table on p. 1). The largest portion of these grants fund health departments that often subcontract service provision to nonprofit community-based organizations.

Currently, nonprofits in a wide range of service areas are effectively "coproducers" of government policies and programs (cited in Skocpol 2003: 149–52), forming what some have labeled a "shadow state" to describe the

contemporary growth of nonprofits involved in direct and indirect delivery of services previously provided by New Deal and Great Society programs (Wolch 1990). Between 1974 and 1995, federal support to all nonprofits increased from $23 billion to $175 billion (Marwell 2004: 269), and the nonprofit sector grew significantly. In 2008, there were approximately 1.5 million tax-exempt nonprofit organizations, up from 1.16 million in 1998 (Wing, Roeger, and Thomas 2010: 2), and they employ nearly 8.6 million paid full-time persons and 7.2 million volunteers (Sokolowski and Salamon 1999: 262–63). On average, 30.5 percent of nonprofits' revenue is from government (Sokolowski and Salamon, 1999: 273). As a result, the charitable nonprofit sector is a major player in the American social-welfare system (Smith and Lipsky 1993, 2001), with 44 percent of such organizations delivering health and human services many Americans depend on (Wing, Roeger, and Thomas 2010: 4).[6] The recipients include some of the most politically marginalized persons in the nation: those at high risk for contracting HIV/AIDS, including members of sexual and racial minority groups who live in poverty, gay men, African Americans, transgender individuals, intravenous drug users, and street-based sex workers (CDC 2007: 1; Alameda County 2003: 1; Boone, Bautista, and Green-Ajufo 2005: 6–7).

To observers of American politics concerned with including the voices of marginalized populations in the political process, the nonprofit sector may seem like a place to begin such a project. But while government may rely on these organizations to provide services—and these organizations may also gather some of the most marginalized individuals in the nation—their institutional environment limits them here. Section 501c3 of the IRC and data-collection requirements from funding agencies restrict nonprofits' ability to engage in political activities that challenge government policy with and on behalf of their constituents.

IRC SECTION 501C3

Section 501c3 of the Internal Revenue Code covers almost 50 percent of all registered nonprofit organizations, including CAL-PEP and the SJI, granting them charitable tax-exempt status (meaning donations to them are tax deductible). In exchange for this exemption, however, the government restricts how nonprofits organize, govern themselves, and act, particularly when it comes to influencing legislation (Scrivener 2001; Block 2000). In 1995, questions about the extent of government oversight amplified when Congressman Ernest Istook (R-TX) initiated a debate about changing how the nonprofit

sector is regulated and monitored. Istook was concerned that nonprofits were using federal funds for lobbying, and so his amendment would lower the amount of money they could spend on advocacy, which he wanted to define as any attempt to influence policy (including education and awareness activities). The Istook Amendment rallied nonprofit organizations of all types, and while it was defeated after each introduction, it always led to a bitter debate (Clarke 2001).

Despite the failure of the Istook Amendment, 501c3 nonprofits remain closely scrutinized by government agencies, most notably the Internal Revenue Service (IRS), which strongly encourages nonprofits registering as exempt entities to be "thoughtful" about governance and thus encourages them to form "an active and engaged board . . . to effectively make sure that the organization obeys tax laws, safeguards charitable assets, and furthers its charitable purposes" (IRS 2008: 2). When nonprofits gain tax exemption, they are monitored further through Form 990, the annual tax return nonprofits must file; this form includes a section on governance to "help ensure that the organization's assets will be used consistently with its exempt purposes" (IRS, 2009: 1).

The IRS also restricts nonprofits' external political actions, namely, their participation in lobbying and election campaigns. Treasury Regulations (501c3–1c3ii) describe a wide range of activities that count as lobbying, including directly contacting government officials with respect to acts, bills, resolutions, or similar items (such as legislative confirmations of appointive office), or seeking to influence the public in a referendum, ballot initiative, constitutional amendment, or other related activity. The IRS thus regards a charitable nonprofit as lobbying if it engages in grassroots lobbying via appeals to the electorate or general public for the purposes of advocating, supporting, opposing, or proposing legislation (IRS 2006; Lunder 2006). Federal government agencies also will not reimburse nonprofits they fund for lobbying expenses.[7]

Section 501c3-1c3iii of the Treasury Regulations specifies limitations on nonprofits' campaign activities. Approved election-related activities must be nonpartisan and may include, for example, conducting unbiased and nonpartisan public forums or meetings where candidates from both sides speak or debate (IRS 2006). The IRS states that managers and leaders of 501c3 organizations can participate in campaign activity in their own private capacity, but they must keep their private views out of their organizations' publications, statements, and so forth (IRS 2007). However, nonprofits have some

lobbying flexibility under Section 501c3 if they make the H-election through IRS Form 5768:[8] by completing this form, they are allowed to spend specific percentages of their budgets on lobbying activities without compromising their tax-exempt status.[9] Larger, well-funded 501c3 organizations may evade this lobbying restriction by registering under IRC section 501c4 and creating separate advocacy organizations.

DATA COLLECTION

In addition to the rules governing nonprofit status, nonprofit leaders also are constrained by government agencies' data-collection requirements, which are imposed through grant agreements. Data-collection requirements have increased notably since the 1960s, when government funding for nonprofit agencies shifted from grants with relatively loose accountability to increasingly specific contracts and requirements (Smith 2006: 234). Today, governments at all levels have moved from regularly renewing grant contracts to performance-based renewal. Now nonprofits must submit increasingly high-quality grant proposals and engage in extensive program monitoring and reporting activities to attain and maintain funding (Gronbjerg and Smith 2006). Not only do data-collection activities consume nonprofits' resources (particularly staff time); in theory, they may also make nonprofits cautious about engaging in activities that could jeopardize funding, especially if they challenge or oppose government policy. These restrictions potentially narrow nonprofits' focus and lessen their political clout by professionalizing them in relation to the state (Gilmore 2007).

In the HIV/AIDS prevention field, where CAL-PEP and the SJI reside, data monitoring and reporting has grown particularly acute for nonprofits, particularly as the variety of funded programs expanded across a range of geographical areas and compromised the CDC's ability to monitor and evaluate grantees' performance (Thomas, Smith, and Wright-DeAgüero 2006: 75).[10] George W. Bush's administration, which was generally suspicious about community-based harm reduction–oriented HIV prevention activities, pressured the CDC to improve accountability (Epstein 2006). Consequently, in 2004, the CDC created program-evaluation practices at the federal level that have increased data-collection requirements for charitable nonprofits conducting HIV prevention work locally. One example is the CDC's Program Evaluation and Monitoring System (PEMS), "a national data reporting system developed to strengthen the capacity to monitor and evaluate CDC-funded HIV prevention programs administered by the

Department of HIV/AIDS Prevention" that included a standardized set of HIV data-prevention variables, web-based software for the data entry and management, assistance with planning and conducting evaluation, training for data collection and evaluation, and support services for the software implementation (Thomas, Smith, and Wright-DeAgüero 2006: 75). In essence, the CDC developed PEMS to standardize data reporting across a disparate range of service providers; however, the program was incredibly complex and, arguably, burdensome, especially for small nonprofits already stretched thin with existing reporting requirements. Of course, not all HIV/ AIDS prevention nonprofits receive funding directly from the CDC, but such examples as PEMS indicate that data collection is a daily (and growing) reality for nonprofits, especially those engaged in HIV/AIDS prevention, because many report data to their state and local health departments, which in turn report to the CDC. In fact, 80 percent of CAL-PEP's $850,000 annual budget is from the CDC (Interview, Gloria Lockett, 11 January 2010). And while over half of the SJI's approximately $450,000 annual budget is from San Francisco's Department of Public Health for HIV/AIDS testing services, in-kind medical staff, and supplies (Interview, Naomi Akers, 5 December 2006), much of the Public Health Department's funding comes from the CDC as well.[11]

Issue Context

In addition to their nonprofit status and grant agreements, CAL-PEP's and the SJI's institutional environment is also defined by a broader set of formal and informal structures that reinforce a long-standing hostility toward any noncriminalizing approaches to prostitution. American prostitution laws do not define prostitution as a legitimate form of work: with the exception of the state of Nevada (where counties with fewer than four hundred thousand residents may license prostitution in brothels), all governments of states in the Union and the national government (where interstate prostitution is concerned) criminalize prostitution. Yet despite the entrenchment of antiprostitution sentiments in U.S. law, activists have advanced competing interpretations of the issue. The following pages sketch the parameters of this debate to illustrate how antiprostitution perspectives, which define the nation's dominant ideational paradigm, are institutionalized through mutually reinforcing laws and discourse.

"SEX WORK" VERSUS "ABOLITIONISM"

Organizations like CAL-PEP and the SJI understand prostitution as a form of "sex work," a term COYOTE member Carol Leigh (1997) introduced into mainstream discourse that refers to the exchange of any commercial sexual services for material compensation, some of which are legal in the United States, including dancing, pornography, and phone sex. This term emerged in the 1970s, on the tail end of one of the nation's most liberal political eras, when the Vietnam War, civil rights, and women's liberation gripped the nation. As sexual liberalism also grew, public attention turned to prostitution, particularly among feminists. Although men and transgender persons also engage in prostitution, the majority of participants are women. For feminists active in the 1960s and 1970s, the issue raised many issues of sex and gender equality (including sexual liberation, sexual violence, and economic opportunity) that dominated their activism in that era.

Furthermore, for the first time in U.S. history women who were working as prostitutes spoke publicly and acted as their own advocates in these debates, most notably through COYOTE in San Francisco. They claimed that laws criminalizing prostitution were enforced in a sexist manner (women were, and are, arrested far more often than men) and increased their risk for violence and danger experienced at the hands of clients and the police. They also drew from liberal feminist and sex radical theories to claim that prostitution is an individual choice for women that may, in cases, be sexually and economically liberating.[12] They therefore argued prostitutes would be safest when afforded the legal protections granted to other workers, and they endorsed decriminalizing prostitution—a legal approach that recognizes it as work, without penalty, where the state's provision of labor standards, contract laws, and other related protections offered to businesses also apply (for some examples of the sex work perspective, see Kempadoo 2005; Kempadoo and Doezema 1998; Chapkis 2000; Jenness 1993; Thompson 2000; Abramson, Pinkerton, and Huppin 2003).

However, a combination of "real world" events and discursive-ideational developments on the American political landscape has limited the influence of sex-worker rights activists. In the late 1970s and early 1980s, the emergence of the AIDS epidemic and the social impacts of reconstruction and development in the Southeast Asia region in the aftermath of the Vietnam War drew public and political attention to prostitution in the United States and internationally. Sex tourism, mail-order brides, militarized prostitution, and the movement

of women to more affluent regions for work in the leisure and sex industries became the focus of those concerned with (and opposed to) prostitution (Kempadoo 2005). In the mid-1980s, media attention to the plight of Latin American and Asian women illegally trafficked to work in brothels in Western Europe (among other locations) illustrated further the dangers of prostitution and made it seem inconceivable that anyone would choose this activity as work (Gozdziak and Collett 2005; Soderlund 2005). As Elizabeth Bernstein documents, to those opposing the sex work perspective, these stories made it easy to dismiss any positive accounts of prostitution by stating that they illustrate a false consciousness of sorts and merely represented the perspective of a minority of white and privileged participants in the sex industry (2007).

Consequently, feminist advocates became increasingly divided about sex work during the so-called "sex wars"—the heated debates over feminist depictions of women's sexuality in pornography that consumed the attention of many theorists and activists through the mid-1980s (Abrams 1995). In contrast to the sex work perspective, the abolitionist position emerged in these debates, and it drew from radical feminist theory exemplified by the work of such scholars as Kathleen Barry (1984) and Catharine MacKinnon (1989). Broadly speaking, radical feminists viewed the division of the sexes between males and females as a mechanism of oppression in a male-defined, male-centered world. From this perspective, although prostitution is only one of many institutionalized forms of oppression forced on women by men to reinforce male domination (Jolin 1994), it epitomizes women's subordination, constitutes the foundation of male dominance, and, hence, should be "abolished" (Barry 1984; Schotten 2005).

Although abolitionists acknowledge the link between economic hardship and entry into prostitution, as Bernstein (2010) writes, they more often argue that individual male pimps (a term used synonymously with traffickers) and clients of prostitutes are predators responsible for tricking and luring women into prostitution and for causing the harms they experience there. According to abolitionists, criminalizing prostitution is essential for apprehending, punishing, and ending pimps', traffickers', and clients' demand for prostitution (Hotaling 2007; Hotaling et al. 1997, 2003). For women in prostitution, they propose decriminalizing their participation so that they may be diverted from the criminal-justice system to social services that help them exit the trade (for some current examples of this perspective, see Hughes 2003; Hughes and Raymond 2001; Farley 2005, 2007; Farley et al. 2003; Farley and Kelly 2000; Hotaling et al. 2003).

Although they are not a unified community, supporters of sex-worker rights have responded to this abolitionism, stating it focuses only on sex as violence, thereby constructing women as passive and denying them agency in making their own sexual and economic choices (Kessler 2002; Jeffreys 2005). Furthermore, critics also charge abolitionists with being "class-blind" in that they oppose prostitution because they are not in a position that would necessitate this choice of occupation (Jolin 1994). Further, many minority feminists claim abolitionism is race-blind in that it ignores how violence is contextualized differently in cultures with histories of slavery and colonialism and thus provides a monolithic, unitary view of women's sexual experiences (Kuo 2002). In this regard, many scholars and activists decry abolitionists' rhetoric of slavery as patronizing, prudish, and articulating colonial representations of Third World women (and other women of color) as helpless victims who supposedly need Western feminists to liberate them (Harrington 2010: 95; Halley et al. 2006: 371–72; Kempadoo 1998).

At the heart of these debates, however, is a desire for state institutions to acknowledge sex workers in particular ways, and both sex work and abolitionist supporters claim their policy proposals will serve sex workers more effectively. However, it is currently difficult to determine what persons in the sex industry need and experience because they largely constitute a "hidden" population that is difficult to access via traditional social-science research methods (Lee and Renzetti 1990). But as Ronald Weitzer (2010a) writes, when generalized to all sex workers, abolitionist claims about sex work apply best to one sector—those engaged in survival sex (the exchange of sexual services for basic needs, such as food). Beyond this group, however, empirical research demonstrates a remarkable diversity of activities fall under the term *prostitution* (Plumridge and Abel 2001; Donovan and Harcourt 2005; Monto 2004). Aside from survival sex, these include street prostitution, which researchers estimate constitutes between 2 percent and 20 percent of the trade (Bernstein 2007: 30); hustling in clubs, bars, and hotels; escort services (for a discussion of this sector, see Norton-Hawk 2003); bondage, domination, and sadomasochism services (which may or may not include sexual contact); independent prostitutes working from their homes; and women on welfare or other social assistance who might exchange sex for cash or other goods, on occasion, with male friends (see, for example, Edin and Lein 1997). Consequently, as Weitzer (2005: 219) argues, the type of prostitution is the best predictor of worker experiences. Oftentimes, individuals who work indoors or with others are more likely to experience

greater control over and safety in their work environments (Cohan et al. 2004), which is particularly true where encounters with law enforcement are concerned. Although female prostitutes in all venues are still arrested more often than their (male) clients, street prostitutes (who are more likely to be women of color and have less education) face the highest risk for abuse by pimps and law-enforcement officials (Weitzer 1999). In sum, current state practices of arresting and jailing prostitutes have done little to improve their working conditions, help them overcome any drug and health problems they might have, and divert them into legal employment (Weitzer 1999, 2000; Kuo 2002; Norton-Hawk 2001, 2003; Jolin 1994; O'Connell-Davison 2002; Delacoste and Alexander 1998).

But even as evidence points to a diverse range of sex-worker experiences (and the negative implications of criminalization), the abolitionist perspective has permeated and influenced public discussions and state institutional responses because it aligns with broader political trends favoring punitive crime policies and sexual moralism (Weitzer 2010a; Bernstein 2010). The right-wing ascendancy of the Reagan and George W. Bush years in particular created opportunities for abolitionist advocates. At this time, Bernstein writes, a "coalition of strange bedfellows" (2010: 65) formed between abolitionist feminists and religious groups (who already had the ear of the Bush administration on many other issues). Despite having different views on such feminist issues as abortion, abolitionists' prostitution narrative incorporated elements of the religious right's (sexual) moralism and broader "tough on crime" proclivities, which allowed these groups to form alliances with powerful right-wing political leaders and advance their agenda (Bernstein 2010).

As a result, writes Weitzer (2010a), such abolitionist groups as the Coalition Against Trafficking in Women formed coalitions with conservative Christians, like senators Sam Brownback and Rick Santorum, and antiprostitution organizations, like International Justice Mission and the Family Research Council. Their combined opposition to prostitution and support for victims of crime allowed them to rally their constituencies, influence U.S. policy, and dominate the debate over any policy and funding related to prostitution (Berman 2006). And the following recent examples illustrate how the abolitionist perspective is institutionalized in law and policy at the state, local, and national levels.

In May 2003, Congress passed the Global AIDS Act and barred the use of federal funds to "promote, support, or advocate the legalization of the prac-

tice of prostitution" (Global AIDS Act 2003). The accompanying National Security Presidential Directive (NSPD-22: 1) asserted, "Our Policy is based on an abolitionist approach to trafficking in persons. The United States Government opposes prostitution and any related activities, including pimping, pandering, or maintaining brothels as contributing to the phenomenon of trafficking in persons" (White House 2003). The Global AIDS Act required nongovernmental organizations (NGOs) it funded to have a policy explicitly opposing prostitution and sex trafficking (Bernard 2006). Public-health officials and sex-worker rights advocates argued this requirement would compromise sex workers' health by limiting the range of service providers (see for example ACT-UP 2003). But lacking powerful allies in Congress, the perspective of these groups was minimized until July 2011, when the U.S. Second Circuit Court of Appeals ruled that the U.S. government may not force U.S. organizations to pledge their opposition to prostitution in order to receive money for international HIV/AIDS prevention work because this action violates the organizations' First Amendment rights (*United States Agency for International Development v. Alliance for Open Society International* 2011).

The Trafficking Victims Protection Reauthorization Act (TVPRA) also reflected right-wing and abolitionist influence by expanding police powers. Specifically, the 2003 TVPRA required all applicants for funding to state that they do not promote or support prostitution, and it expanded financial support for local law enforcement engaged in antitrafficking activities (Trafficking Victims Protection Reauthorization Act 2003). Sex-worker rights activists were vocal in the TVPRA's creation process, arguing it effectively conflated all forms of prostitution with sex trafficking and placed victims at risk (Chapkis 2005). However, these arguments lacked powerful advocates (in Congress and elsewhere), and so to date the federal government has spent $528 million toward eliminating human trafficking (Todd 2009: 25), although it only identified 1,362 victims of human trafficking in the United States since 2000 (cited in Markon 2007: 1). And there have been even fewer prosecutions. In 2009, only 114 individuals had been charged, and the government obtained only 22 sex-trafficking convictions—the highest number of prosecutions and defendants charged in a given year (U.S. Department of State 2010: 339).

At the state and local levels, the abolitionist story has also influenced policy formation, most notably in 2008 when the Sex Workers Outreach Project (SWOP) and a number of other organizations spearheaded Proposition K, which would have barred San Francisco police officers from arresting or investigating or prosecuting anyone for selling sex. Advocates claimed this ban

would free up $11 million per year in police resources and allow prostitutes to form collectives and defend their rights as workers (YesOnPropK.org 2009). However, advocates of Proposition K were not able to overcome antiprostitution sentiments in the region (a similar ballot proposition, Measure Q, failed in Berkeley in 2004 with only 36 percent support). Drawing on popular abolitionist discourses of victimization, then Mayor Newsom and then District Attorney Kamala Harris waged a strong campaign against Proposition K, claiming it would limit law enforcement's ability to curb human trafficking and provide services for victims. They stated, "We cannot give a green light or a pass to predators of young women" (Harris, cited on NBC News 2008).

Navigating Constraints: A Neo-Institutional Analysis

Conventional (academic) wisdom holds that formal and state-oriented institutional structures compel strong compliance and discourage opposition or disruption of their attendant values and norms. Most notably, Frances Fox Piven and Richard Cloward (1977), in their study of protest movements that erupted among lower-income groups, predicted that once the radical protest movements of the 1960s shifted their focus to creating formal organizations (and partnering with government agencies), much of the protest element would disappear. Consequently, as Mary Fainsod Katzenstein explains, much scholarship continues assuming that "claims voiced by social movements, when incorporated into institutional settings, broadly defined, are thought to be routinized and depoliticized. . . . Social movements . . . are necessarily extra-institutional" (1998b: 195).

By incorporating as nonprofits and depending on government grants, CAL-PEP and the SJI exemplify these assumptions at first glance. Yet this is also a uniform, static, all-powerful view of institutions and a limited, no-nagency centered view of the actors—like CAL-PEP's and the SJI's leaders—who engage with them. Indeed, state-oriented institutions are powerful, but activists who wage oppositional claims are also strategic. This book is therefore concerned with the potentially dynamic, interactive relationship between activists and the formal and informal institutional environments they engage with. Such an analysis examines how institutions (broadly defined) foster or quash oppositional political consciousness and how individuals act rationally and strategically within them. Therefore, the focus here is on the broader processes of institutional*ism*, which considers "the relations between

institutional characteristics and political agency, performance, and change" (March and Olsen 2006a: 4).

My analysis of CAL-PEP's and the SJI's capacities to sustain and foster oppositional political commitments—as social movement–borne nonprofits—therefore draws theoretically from "new institutionalism," which holds broadly that formal and informal institutional structures matter for shaping political attitudes, events, and behavior over time (March and Olsen 1984, 2006a). Emerging from calls to "bring the state back in" to political science (Evans 1985) after the rise to dominance of behavioralist, agent-centered approaches to the discipline that came to popularity in the 1950s and 1960s, so-called new institutionalists "argued for the need to contextualize politics institutionally—in other words, to see the conditions of political opportunity as being, to a significant extent, set institutionally" (Schmidt, 2006: 99–100). In essence, political outcomes were no longer a function solely of rational, individual behavior, nor were they simply explained by describing the political, legal, and administrative institutions of government.

Today, new institutionalism is a diverse body of work, roughly divided into rational choice, historical, sociological, and discursive "sub-schools" of thought that "reveal different and genuine dimension of human behavior and of the effects institutions can have on behavior" (Hall and Taylor 1996: 955).[13] For this analysis, however, my goal is not to crudely synthesize these schools or determine the "best" one for analyzing how CAL-PEP and the SJI negotiate their institutional environments. Instead, I draw from these schools' shared theoretical core that rejects the proposition that observable behavior is the basic datum of political analysis (Immergut 1998). And I acknowledge that political conduct is shaped by the institutional landscape it occurs in, by historical legacies bequeathed from past to present, and by the diverse range of strategic orientations to the institutional contexts that actors find themselves in (Schmidt 2006).

At the same time, institutions are also shaped by political actors' conduct: after all, as Peters (2005) writes, in all but the most extreme conceptualizations, institutions are the results of purposive human action. Social movements are composed of political actors, and they often target their actions at institutions, especially those of the state, such as legislatures and government agencies (Van Dyke, Soule, and Taylor 2004). However, as Lee Ann Banaszack and Laurel Weldon observe, institutionalists "overlook the power of social movements as mechanisms of change in formal and informal institutions" (2011: 270). And so while much of the social-movement research con-

siders how these social movements emerge and mobilize people, they have paid less attention to their outcomes and consequences (Wolfson 1995; Giugni 1998).[14] Of the work that does examine outcomes, most focuses on political and policy outcomes and not on broader cultural and institutional effects (Giugni 1998). In response to this omission, Edwin Amenta and Neal Caren (2004) identify some criteria for assessing social movements' achievements and success. These include achieving legislation (the most common but also the most basic achievement); having the state recognize the challenger(s) as a legitimate representative of the constituency; and attaining procedural, representational, and structural gains (the highest achievement).

Feminist political scientists present some of the most notable research about social movements' impact on institutions. They show how women's movements have brought changes to gender norms, policies, and formal and informal (state and nonstate) institutions (Banaszak and Weldon 2011). Applying Amenta and Caren's criteria, we see the movements' many legislative and representational gains. Laws prohibiting sex-based discrimination in the workplace and violence against women are but two examples of these achievements, and governments in the United States recognize such groups as the National Organization for Women and the League of Women Voters as representatives of women's interests. However, research also indicates that the women's movement (in the United States and internationally) has not yet attained many procedural and structural gains: women remain underrepresented in legislatures, particularly in the United States, and an extensive body of research also indicates how these institutions are often hostile to women.[15]

Nonprofit Social-Service Initiatives and Institutional Change

By examining how CAL-PEP and the SJI maintain their oppositional politics within a range of political-institutional constraints, this book draws from and contributes to research about social movements, civic engagement, and new institutionalism. But since these nonprofit organizations, like many others, depend on government grants, readers are forgiven for their skepticism that these groups are able to engage in any oppositional political work within and outside of their organizations, let alone influence and shape the actions of mainstream (state) institutions. However, research that applies new institutionalism to the nonprofit sector indicates that while political conduct here is shaped by the institutional landscape, political actors are often strategic (and

even influential) within it. Kirsten Gronbjerg and Steven R. Smith propose a new institutional theory of government-nonprofit relations that illustrates this understanding. Here "government" is defined as creating the institutional context—through laws, policies, and politics—in which nonprofits emerge and act. Their theory suggests that instead of assuming nonprofits' relations with government depoliticize them, there is actually a mutual synergism between government and nonprofits, meaning that the "prevalence and vitality of nonprofit organizations is largely a product of the political, legal and institutional environment" (Gronbjerg and Smith 2006: 235).

A new institutional understanding of nonprofits thus indicates that even when a nonprofit organization appears depoliticized, it is important to look for other ways it retains or develops goals or features that engender oppositional stances or reactions (Morgen 2002) and for the ways that it also shapes the institutions it interacts with. In fact, emerging empirical research shows that nonprofits are in a much more synergistic, reciprocal relationship with their institutional environments, where their leaders often navigate restrictions on their political activities to influence law and policy development to effect social change (Gronbjerg and Smith 2006). For example, Jeffrey Berry and David Arons's (2003) seminal study of nearly 2,500 nonprofits nationwide compared the political activities of charitable nonprofit service providers who signed IRS Form 5768 to make the H-election under IRC 501h with those that did not.[16] The H-election subjects nonprofits to an expenditure test, under which they may devote a percentage of their tax-exempt purpose budget to lobbying legislators directly.[17] Berry and Arons found the H-electors actually advocated for and represented their constituents' interests in the political process, while non–H electors did less (or none) of this, indicating that nonprofit status may limit political activity but nonprofit leaders with sufficient information may act strategically to counter these limitations. In another study, Mark Chaves, Joseph Galaskiewicz, and Laura Stephens (2004) considered the effect of government funding on nonprofits' political activities by using a national sample of religious congregations and a longitudinal sample of nonprofit organizations in the Minneapolis–St. Paul area. Although one may assume that nonprofit rules and funding agreements limit their political activity, their results showed that government funding did not always suppress nonprofits' participation in the political and policy process. In fact, government's dependence on nonprofits and nonprofits' self-interest often combined to increase nonprofits' engagement in the political process in a range of ways, from simply informing their constituents of political activities

and discussing politics to registering people to vote (Chaves, Galaskiewicz, and Stephens 2004: 304). And Nicole Marwell (2004) shows that nonprofit organizations may operate as the fulcrum through which patronage resources (i.e., grants and contracts) are distributed and nonprofit clients are organized as voters. By engaging in electoral organizing and producing reliable voting constituencies, nonprofit leaders may in fact pressure political actors to make favorable contract allocations.

All of this research indicates how nonprofits are able to engage in political activities, broadly defined, in the face of institutional constraints. But from a new institutional perspective, it is also important to consider nonprofits' potential impact on the government institutions and agencies that fund and regulate them. Studies of rape crisis centers, and needle exchanges—nonprofit health- and social-service initiatives created by social-movement actors (whose populations and concerns intersect with CAL-PEP's and the SJI's in many ways)—demonstrate the potentially synergistic relationship between nonprofits and (state) institutions. They also indicate how activists' entry into the nonprofit sector and, hence, partnerships with mainstream (state) agencies do not necessarily undermine their political commitments.

As John D'Emilio and Patricia Donat (1992) write, the feminist movement has long been concerned with issues of rape and sexual assault, and because of their work, contemporary understandings of these issues and social and institutional responses to them have changed significantly. Feminist activists created rape crisis centers, which provide services to victims, such as hotline counseling and medical and legal assistance. Run collectively, their major focus was to provide services and seek broader sociolegal changes, including legal rights for rape victims and eliminating rape from society (Maier 2011). Initially, as Patricia Yancey-Martin (2009) documents, the founders of these centers did not want to collaborate with mainstream institutions because they saw them as patriarchal and unsupportive of their broader mission to end violence against women and rape. However, as their work increased, rape crisis centers faced pressures to maintain funding for services, and so many of them entered into funding relationships with mainstream (government) health- and social-service institutions. In many cases, the centers became more professional, bureaucratic, and hierarchical, which—combined with government restrictions on nonprofit-grantee political activity—limited their capacity to engage in the same degree of political activism (Schechter 1982; Maier 2011; Campbell, Baker, and Mazurek 1998). Although many rape crisis centers continue engaging in lobbying and demonstrations and public-

awareness campaigns, these activities often have a less radical bent (Campbell, Baker, and Mazurek 1998: 2247).

However, rape crisis centers also demonstrated the potentially influential synergism that may exist between activist-run nonprofits and mainstream institutions. In fact, rape crisis centers have changed how these institutions operate and act in many ways. For example, activists involved with rape crisis centers lobbied for and achieved legislative change: in 1974, Michigan was the first state to enact comprehensive rape-legislation reform, and many states have followed (D'Emilio and Donat 1992: 19). Furthermore, rape crisis centers have also changed mainstream institutional practices. Although there is still much work to be done in this regard, the police, attorneys, judges, and medical providers now are trained to be more sensitive to rape victims' concerns (for example, the burden for evidence, at least in theory, is no longer on the victim). All of these changes have led many scholars and observers to conclude that although there is a long way to go, rape crisis centers' collaborations with mainstream institutions have brought many positive changes for rape victims (Zweig and Burt 2003).

Similarly, syringe-exchange programs also indicate how activist-led nonprofit health- and social-service initiatives may also shape mainstream institutional practices and actions. As Ricky Blumenthal (1998) writes, these programs allow intravenous drug users to exchange used syringes for clean, unused ones at designated sites to reduce the spread of HIV/AIDS. But while scientific, medical, and public-health associations support syringe exchanges, the federal ban on funding for these, combined with state laws prohibiting the possession and distribution of syringes (through prescription and paraphernalia laws), created a legal-institutional environment that was (and still is) very unfavorable to these programs. And so in the 1980s, in response, members of communities affected by HIV and substance use (and their allies) mobilized by setting up needle exchanges in various jurisdictions across the United States. These acts of civil disobedience publicly tested state prescription-drug laws and drew attention to the issue of HIV transmission among intravenous drug users (Keefe, Lane, and Swarts 2006).

Like the founders of rape crisis centers, needle-exchange activists have also maintained their political commitments and have affected mainstream institutional practices (albeit in a more limited and regionally varied way). In California, for example, many activists across the state were initially arrested for setting up exchanges, and in 1994, when the state legislature passed a pilot legislation that would expand and test the exchanges officially, then Governor

Pete Wilson vetoed it, stating that it contradicted other efforts to prevent drug use. But local government institutions, such as public-health departments and the police, saw the benefits of syringe exchanges, and they began supporting them to varying degrees. In Berkeley, Redwood City, and San Francisco, the local authorities (namely, the police) allowed needle exchanges to operate. In Oakland, while the sheriff and local police initially arrested volunteers, growing community and public support forced an end to the arrests (Blumenthal 1998: 1167). And in Tacoma, Washington, the late Dave Purchase, an activist who had worked for many years with drug-rehabilitation programs, forged relationships with and gained the respect of local officials. In 1998, he informed the mayor and other city officials that he was setting up a syringe-exchange table in downtown Tacoma. The program's success later changed the local health department's institutional practices: they eventually negotiated with the nonprofit Point Defiance AIDS project, a local program, to provide an officially sanctioned and funded syringe exchange (Keefe, Lane, and Swarts 2006: 2238). Although current federal law still prohibits syringe exchanges (White House 2012), these and other activists' actions nationwide have led many other jurisdictions to create syringe exchanges through partnerships between nonprofits and government agencies. All of these examples indicate how nonprofits may shape government institutional practices and procedures to better meet the needs of marginalized communities.

CAL-PEP, the SJI, and New Institutional Theory

The following chapters indicate how, when a nonprofit organization appears coopted by a range of formal and informal (and often state-created) institutions, there are ways it can retain or develop goals or features that engender oppositional stances or reactions (Morgen 2002). CAL-PEP and the SJI are particularly valuable cases for examining, illustrating, and specifying this dynamism. Since they were developed by and serve one of the most marginalized groups in the nation, one may assume that they would quickly abandon their explicit support for prostitutes' rights as they grew more dependent on government. After all, organizations championing precarious, politically contentious values are prone to conformity to ensure their long-run survival (Zucker 1987). Yet Elisabeth Clemens and James Cook also note that groups marginal to the political system are also more likely to experiment and "tinker" with existing institutional formations in order to provide them with al-

ternative models of mobilization and to gain access to the polity (1999: 452).

CAL-PEP's and the SJI's experiences demonstrate how organizations like them may do much more than tinker: they also help us redefine, reconstruct, and reconceptualize social movement–borne nonprofit institutions as spaces that foster community interaction and mobilization in significant ways. By using the process of institution building and maintenance to sustain oppositional political consciousness, they implement a commitment to prostitutes' rights within their organizations. Specifically, they have done this through a practice I term *resistance maintenance*, where—within the institutional constraints of nonprofit status, grant agreements, and a political climate hostile to noncriminalizing approaches to prostitution—they foster and promote politically contentious ideas and challenge state policy inside and outside of their organizations.

The following chapters draw from my multimethod qualitative research in the San Francisco Bay Area with CAL-PEP and the SJI between July 2006 and July 2010 to demonstrate the following three properties of resistance maintenance (for a more detailed explanation of my research methods, see the appendix). In outlining these properties, my goal is to move scholarship beyond asking *whether* activists who form nonprofit health- and social-service organizations are capable of community engagement and participating in political activities to identifying *how* they do this, perhaps paradoxically, within a varied, complex, often contradictory set of institutional constraints.

Chapter 2 considers a property I term *oppositional implementation*, which involves activists capitalizing on trends toward government-nonprofit policy coproduction to implement a mission and method service delivery that directly reflects oppositional political goals. To clarify this concept, Mary Fainsod Katzenstein's work on feminist activism in the Catholic Church and the U.S. military is instructive (Katzenstein 1998a, 1998b). By conceptualizing the process of institutionalization in spatial terms, she indicates how activists may establish "habitats"—"spaces where advocates of equality can assemble, where discussion can occur, and where the organizing for institutional change can originate" (1998b: 197). Although CAL-PEP and the SJI are not of the same scale as the church or the military, their funding agreements place them within larger health- and social-service institutional structures; within these, they have capitalized on trends toward local, community-based service provision that allow them to provide spaces for marginalized communities to gather, develop a sense of community, and be exposed to oppositional political discourse.

Yet questions arise here about why and how they may establish these habitats, especially when they are linked so closely to government through funding agreements and nonprofit status: after all, why would any arm of government fund an organization that might foster resistance to the laws and policies it enforces? I argue that the answer to this question rests in what I term *localism*. This concept refers broadly to how the decentralized nature of the American (welfare) state has fostered the provision of social services by state and local-level agencies since the War on Poverty, but particularly since the 1980s when the functions of the American welfare state were increasingly carried out by third-party, nonstate contractors, such as nonprofit organizations, through processes of devolution (Pierson 2001). As Neil Brenner and Nik Theodore (2002a) write, at this time, policy makers saw "local" areas as key institutional arenas for a wide range of policy experiments and political strategies, particularly, as Arthur Alderson writes, since "cities and regions in the advanced industrial world endured two decades of severe social dislocation and upheaval due to deindustrialization and consequent economic relocation, all of which has increased inequality" (Alderson 1999: 701).[18]

Various scholars of federalism (see for some examples Peterson 1995; Volden 2003) have discussed the costs and benefits of decentralized policy development and implementation (or localism, as described here). On the one hand, this method of policy development and delivery has high costs, including but not limited to regional inequalities and inefficiency in the delivery and administration of programs (Peterson 1995). On the other hand, the benefits have included greater responsiveness to citizen needs, the ability to respond to heterogeneous preferences, and the possibility of learning from other jurisdictions (Volden 2003). In effect, this tendency toward localism has institutionalized conditions that create opportunities for local innovation, particularly by underserved groups.

My ethnographic descriptions of CAL-PEP's and the SJI's experiences indicate how opportunities for local innovation are particularly apparent in the field of health- and social-service delivery. Welfare-state devolution has meant that health- and social-service provision is increasingly funded by federal block grants to state and local governments, which subcontract to local community-based organizations. Certainly, this devolution has meant health-service delivery in the United States has (in comparison to other nations) been incomplete, regionally varied, and precariously funded; however, it has also provided opportunities for marginalized groups to create their own institutions. At CAL-PEP and the SJI specifically, sex-worker rights activists

have capitalized on these experiences by creating health-service institutions that meet their own community's needs in ways state agencies may never be able to and, by extension, have created a condition under which more radical projects could be continued.

Chapter 3 considers the property of *community engagement,* a practice of involving nonprofit constituents in organizational management and service delivery. Nonprofits' capacity for community engagement rests in their role as "civic organizations," which are defined by their location in the "middle ground" between the governmental and market sectors of society. They gather individuals around a common interest or concern and promote "civic engagement"—the ways people connect to one another and become drawn into community and political affairs (Skocpol and Fiorina 1999). Although the diverse range of civic organizations makes it difficult to determine what types of engagement they foster specifically and whether it leads to positive, prodemocratic political participation (Tamir 1998; Berger 2009; Young 1992; Stolle and Rochon 1998; Stolle and Howard 2008; Skocpol 1996; Fiorina 1999; Theiss-Morse and Hibbing 2005), scholars believe they provide fertile sites for political development and democratic engagement.[19] Specifically such organizations do this by serving as "schools of citizenship" that gather individuals and involve them in activities that help them develop civic skills and social capital, defined as the networks, norms, and trust that enable participants to act together more effectively to pursue their shared objectives (Putnam 1995: 664; 2000).

Nonprofits' constituents—particularly those from marginalized communities—may engage in the organization and develop civic and political skills through the professional training they receive at the nonprofit. For the purposes of this discussion, professionalism has a twofold definition. At the individual level, it is the possession of a qualification or credential demonstrating the possession of a special form of knowledge used to serve others (Cruess, Cruess, and Johnston 2000). At the organizational level, professionalism also refers to the implementation of standardized processes and procedures that allow an organization to deliver services efficiently and effectively. In health-service delivery, professionalism has been increasingly required of provider organizations for liability reasons (to ensure services are delivered safely and consistently) and because (as noted above) the applications for and administration of grant agreements are more complex.

At first glance, acquiring a professional skill may appear more conformist than conducive to fostering and promoting political engagement and re-

sistance. As various scholars demonstrate, professionalism, particularly in the medical field, has long served as a mechanism of exclusion. Scholars, such as Linda Gordon (2002), document how midwives were often discredited and ignored by doctors for their lack of professional (medical school) training. The women's health movement was a response by women to such exclusions in an effort to seek control of and empowerment in their own health care (Ruzek and Becker 1999). But for the marginalized groups many nonprofits like CAL-PEP and the SJI serve, community engagement of this sort in fact creates opportunities for constituents to be involved and empowered in their own care and gain skills they may transfer to the broader civic and political realm. In a somewhat counterintuitive twist, the very professionalism that many scholars assume decreases community engagement may actually foster it: for stigmatized and marginalized groups, such as women, persons with AIDS, and sex workers who have traditionally been ignored or spoken for by mainstream health institutions, it creates a condition under which they might be involved in their own care, develop civic skills, and advance broader political goals. Professionalism's possibilities for empowerment are particularly evident in the field of HIV/AIDS prevention, where a proper credential, such as a phlebotomist certificate for drawing blood for HIV and sexually transmitted infection testing, is often all that government grants require for service delivery. Although requiring this professional credential may impose rules on the organization and require employee training, the credential it provides ultimately (and ideally) supersedes value judgments about what the individual providing the service does in his or her spare time. This lack of judgment allows organizations serving (so-called) morally despised populations (like sex workers) to engage in the more radical project of involving them in service delivery and empowering them with civic skills to employ beyond the organization.

In Chapter 4, I explain how nonprofits like CAL-PEP and the SJI may also use the process of institution building and maintenance to implement the third property of resistance maintenance, which I term *claims-making activities*. This property involves nonprofits' circumventing the constraints that nonprofit tax status and funding agreements impose on them to challenge government policy and the sociomoral order it reflects. Although creating a "habitat" is valuable on many levels, engaging in political activities outside of the organization is ultimately necessary to improve the conditions under which many nonprofits' constituents live and work. Activities that constitute claims making thus include but are not limited to state-centered activities in the formal political arena, such as making the H-election; participating

in approved election-related activities, such as conducting unbiased and nonpartisan public forums or meetings where candidates from both sides speak or debate; and conducting educational public-policy advocacy, where a nonprofit's constituents may express their position on a social issue in broad terms (but they cannot discuss or express support for a specific piece of legislation related to the issue) (IRS 2007; Lunder 2006).[20] These activities also may include informal activities, which are not state-centered per se but are political in that they challenge the sociomoral order more broadly through, for example, engaging in and contesting popular discourses or creating community dialogues, among other activities.

Admittedly this idea of claims making counters much of the dominant social-movement and civic-engagement research that holds that individuals are more inclined to challenge politics as usual when they are operating autonomously from government. However, research also indicates that nonprofits' proximity to government through policy coproduction may in fact have "feedback effects" that indicate a more dynamic, interactive relationship with government.[21] While it is true that nonprofits' dependence on government for grants may decrease their capacity to oppose government, there is little doubt that receiving grant and contract agreements throws them into the political arena, where they are required to maneuver politically (Berry and Arons 2003). Here nonprofits often operate as intermediaries between their constituents and government, potentially linking those too poor, unskilled, or overwhelmed with problems of their own to the political process (Berry and Arons 2003). Scholarship on NGOs' role in evaluating and administering self-help, social service, and training programs for marginalized communities internationally illustrates this dynamic, reciprocal relationship. This research acknowledges that while NGOs often become more hierarchal and less likely to act as "critical outsiders" when they work with governments to deliver services (Alvarez 1999), they also provide space for marginalized groups to gather, heal, and develop civic skills and political capital (Magno 2008). Moreover, as Sonia Alvarez and others write, these NGO collaborations with government provide a seat at the table for many groups previously excluded from policy development and implementation processes (Alvarez 1999), which may further empower and enable them to promote social change (Magno 2008; Courville and Piper 2004).

In the American context, Mark Warren (1998) also provides evidence of the benefits of connecting civic and political institutions. Focusing on the Industrial Areas Foundation, a nonprofit organization that develops the po-

litical capacity of church leaders to reach beyond their neighborhoods and influence political and economic institutions, he argues their linking of community building to political action has helped communities historically excluded from political power go beyond mobilizing their own internal resources and connect their civic institutions to the political institutions and processes. Through these linkages, they are better able to demand a greater share, if not a restructuring, of societal resources to effect change. Carmen Sirianni's *Investing in Democracy* (2009) presents one of the most current arguments for connecting civic organizations to government in order to promote citizen engagement and social change. Based on three case studies, Sirianni considers the relationship between civic organizations and government and whether this relationship promotes political engagement for those served by the organization.[22] As Margaret Weir (2010) writes favorably, Sirianni expands conceptions of political activity by focusing on it in the context of policy implementation through organizational actors, most notably nonprofit and for-profit organizations. In so doing, Romand Coles (2010) notes, Sirianni's work shows governmental systems may be reciprocal and communicative with citizens, making them key agents in a process where they are proactively engaged in limiting, shaping, and coproducing government behavior.

This chapter therefore indicates the potentially reciprocal relationships social movement–borne nonprofits may have with state and societal institutions. In particular, CAL-PEP and the SJI demonstrate this reciprocation through two types of state- and nonstate-oriented claims-making activities. I define the first as *knowledge production*, whereby they conduct, publish, and disseminate research on and analysis of nonpartisan issues to inform the public and policy makers about their constituents' needs. And I define the second as *policy advocacy*—activities permitted by nonprofit law, which I identify as individual actions, permitted lobbying, public awareness, and international (health) advocacy. These claims-making activities indicate how nonprofits may engage in politics outside of their organizations to challenge the laws, policies, and broader sociomoral regime that regulates and marginalizes their constituency.

The concluding chapter returns to broader questions of social-movement evolution and the nonprofit sector, particularly as this pertains to the sex-worker rights movement and its possibilities for shaping and influencing the actions of more mainstream institutions. The chapter also considers some limits of resistance maintenance and concludes with a discussion of how governmental and societal actors may support organizations like CAL-PEP and the SJI so they may empower and serve their communities and gain a larger voice in the polity.

CHAPTER 2

Oppositional Implementation

So many people say to me, "I feel at home here. Thank you for not asking me five million questions about whether I was abused as a child and for not asking me what I am going to do to change." The St. James Infirmary gives people validation and the feeling that they do matter and have the right to have health care and be who they are. Small changes like this can lead them to want to give back and volunteer somewhere.
— Drew, SJI staff member (Interview, 27 July 2010)

Over lunch one day in San Francisco's Civic Center neighborhood, Drew, a former sex worker and current HIV test counselor at the St. James Infirmary (SJI), explained the effects that criminalization and stigma have on individuals who engage in sex work. He told me that oftentimes they do not disclose what they do to their health-care providers, friends, and family, and there are very few places where they can receive health and social services without encountering questions or judgment. As a result, it is not surprising that scholars have concluded that sex workers are some of the most socially isolated, resource poor, and politically marginalized individuals in the nation (Mathieu 2003). However, as Drew explained further, organizations like the SJI (and CAL-PEP, by extension) create safe spaces where sex workers can gather, free from public and police harassment, to receive occupational health and safety services that are not conditional on exiting the sex industry. But these organizations are not only health-service providers: they also demonstrate how activists may create "habitats" within the nonprofit sector that reflect broader political commitments, in this case to prostitutes' rights.

Creating these habitats requires strategic compromises: sex-worker rights activists, like many other activists before them, negotiated broader political-institutional environments that were (and are) variously hostile to their efforts. And so to implement their oppositional politics into their own organizations, they often work with various mainstream actors and institutions. This chapter draws from CAL-PEP's and the SJI's experiences to illustrate how this cooperation is not necessarily synonymous with cooptation. After first briefly tracing the political-institutional environments CAL-PEP and the SJI negotiated and emerged from, this chapter shows how oppositional implementation occurs at these organizations. Through their naming strategies, mission statements, and service-delivery methods, these organizations create habitats that reflect and support the philosophy that sex work is legitimate work, even as they gather a community with diverse needs and opinions. In so doing, CAL-PEP and the SJI indicate how activists may use the process of building and sustaining their own institutions to maintain their more radical political commitments and create safe, empowering spaces for members of a marginalized community, within a broader issue context where there is little support for such projects.

Institutional Negotiation:
The Emergence of CAL-PEP and the SJI

At first glance, CAL-PEP and the SJI's recognition of prostitution as legitimate work seems unlikely: after all, prostitution is illegal in California, as codified in 1961 under Section 647(b) of the California Model Penal Code, which states that anyone is guilty of a misdemeanor "who solicits or who agrees to engage in or who engages in any act of prostitution."[1] And successive governments in the San Francisco Bay Area have enforced these laws, despite the region's reputation as the nation's vanguard progressive city, nationally known for its culture of tolerance and celebration of diversity, high degrees of political engagement, liberal ideology, secularism, friendliness toward immigrants, and sexual liberalism among its residents (DeLeon 1992, 2007).[2] How then did CAL-PEP and the SJI, as organizations that understand prostitution as legitimate work, emerge and receive support from agencies in a state where the criminalization of prostitution was firmly institutionalized in the letter of the law and its enforcement? By negotiating the local political-institutional environment in a way that focused on health promotion, they

capitalized on opportunities to offer nonjudgmental health services in partnership with mainstream (health service) institutions.

Creating Space for CAL-PEP: HIV/AIDS in San Francisco

CAL-PEP emerged in a political-economic climate that was open to local, community-based innovation in health and social services, even though antiprostitution sentiments were amplified in the region. In San Francisco, the gay community's response to the AIDS epidemic, in concert with the city's health institutions, created space for prostitute-rights activists to shape their own (similarly stigmatized and marginalized) community's health needs. As the illness spread and patients required more care, existing facilities—especially public hospitals and clinics—were not capable of dealing with these demands, and such private facilities as nursing homes and convalescent-care facilities were often unwilling to accept AIDS patients because of the perceived threat their illness posed to patients and staff. And so in order to deliver care at reasonable costs, the city and county looked to the network of social-welfare organizations within the gay community.

Gay men and women were able to respond in concert with the local government because of their community's relationship to the city (Cohen and Elder 1989). Before the epidemic, they had established themselves as a worthy, participatory community within the social and political fabric of the city (Armstrong 2002). Therefore, when AIDS emerged, the city took responsibility from the start—in conjunction with the gay community—for AIDS service provision in a manner characterized by rapidity (in comparison with other cities), a multidisciplinary approach to treatment, and strong links between the affected community and public-health officials (Cohen and Elder 1989). The most noteworthy example of this collaboration was the San Francisco AIDS Foundation, which was founded in 1982 as a direct response to the AIDS epidemic. The foundation's initial goal was to raise funds for supporting and disseminating research about AIDS, but it soon became clear that this goal would be of little immediate, practical help for the increasing numbers of gay men afflicted with AIDS (Cohen and Elder 1989). In no time, the foundation's Information and Referral Hotline became nationally known as a source of accurate information about AIDS (Armstrong 2002; Arno 1986), and by October 1982, it had contracted with the San Francisco Department of Public Health (SFDPH) to provide educational services in San Francisco, including

educational events, telephone services, materials development, and provision of accurate information to the media. In 1983 the foundation also contracted with California's Department of Health Services to provide information about AIDS to other counties in Northern California, and it established a social-services department that same year to help persons with AIDS (and related conditions) access emergency services, such as shelter, financial assistance, and medical attention (Arno 1986). The foundation's rapid growth coincided with an increase in the number of community-based organizations dealing with HIV/AIDS in San Francisco, from three to forty-three between 1981 and 1994 (Armstrong 2002).

CAL-PEP, founded in 1984, was among these organizations that emerged and capitalized on institutional incentives (grants) from various government agencies to promote local, community-based service provision to communities—like sex workers—that these agencies considered hard to reach and at high risk for contracting HIV. In 1985, CAL-PEP accepted a grant of $30,000 from the California State Office of AIDS, which funded the agency to distribute condoms and information about HIV/AIDS to street-based sex workers in San Francisco's Tenderloin neighborhood. In order to capitalize on more funds to continue their work, in 1987, CAL-PEP incorporated as a nonprofit organization under section 501c3 of the IRC and thus became a separate legal entity from COYOTE. By 1988, CAL-PEP received grants from the CDC, the California Department of Health Services, and the National Institute of Drug Abuse. This funding enabled them to build their own institution and expand their HIV prevention activities in the prostitute community.

But for CAL-PEP, like many other social movement–borne nonprofits, this grant capitalization did not come without conflict and anxiety among some COYOTE members. Lockett (Interview, 12 January 2010) recalled that many COYOTE members were unhappy with the CDC grant because they felt "that's the government and they aren't on our side." She explained that some of her fellow COYOTE members thought "taking money from [the CDC] was taking money from the enemy. They thought the CDC would control everything." Ultimately, Lockett stated (Interview, 16 July 2010), "It was a hard decision, but you can't help people without the money to help them. That is why I said to COYOTE, 'I don't have a rich daddy' . . . so I had to go to the CDC [and other government funders]." And as Dr. Nancy Stoller, who came to know, work with, and write about CAL-PEP through her involvement in the foundation, explained further, "There was a real struggle to make [CAL-PEP] look legitimate to get money. . . . To continue to get money

to people directly, there was a need to present the organization as a service/health organization that was about saving lives. COYOTE, on the other hand, was created based not on the service idea but around decriminalization and the assertion of feminist stances, etc." As Stoller went on to note, CAL-PEP had to stay away from prostitutes' rights and instead focus on the right of sex workers to obtain condoms without risk of arrest: "[In CAL-PEP's] appeals for money and speeches to city council, they would agree for a limited set of rights for prostitutes and used the frame of AIDS prevention and the frame of ethics and access to health care. They argued that they knew how to reach these people, so if politicians really wanted to help them, they would fund these organizations. They marketed their personal experience" (Interview, 7 July 2010). And local government officials did buy what CAL-PEP sold. CAL-PEP continued developing innovative programs, such as support groups for sex workers, safe-sex workshops, information and education programs in the jails, a safe-sex quiz contest, and a speaker's bureau, which worked with the AIDS Training Center in San Francisco to train community health-outreach workers to be sensitive to sex-worker concerns (Lockett 1994; CAL-PEP 1989).

CAL-PEP's experience with the CDC demonstrates the synergistic, reciprocal relationship possibilities between government agencies and activists who form nonprofits. Their first grant from the CDC was for $130,000, and CAL-PEP wanted to use it for outreach in areas in the city with high concentrations of prostitution, such as the Tenderloin, Western Addition, Hayes Valley, and the Mission. Understanding that for many prostitutes, "time was money," Lockett explained to the CDC that part of the grant would offer sex workers cash incentives to take HIV tests and participate in educational activities. Initially, the CDC rejected this idea, confirming fears that sex workers would have no say in how the grant was used. But Lockett would not accept this objection, and so she told the CDC, "You funded us; so this is what it is about" (Interview, 16 July 2010). The CDC acknowledged that the need to reach this population with HIV/AIDS prevention messages was greater than judging how CAL-PEP did it, and they agreed to Lockett's strategy to pay cash incentives. As of 2012, according to Lockett, the CDC has been their longest and best funder.

Yet CAL-PEP's partnerships with mainstream agencies also placed them in a position familiar to many activists who move to the nonprofit sector: their eventual growth as a nonprofit service organization led them to focus more on maintaining service provision at the expense of prostitutes' rights

advocacy. Initially, CAL-PEP maintained a strong link to its COYOTE roots by staffing its board with sex workers and by continuing with its philosophy not to moralize or judge women for their participation in prostitution but to help them "protect themselves, their partners and their clients from contracting AIDS" (CAL-PEP 1989: 1). But over time, many COYOTE members, as CAL-PEP staff, were overworked and had less time for COYOTE-oriented prostitutes' rights organizing, especially as CAL-PEP's grants were increasingly specified for AIDS prevention activities. COYOTE/CAL-PEP members attended national and international AIDS meetings, and only when there was time (or a stopover on a plane ticket) would they pursue COYOTE's agenda as well (Stoller 1998).

By 1991, CAL-PEP had only one COYOTE activist on its board, and by 1992, there were none, as many of its members moved on to other pursuits often related to prostitution and HIV/AIDS prevention. Margo St. James, COYOTE's founder, moved to France, working odd jobs and teaming up in Amsterdam with Gail Pheterson, a scholar, to inform Dutch health officials about AIDS education. They also organized two International Conferences of Prostitutes, which many COYOTE members attended to discuss such issues as the impact of HIV on sex-worker communities worldwide. In 1989, Priscilla Alexander accepted a position with the World Health Organization as an adviser on prostitution and AIDS issues. Here, drawing from her experience with CAL-PEP, she wrote the first guide to setting up HIV prevention programs for sex workers, which was distributed globally (Alexander, Interview, 11 July 2006). Gloria Lockett continued as CAL-PEP's executive director, and Carol Leigh as an artist and sex-worker activist. All of this led Stoller to conclude that "the child [CAL-PEP], as it were, swallowed the parent [COYOTE]" (1998: 89–90).

But this separation from COYOTE—the organizational mainstay of the prostitutes' rights movement—did not end CAL-PEP's commitment to its constituency; instead, it signaled how activists may negotiate with mainstream institutions to expand their work, especially in response to broader socioeconomic changes. To better serve persons engaged in prostitution, CAL-PEP decided to move to Oakland, California, in the early 1990s because they were concerned about the increasing number of prostitution arrests in the area. At this time, urban scholars have noted growing international economic integration and capital mobility led corporate operations to disperse, while metropolises competed nationally and internationally to attract profitable enterprises with promises of financial incentives and subsidies, low-

cost labor, and modern infrastructures (Godfrey 1995; Sassen 1999). Consequently, Phil Hubbard (2004) writes, urban governors sought to revitalize cities in the face of deindustrialization and the flight of high-income earners from their cores. But with budgets for spending on education, social services, and training for the (urban) poor politically out of favor, cities became institutional laboratories for work-for-welfare, property redevelopment, and policing and surveillance efforts to remove the populations deindustrialization left behind (Brenner and Theodore 2002a, 2002b). Specifically regarding prostitution, as Hubbard (2004) writes, the desire to purify urban spaces for capitalist growth meant prostitutes have faced removal from these spaces by local governments aiming to attract more "respectable" populations, hence the emergence of punitive policies designed to exclude sex workers from gentrifying city centers.[3]

Not surprisingly, the cities most affected by these inner-city revitalization, gentrification, and displacement projects were regional or national corporate headquarter cities with strong downtown office sectors, such as Boston, New York, San Francisco, and Washington (Godfrey 1995). When an "economic tidal wave" hit the Bay Area in the 1990s with the so-called Internet boom that originated in Silicon Valley, individuals working in the technology sector were drawn to the area for its physical beauty, cultural amenities, and overall quality of life (Kennedy and Leonard 2001: 42). This population shift also, consequently, shifted the forms and locations of prostitution in the region and ushered in new governmental responses to it. Oakland, with its proximity to San Francisco, was no exception to these trends. As Figure 1 illustrates, although arrest numbers in Oakland fluctuated between 1985 and 1995, the largest increase occurred between 1996 and 2000. At this time (in 1998), Edmund "Jerry" Brown was elected on a platform that would further this redevelopment agenda through his 10K Program, which aspired to increase Oakland's downtown population by ten thousand by bringing people from the suburbs (Brookings Institution 2003: 47). To achieve this growth (by attracting property developers), Oakland's downtown core needed to be free of street-based populations, and so policing increased and prostitution arrests in Oakland spiked sharply during this period to an average of 1,197 arrests between 1996 and 1999.

Although the downtown core acquired a convention center and hotel under the 10K plan, high crime and unemployment rates did not ease private capital's reluctance to locate in the city: Jack London Square, which was meant to be a dining and entertainment district, had difficulty attracting in-

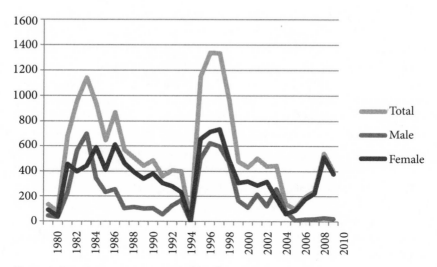

Figure 1. Prostitution Arrests in Oakland, 1980–2010

Source: California State Department of Justice, Crime Data Services
(http://oag.ca.gov/crime).

vestors, and the Oakland Raiders left for Los Angeles in the 1990s, despite the
construction of a new coliseum for the team. Moreover, the 10K plan did little
to decrease the city's racialized poverty and health disparities. When CAL-
PEP moved to Oakland in 1990, the U.S. Department of Health and Human
Services had designated every census tract in areas like East Oakland (with
its majority African American population) as medically underserved (Rhom-
berg 2004: 186), and Alameda County had 13 percent of the syphilis infections
in the state (CAL-PEP 1992: 1). By the mid-1990s, one in five intravenous drug
users in West Oakland was HIV positive, making it one of the communi-
ties hit hardest by intravenous drug–related AIDS west of the Mississippi;
however, Alameda County was only spending $4 million per year on health
services compared with San Francisco's $40 million (Blumenthal 1998: 1148).
In 1998, a few days after the Clinton administration announced a $156 million
initiative to address AIDS in ethnic and minority communities (CAL-PEP
2004: 16; State of Emergency Taskforce 2003), the Alameda County Board of
Supervisors declared a state of emergency for the African American commu-
nity regarding the levels of HIV/AIDS transmission.

How, then, did CAL-PEP negotiate this otherwise challenging environment and bring services to sex workers on the streets? It did so by working with government agencies to coproduce much-needed services that the county lacked the capacity to provide. According to Dr. Ben Bowser, a professor at California State University, Hayward, who has served as an external evaluator for a number of CAL-PEP's programs, "The Alameda County Public Health Department had tried to provide services similar to CAL-PEP's, but being a civil service, they only offer services until 6:00 P.M., which works for their clients who can make it there."[4] Since CAL-PEP was and is willing to work after 6:00 P.M., the county had an incentive to fund CAL-PEP because of their flexibility. Bowser explained that this scheduling mattered because many of those that CAL-PEP served are on parole and "cannot be seen in areas where they might have been in trouble, such as on main streets or near liquor stores." However, noted Bowser, these locations are often the only places where "they are less likely to be harassed as poor, African American, unemployed people. So they stay inside somewhere all day and then come out around 8:00 P.M. . . . because parole officers finish paroling/working around 6:00!" (Ben Bowser, Interview, 17 November 2006).

The St. James Infirmary: Negotiating for Health

By demonstrating to mainstream health institutions and authorities that sex workers could be experts in developing and implementing their own methods of HIV/AIDS prevention and care, CAL-PEP was an important precursor to the SJI (Lutnick 2006). Created by COYOTE activists concerned with governmental responses to street prostitution during a period of economic expansion in San Francisco, the SJI also illustrates how activists may draw from their expertise and connections to mainstream institutions to continue their oppositional political work.

As Elizabeth Bernstein carefully documented in her ethnography of prostitution in San Francisco in the 1990s, street prostitution was already declining as newspaper and online ads, corporate-run strip clubs, licensed massage parlors, and cell phones became the preferred means of doing business in more dispersed indoor locations throughout the city and in suburban areas (2007: 30–31). At the same time, San Francisco was rapidly becoming the global headquarters for the Internet economy and venture capital, thereby attracting more residents and businesses to the city. The Union Square area—the city's street-

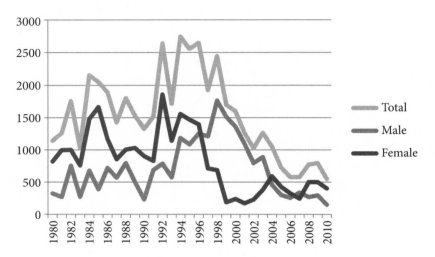

Figure 2. Prostitution Arrests in San Francisco, 1980–2010

Source: California State Department of Justice, Crime Data Services
(http://oag.ca.gov/crime).

prostitution hot spot for over seventy-five years—was being redeveloped into a
shopping, hotel, and tourist-oriented entertainment district. Further, demand
for space grew in other high-prostitution areas, such as the Mission district,
known for its ethnic diversity, working-class small businesses, affordable rents,
and live-work studios for writers and artists, and the Tenderloin, known for
its homeless population, single-resident occupancy hotels, and proximity to
the Union Square tourist and shopping district (Schwarzer 2001). Incoming
residents grew vocal about the presence of street prostitutes in these areas and
claimed that prostitutes were bringing drugs, violence, and other related crimes
with them while the police did little to enforce the law (Popp 1991). By the end
of 1992, these resident concerns inspired a four-part series in the *San Francisco
Chronicle*'s "First Person" section entitled "A Neighborhood at War with Prosti-
tution" (Winokur 1992a, 1992b, 1992c, 1993).[5] Ultimately, the city responded to
prostitution by increasing arrests (Figure 2).

 Although such COYOTE activists as Carol Leigh stated that the real is-
sue driving street prostitution was female poverty, the city placed more uni-
formed police officers on the streets and created more spaces in the already

overcrowded jails (Winokur 1992c). All of this culminated in a six-day police crackdown that resulted in over eight hundred arrests, mainly of street prostitutes (Strupp 1994a: 1). However, this crackdown was not a one-time affair: as pressures from property owners mounted, prostitution arrests increased in the city, peaking at an average of 2,500 arrests per year between 1992 and 1998. This overzealous, property-driven policing of prostitution also reinforced traditional racialized sex-gender norms: arrests were often based on characterizations of women who "looked" like prostitutes, thereby reinforcing notions about and anxieties regarding women alone on the street. Clear evidence of this profiling came in the case of Yvonne Dotson, an African American female nurse with a master's degree in public health. She had dinner in February 1993 at a restaurant near the Tenderloin and, while waiting alone near the parking garage for her car, was arrested by two San Francisco officers on suspicion of engaging in prostitution. The officers denied Dotson information about her arrest or contact with friends who could post bail, and they verbally abused her. She was finally released, but suffered from posttraumatic stress disorder and eventually sued the city successfully for damages (Davis 1995).

All these events led the city's Board of Supervisors to create the San Francisco Taskforce on Prostitution in 1994. The taskforce considered new approaches to prostitution for the city, including anything from the nonenforcement of prostitution laws to city-owned love barracks (McCormick 1993). However, the unique aspect of the taskforce was that it offered sex workers an opportunity to be fully included in the process, providing an important cultural and political site in which conversations took place and recommendations were made for alternative approaches to prostitution (Lutnick 2006). The taskforce was thus an important formative organization in the SJI's establishment: it brought activist sex workers into the political institutions and processes of local government, where they capitalized on this (brief) political moment to promote a nonjudgmental, noncriminalizing approach to prostitution.[6]

The taskforce produced its final report in March 1996, presenting its findings and making recommendations in the areas of law enforcement, health and safety, quality-of-life concerns, labor policy, immigration, and youth issues (San Francisco Taskforce on Prostitution 1996). Its major finding was that prostitution was not monolithic, but the city had institutionalized one approach—prosecution—that disproportionately targeted street-based workers, who composed less than 20 percent of the prostitution trade in the

city. The taskforce emphasized further that this approach was costly to the city (at approximately $7.6 million per year in law enforcement–related expenditures) and did little to eradicate resident concerns or provide safety, security, and services to prostitutes. It therefore recommended that the city stop enforcing and prosecuting prostitution crimes and focus instead on quality-of-life infractions, which in turn would free up resources to provide services for needy constituencies. The taskforce also made recommendations that the SJI would later reflect: that health care be accessible to sex workers, and that health-care providers be trained to be sensitive to sex-workers' needs.

As it became clear in the years following formation of the taskforce that the city was not going to act on these recommendations, COYOTE activists Margo St. James and Carol Stuart realized the public-health avenue might be the better route to decriminalizing prostitution (Alexander 1995a). Together with Priscilla Alexander, they conceived of a clinic that would provide much-needed services to the sex-worker community and a site from which prostitution research would be conducted and disseminated. Their clinic model (Alexander 1995b) was based first on the idea that sex work was work that, like any other physical occupation, had certain health and safety hazards. To counter notions that sex workers were irresponsible regarding their sexual health, this clinic would be peer run, mixing professional and administrative personnel, wherever possible, with those with sex work experience, to provide free and nonjudgmental health services, including general medical care, gynecological services, orthopedic care and physical therapy, mental-health services, and drug-treatment groups (Alexander 1995b).

Like many other social-movement activists, the SJI's founders knew that implementing this plan for a clinic would require negotiating with mainstream institutions, and they were able to find support for their clinic at the SFDPH through Dr. Jeffrey Klausner, the newly appointed head of the SFDPH's STD Prevention and Control Division. Klausner was open to new approaches to sex-worker health and safety after learning from COYOTE activists that prostitutes in the city's jails were tested (illegally) for syphilis. At the same time, sex workers in the dancing sector were also becoming increasingly visible. Johanna Breyer and Dawn Passar, heads of the Exotic Dancers' Alliance, had recently won a $2.85 million settlement for dancers in 1998 in reference to pending sexual-harassment cases against the Bjiou Group, which owned a number of dance clubs in the city (Lutnick 2006; Akers 2005). Even with this victory Breyer was increasingly concerned about meeting the health

needs of dancers. At the same time, she and Passar had jobs with various community-based public-health services (Breyer worked for the San Francisco AIDS Foundation and Passar was with the Asia-Pacific Islander Wellness Center and the Asian AIDS Project), which brought them into contact with various public-health officials. In August 1998, Breyer and Passar were at an HIV Planning Council meeting, where they met Klausner and encouraged him to meet the sex workers' health needs more effectively; he in turn found the support he needed from the sex-worker community for shifting the massage-parlor regulations away from the police. He arranged a meeting with Carol Stuart and Priscilla Alexander to discuss their clinic, and with his support, the city donated the space and many of the supplies and medical staff needed for the clinic. The St. James Infirmary opened on 2 June 1999, after hours in the San Francisco City Clinic offices. But there was little else in terms of funding. According to Stuart (Interview, 20 November 2006), no one would give them money when they started as there was an aversion to funding something that did not focus on "saving fallen women." So initially Stuart, who worked for the city government, paid some of the SJI's staff and the incorporation fees out of her own salary.

The SJI also accepted money from the San Francisco AIDS Office, which created conflict for many sex-worker rights activists. Breyer, who became the SJI's first executive director (Interview, 23 October 2006), stated that this funding arrangement was unfortunate because the SJI wanted to counter the idea that sex workers were "vectors of disease," and now the agency that historically promoted that idea also funded them. Moreover, the SJI's location in City Clinic hindered its ability to establish itself as a legitimate, independent group that could act as a claims-maker and service provider (Lutnick 2006). According to Charles Cloniger (Interview, 7 July 2010), the SJI's current clinical director, while many of the clinic's day staff generally supported the project, a number of them were prejudiced against sex workers and resented their special access to the clinic; they began complaining that the SJI staff left garbage out, among other things. It was clear that the SJI needed its own space, and so with some help from the SFDPH, the SJI moved to its current Mission Street location, in the city's former Disease Control and Investigation unit's building. Today, financing for its $450,000 per year budget comes mainly from the SFDPH's Sexually Transmitted Disease Prevention and Control unit for HIV prevention work and other free, nonjudgmental health and social services to sex workers, including primary medical care; acupuncture and massage; transgender health care; peer counseling; substance-use counseling; legal, housing, and social-

assistance referrals; condom and lube distribution; a needle exchange; and a food and clothing bank. The SFDPH also pays their rent.

Oppositional Implementation at CAL-PEP and the SJI

At this point, CAL-PEP and the SJI may confirm many social-movement scholars' and observers' worst fears about activists who collaborate with mainstream institutions to focus on service provision. Not only are the majority of their budgets from government sources, they are also physically located in government buildings. When I first began working with CAL-PEP in 2006, its main office was on the third floor of a former Alameda County Health Department building that was located, somewhat ironically, across the street from the Oakland police department's headquarters. Yet dismissing these organizations as mere sites of cooptation ignores a central insight of neo-institutional theory—that political actors also have the capacity to act strategically within their institutional environments. Therefore, examining social movement–borne nonprofits internal environments closely is imperative for understanding how activists incorporate their resistance efforts into their own institutional practices.

What's in a Name (and a Mission Statement)?

Activists may implement a commitment to oppositional politics through their nonprofits' names and mission statements. Although the SJI's physical space is part of a government department, the clinic's very name—after Margo St. James, COYOTE's founder—indicates its ties to the prostitutes' rights movement, despite its physical and monetary proximity to a city government institution. As St. James recalled to me, she always had a sign that said "St. James Infirmary" outside of the various apartments in which she lived because people would often ask her for referrals to non-mainstream or controversial medical services, like "marijuana, or doctors who provided abortions" (Interview, 25 October 2006). By naming the clinic after her, the SJI continues her (and COYOTE's) commitment to prostitutes' rights and to the idea that all people, regardless of their occupation, deserve accessible, nonjudgmental, and comprehensive health care. This commitment is reflected in the SJI's mission, which states,

The mission of The St. James Infirmary is to provide compassionate and non-judgmental health care and social services for all sex workers while preventing occupational illnesses and injuries through a comprehensive continuum of services. There are many factors which affect the working conditions and experiences for all sex workers including the political and economic climate, poverty and homelessness, stigmatization, violence, as well as the overwhelming intricacies of the legal, public and social systems. It is the philosophy of The St. James Infirmary to build upon existing skills and strengths in order to allow individuals to determine their own goals while providing culturally competent and non-judgmental services. (www.stjamesinfirmary.org, 2013)

According to Klausner (in Lelchuk 1999), this mission acknowledges what people do in their private lives is not relevant to their health-care or social needs; after all, he says, "If someone is driving under the influence and crashes his or her car, are we not going to take care of him or her?" In an issue context that largely frames prostitution and other forms of sex work as inherently victimizing activities, this position is radical. In stark contrast to many community and government-related programs that seek to "save" sex workers by making their exit from the sex industry a prerequisite for service provision, the SJI accepts the performance of all kinds of sex work nonjudgmentally, and it helps people leave the industry if that is what they desire (Selke 2004).

Similarly, CAL-PEP's current mission—"to provide accessible health, education, disease prevention, risk reduction and support services to people at high risk for HIV/AIDS or those already infected in a culturally appropriate way" (CAL-PEP 2004: 1)—reflects a commitment to accessible and nonjudgmental health care. But in contrast to the SJI, this mission is not connected solely to sex-worker health and safety. By the early 1990s, it was increasingly clear to CAL-PEP that if it were to prevent AIDS among street-based sex workers, it would have to expand its definition of "community" by working with sex workers' entire familial and social networks, including their clients, partners, friends, and fellow drug users, among others (Lockett, Interview, 18 July 2006). As Lockett noted in a 1992 newsletter, "We began as a prostitutes' health organization. . . . Today . . . seventy five percent of our clients are minorities, most of them need services because they're poor. The bottom line is we're changing to meet the needs of the communities we serve—and represent—because there's no one else out there doing it" (CAL-PEP 2004: 1–4). Yet this expansion of the agency's constituency and mission

statement did not preclude its commitments to prostitutes' rights. CAL-PEP's name—and how it has changed over time—indicates how activists who provide services through more formalized nonprofit organizations must negotiate a broader political-institutional climate that often constrains their efforts. Put differently, when activists appear as though they have been coopted (or that they "sold out"), they may actually be operating strategically to maintain their broader political commitments.

Given how current policy discourse focuses on abolishing, not educating, persons engaged in prostitution, CAL-PEP's name signals roots in and a commitment to a more radical project. However, the agency's name has not remained static. According to Lockett (Interview, 7 July 2006), in the late 1990s, the name became the California *Prevention* and Education Project.

As nonprofit sector researchers (Minkoff and Powell 2006) document, strong empirical evidence shows that receipt of government grants makes many nonprofits more likely to avoid confrontations with their funding agencies. And for CAL-PEP, this tendency was apparent: since they were applying to many federal government and other agencies that seemed more conservative (such as the United Way), CAL-PEP's officials worried their applications would be rejected because of the word *prostitute* in the agency's name. Lockett explained to me that when they were rejected for some grants, many of the funders expressed concerns that CAL-PEP was "teaching women to be prostitutes" (Interview, 16 July 2006). Therefore, CAL-PEP's organizational survival required a strategic compromise: it would change its name to stress that it was not helping people do something illegal but protecting them and their partners from transmitting HIV. And so they retained the acronym CAL-PEP but replaced the first P (for "prostitutes") with "prevention."

However, making this name change did not come without resistance from COYOTE members. Even though there were very few COYOTE members on their board of directors by this point, Lockett (Interviews, 16 and 18 October 2006) knew some COYOTE members were "pissed off" that they changed the name. But, she explained, the "big problem with community-based organizations is that they come and go, leaving the people they serve." Her responsibility to her community and her employees meant that she had to do whatever she could to secure funding, and ultimately the name change was beneficial for organizational survival, especially during the tenure of the George W. Bush administration, which Lockett felt was the most sex negative yet. She told me that she had seen "sex friendly organizations" close down, and it "scared the Jesus" out of her. Lockett's belief was not irrational: scholars

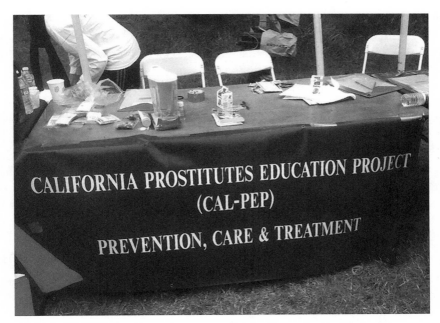

Figure 3. CAL-PEP banner, San Francisco AIDS Walk 2010. Photo by author (2010).

have documented how the Bush administration was more sex negative and suspicious about the efficacy of community-based harm reduction–oriented HIV prevention activities (Epstein 2006). In light of this negativity, Lockett firmly believed CAL-PEP would have been defunded if it had kept its original name containing the word *prostitute*, "especially with [the George W. Bush] administration who shuns any use of the word sex. . . . I'm especially glad [we] made the change pre-Bush!" (Interview, 13 October 2006).

But as organizations change, so too do the political-institutional contexts they operate in. When I returned to the Bay Area in July 2010 and met with Lockett, she told me she had some news I might find interesting: CAL-PEP was going back to their old name, with the word *prostitute* as the first P in the acronym. When I asked why, deputy director Carla Dillard Smith summed the reason up by stating, "We can exhale. We are beyond the Bush era. This allows us to pursue CAL-PEP's core mission—to help prostitutes" (Lockett and Smith, Interview, 6 July 2010). And sure enough, on 18 July 2010, I went to the San Francisco AIDS Walk with some CAL-PEP staff and their new-old name was on display. As we set up the table, we put out condoms, safe-sex

kits, brochures . . . and the banner (Figure 3) that said "California Prostitutes Education Project."

CAL-PEP's name change indicates how social movement–borne non-profits may balance their political commitments with their obligations to the communities they serve. Lockett told me later that she never felt good about the name change (to "prevention"), but through the process of institutional learning many activists experience, she has grown more creative and strategic. Today, Lockett has reframed CAL-PEP's name and work as something that gives them a competitive edge when they apply for funding. As she explained to me, CAL-PEP "offers something they [government officials] want—no one else is talking to prostitutes, and [our services] help national and local health departments." To illustrate, Lockett described her experience at a 2009 National Minority AIDS Coalition workshop in San Francisco about funding sustainability and development, where she learned that "if you want to write a grant to whoever, what makes your grant stand out more than anyone else's? You have to use your niche. We're important because we work with prostitutes. When funders look at a grant and see 'prevention' and 'education,' [they think] 'boring, boring' . . . but 'prostitutes'? It's different. We need to be able to tell them why to fund us and not someone else. It was like a lightbulb for me. I said, 'we're back' (to prostitutes) and never going back" (Interview, 6 July 2010).

Although CAL-PEP's budget remains smaller than it was in past years, it has maintained services for sex workers, and its naming strategy illustrates the importance of activists' strategic actions in the nonprofit sector. As Leah Sanchez, a CAL-PEP board member, stated to me, "Gloria knew to sustain the organization she would need to build relationships and put her project at the forefront. The name change at CAL-PEP shows the heart of her politics" (Interview, 8 July 2010).

Creating Habitats: Continued Resistance in Spaces of Service Delivery

Through their naming strategies and mission statements, activists may incorporate oppositional political commitments into their own institutions and operationalize these through their service-delivery practices. In one of CAL-PEP's most recent locations, in an office space on Franklin Avenue that it leased from a private landlord in downtown Oakland, the reception area was

crowded with desks, a couch, and fliers for HIV/AIDS prevention and edu-cation.[7] A rotating cast of characters, ranging from HIV test counselors, peer counselors, and mobile-van drivers, streamed in and out of the reception area or Gloria's office, saying hello to an employee who just returned from va-cation or going back and forth to clarify matters related to year-end account-ing. On many occasions, Joe, a young man hired for technical support, was the busiest, running back and forth between the always-crashing computers. However, beneath this somewhat politically neutral veneer of a buzzing of-fice, CAL-PEP has maintained its ties to the sex-worker rights movement. It creates habitats—safe spaces where sex workers (and other members of street-based populations) may gather and receive medical services—on the streets, a space traditionally hostile to these individuals. In so doing, it cre-ates a site of resistance by treating sex workers as individuals who engage in legitimate, income-generating activities, and who therefore have unique oc-cupational health and safety needs.

THE MOBILE TESTING SERVICE:
CREATING HABITATS ON HOSTILE STREETS

Although sex workers still compose up to 40 percent of CAL-PEP's clients (Lockett, Interview, 18 July 2006), the organization now reaches out more broadly to street-based populations that epidemiologists considered at high risk for HIV/AIDS. Today, the majority of CAL-PEP's clientele are African American, often parolees, homeless and without jobs and health insurance, all of which commonly leaves them out of traditional health-care channels (Boone, Bautista, and Green-Ajufo 2005: 44). CAL-PEP's data shows that in 2008 alone it provided services to 7,253 clients primarily through HIV testing, street outreach, workshops, substance-abuse treatment services, and case management. Of these clients, 5,417 were African American, and 4,264 were under age 29. CAL-PEP provided services to 818 crack-cocaine and injection-drug users, 922 sex workers, 192 homeless individuals, and 288 HIV-positive individuals (CAL-PEP 2008).

CAL-PEP reaches these individuals in a harm-reduction manner firmly rooted in and reflective of its political commitments: instead of judging its clientele or requiring them to abandon activities like sex work and substance use as a condition of receiving services, CAL-PEP offers them HIV/AIDS and sexual-health education so they can live their lives, as they are, in a safe and healthy manner. Since most of its clients are often marginalized in traditional health-care channels, CAL-PEP operationalizes its harm-reduction philoso-

phy through programs following the motto "their time, on their turf," meaning CAL-PEP workers will go to places where their clients might congregate, at times convenient for those clients, and distribute literature, condoms, and bleach kits.

CAL-PEP's Mobile Outreach and Recovery for Ex Offenders Project (the MORE Project, which began in 2001) is the agency's predominant mode of implementing oppositional commitments through service delivery to reach its constituency. Funded by a grant from the Substance Abuse and Mental Health Services Administration, the MORE Project uses two large recreational vehicles equipped with testing and counseling rooms to bring HIV testing and counseling to communities where, because of socioeconomic impediments, people might not otherwise be tested. But the MORE Project is more than just a testing service for marginalized people. Wherever it stops, it creates a space that directly reflects COYOTE's oppositional view that prostitutes (and other street-based populations) were and are safest and healthiest when they are not criminalized, moralized, or judged.

My outing with CAL-PEP's mobile HIV-testing project one morning in November 2006 clearly illustrated CAL-PEP's capacity to create habitats on the streets. On this day, a group of African American CAL-PEP outreach workers parked a large recreational vehicle housing the organization's mobile HIV-testing clinic near 32nd Street and San Pablo Avenue in Oakland, where violent crimes occur frequently and many of the houses are surrounded by chain-linked fences. Many persons who were homeless, marginally housed, or recently released from prison congregated in this area. The CAL-PEP workers—many of whom lived in the neighborhood—were unfazed by their surroundings. Instead, toting bags of condoms and informational fliers about HIV/AIDS, they walked up to various individuals, introduced themselves (if someone did not already know them), and struck up conversations, asking these individuals if they would like to participate in an HIV education session (with a free hot lunch) and take a free HIV test.

The CAL-PEP workers gave every person they encountered condoms and information about HIV testing, and they quickly filled the available spaces at the education session and lunch, which was held on the main floor of a house that a local church no longer uses. It was clear that this space, in a neighborhood where the police roam frequently, was a respite for their clients. No one running the session was chastising or trying to reform the (mostly male) members of street-based populations (according to CAL-PEP's data, 70 percent of their MORE participants are male [Williams 2003]). Instead, the men

gathered for the hot lunch of collard greens, cornbread, and chicken served in Styrofoam containers, and as they ate, Elena, a CAL-PEP staff member (and former prostitute), quizzed them about HIV/AIDS prevention. There was no reference to prostitution, or to the prostitutes' rights movement, or even to the fact that CAL-PEP's executive director was a sex worker. Instead, Elena called out questions like "how is HIV transmitted?" to which various men called out "through sex" or "dirty needles." No one was told to leave prostitution (or other illegal activities) as a condition of receiving lunch and HIV tests. Instead, the participants were encouraged to speak freely and openly with Elena and each other.

After the lunch, I spoke individually with a number of participants about their experience with CAL-PEP. Although some complained that they had to wait too long for the lunch or their HIV test results, they were grateful for the space CAL-PEP created, where they could speak openly and receive services. Dennis, an African American male in his fifties with tired eyes, spoke to me about how he came to know and appreciate CAL-PEP. Struggling with addiction, he had exchanged sex for cash (which he described as "degrading") and tried many different drug-treatment programs. A friend told him about CAL-PEP six months before our interview, and he has used the mobile van for HIV testing and referrals to other medical services ever since. For Dennis, CAL-PEP was important and effective for him because many of the staff had also dealt with addiction. Although he said he was not politically active in any formal way, he indicated to me that being in a space like the one CAL-PEP provided was empowering because it allowed him to speak freely about his own struggles with illegal substance abuse without fear of judgment or other repercussions. To him, treatment programs where the staff did not share his experiences had "no validity in their facts. How can [they] possibly know or understand? . . . You have a given knowledge about it which comes from books but as far as it being in your body and eating away at you, you have no idea what that's like" (Interview, 6 December 2006).

Dennis was not the only person who benefited from the safe, nonjudgmental space programs like MORE creates. By all accounts, the MORE Project is successful, showing that a nonjudgmental nonprofit environment is useful for gathering a marginalized community and for providing a place where they can focus on their own health. As evaluation data collected by Dr. Bowser indicates, by the six and twelve month follow-up interviews with MORE participants, "active drug using clients reported significant reduc-

tions in their use of alcohol, cocaine/crack, heroin, and fewer sex partners and crimes. Program completers also reported significantly reduced cocaine/ crack and heroin use as well as fewer days in jail and crimes than non-completers" (Bowser et al. 2010: 16). All of this data indicates that establishing a safe, nonjudgmental environment can increase trust of health-care providers and create an environment that promotes self-sufficiency through reduced substance use and recidivism, and increased HIV prevention knowledge (CAL-PEP 2004: 17)

But while health experts like Bowser approve of CAL-PEP's work, the organization does not always have immediate access to the communities they serve. Salina (Interview, 9 November 2007), a CAL-PEP program coordinator, noted that when CAL-PEP started their mobile-van service, many people in the communities they visited did not trust the van because they thought it was maybe a parole officer or "something to do with the police." Lisa, an HIV-positive African American CAL-PEP client in her thirties, confirmed this observation. Struggling with drug addiction from the age of twelve, Lisa worked as a street prostitute in Oakland from age fourteen to support her addiction. While working at 14th Street and International Boulevard (an area in the city with a high rate of prostitution), the CAL-PEP mobile van came to the area "and asked people if they wanted to learn about HIV." Lisa told me that "people [living and working in the area] were suspicious at first because they were doing drugs and were worried that CAL-PEP was part of the police." However, Lisa went on to say, CAL-PEP offered food and put up a schedule of their lectures about HIV, and they had an HIV quiz and raffle where participants could win twenty-five dollars. Consequently, she said, CAL-PEP became very popular, and "people wanted them to come every week" (Interview, 29 November 2006). To date, Lisa has used CAL-PEP for HIV and sexually transmitted infection tests, and she also has a peer advocate who helps her find housing and navigate the health-care system so she can manage her HIV.

To decrease suspicions about their motives, Salina explained to me that CAL-PEP has had to "walk the walk and talk the talk and meet people where they are" because "people want to know who you are and what you are going to do about their problems" (Interview, 9 November 2007). As a result, Salina stated, when CAL-PEP goes to a new area now, they do not just bring the van right in but instead park farther away, walk to the target area, and introduce themselves to the apparent gatekeeper, saying who they are and what they do (that they test for HIV and offer incentives for the test). She emphasized that to be effective, they need to gain trust, pay people for their time, and feed

them hot meals. CAL-PEP usually stays in an area for two to three weeks to make sure everyone has a chance to obtain a test and, if necessary, receive linkages to other health services.

CAL-PEP has also had to convince other community institutions, such as the local churches, to accept and assist them with their HIV prevention efforts. As scholars have documented extensively, churches have played a major role in African American life by providing "rare centers of economic, political and social independence in Black communities" (Smith 2004: 276). As such, they have often been places of charity and, in theory, provide an invaluable partner for CAL-PEP, in Oakland, where African Americans have long composed the largest segment of the population. But CAL-PEP has also contended with the homophobia and broader sex negativity that has permeated many of these churches, which has led to an overall reluctance on the part of these churches to address the toll AIDS has and is taking on the African American community (Cohen 1999). As Lockett remarked to me, "Those churches with an HIV/AIDS ministry and/or prevention effort have the attitude that they want to help, but the thing with churches is many don't want you to hand out condoms because they don't want to promote premarital sex. They have the attitude 'if you're fornicating, you deserve what you get.'" As Lockett and Dillard Smith explained further (Interview, 6 July 2010), "Sometimes all these churches will let us do on their property is store the mobile van," but handing out condoms or providing HIV tests is often not an option, as many congregants do not want to be seen taking the test for fear of the stigma. However, the churches have also indicated growing openness to addressing the epidemic in less restrictive ways and have formed partnerships with CAL-PEP to address it. CAL-PEP was able to host a Community Appreciation Day in 2003 at the North Oakland Baptist Church. The day, attended by over two hundred people, provided a barbecue, a job fair, and HIV testing.

A PLACE INSIDE: A SEX WORKER–FRIENDLY HABITAT AT THE SJI

As CAL-PEP creates habitats on the streets that reflect commitments to sex workers' rights, the SJI has created such spaces off the streets, illustrating further how activists may use the processes of institutional building and maintenance to advance their oppositional politics. At the SJI, however, its political origins and commitments may not be immediately clear to passersby: if one looks for the SJI, there is no sign on the building, and it is located in a neighborhood with a transient air. Auto-repair shops seem to outnumber all other businesses, making it an area people pass through but do not linger in. Here,

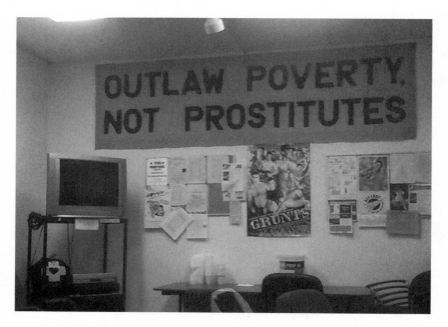

Figure 4. "Outlaw Poverty, Not Prostitutes" banner in the SJI community room. Photo by author (2010).

the clinic seems invisible, but for hundreds of America's sex workers—ranging from street prostitutes to high-end dominatrix workers—the SJI is very real, providing a rare space where they can be served by their peers and, most important, receive vital health services without judgment about their activities exchanging sexual services for cash or other trade. As I overheard one SJI client say to a woman in a wheelchair who stopped in front of the building, "You should come in here; you get food and clothes for free, [and] if you ever sold yourself once they'll take you" (13 July 2010). Today, the SJI offers its extensive range of services, free of charge, to a primarily uninsured but very diverse sex-worker community "in the San Francisco Bay Area . . . [including] current and former sex workers of all genders: escorts; street-based workers; strip club dancers; massage parlor workers; porn actors; BDSMs; Internet workers; and people engaged in survival sex exchange." In 2009, they served "531 unduplicated participants and provided 1,647 total visits during [their] primary health clinic, transgender program and [their] health education trainings" (SJI 2009c: 2).

When one enters the main reception area—a large open space with a

reception desk against the back wall, a carpeted floor, and well-used chairs lining the perimeter—it is clear this is not just "any" clinic. In addition to a picture of Margo St. James over the doorframe, the walls are covered in posters from COYOTE with captions like "if prohibition couldn't curb alcohol, how can it stop something like this?" above a picture of a naked woman in heels, shown from behind. A door at the far end leads to a hallway with a kitchen area, bathrooms, and a number of examination and meeting rooms. While the examination rooms are like those in any clinic, some have frilly bra and underwear sets adorning the walls as decorations. But the community room—an open space where those waiting for services can help themselves to hot meals, watch a movie, use the computer, or take items from the food and clothing bank—makes the most sex worker rights–friendly statement of all. Hanging on the wall is the large banner Monica referred to, which reads "Outlaw poverty, not prostitutes" (Figure 4).

These posters and other decorations create a habitat at the SJI that makes a political statement. As SJI founder Carol Stuart remarked, "While people at the clinic will say they are not political or doing anything political, the fact that they can sit in a room together without the threat of arrest is in fact a political act . . . especially in a state where two or more people in a room talking about/doing prostitution can land you in jail for conspiracy" (Interview, 20 November 2006). According to David (Interview, 10 November 2006), this accepting environment makes "the waiting and community rooms at the SJI one of the most powerful things about the clinic." Alexandra, a longtime peer volunteer and staff member at the SJI (Interview, 18 July 2006), added that here the SJI is indirectly politicizing sex workers by providing a space where a marginalized population can come together and share information in a protective environment, which brings a lot of self-efficacy and social capital development as a result of feeling and being part of a community.

This safe community environment was apparent to me every evening I volunteered at the clinic, where sex workers—a marginalized community—gathered and were able to openly discuss their sex work in a way they often could not outside the clinic's doors. One night in July 2010, Jeana, the woman working at the reception desk, told me she had moved recently to San Francisco and opened a massage parlor. Her sex-worker friends told her about the SJI, and she used their services and got involved as a volunteer. Here at the clinic, instead of avoiding any discussion of her work (as she would likely do in other clinical venues), Jeana spoke openly to me about her parlor as one would any other new business venture, laughing about the trials and tribulations of hir-

ing staff and bringing in clients. And during another evening, while chopping vegetables in the back kitchen space, I spoke with Troy, a gay male who was volunteering at the clinic. When I asked him why he was here, Troy explained that he struggled with an opiate addiction after being injured in a car accident. As part of his recovery, he worked with a sexual surrogate, an individual who is paid for therapy that involves engaging in sexual activity to help clients resolve difficulties they may be having in their sex lives. Troy found working with the surrogate so effective that he now does this work with others. Through other surrogate colleagues, he heard about the SJI, liked what they did, and decided to volunteer. Although sexual surrogacy occupies a legal gray area, here at the St. James Infirmary, Troy spoke openly about working in this field (and his addiction) while helping put food out for dinner.

The SJI's clients were also open about their sex work and other aspects of life on the margins of society. At 6:00 P.M. on a clinic night in January 2007, the doors opened and community members streamed in—a mix of biological and transgender men and women—chatting, taking a number and a chart, and helping themselves to food that we laid out earlier in the community room. Some ventured to the community room to watch a movie or sign up for the reiki and acupuncture offered while they waited for their appointments. Pratima, the physician on duty (everyone is on a first-name basis), came to the community room to hug a patient she had not seen in a while. It was clear that many of the clients knew each other well, and they did not hide their sex-worker status either.

I witnessed this openness among clients firsthand on a clinic night in July 2010, when I was sitting in the community room where most of the clients were gathered that evening to wait for services and to watch the movie *New Moon*. For the most part, everyone was silent, but occasionally some of the clients would chat with each other. At one point, the conversation among a group of transgender women in the community room turned to clothing, and one woman told the group that she "had all designer shoes" because she "had good [sex work] clients." Another woman asked whether the clients who gave them to her were "Japanese" because in her experience, "They're good [for giving expensive gifts and clothing as payments]."

More often, however, conversations among clients at clinic nights were not about sex work but about negotiating survival on the margins of society. In the community room during a July 2010 clinic night, Elton, a short, energetic man with broken glasses, began talking to me and others in the room about how he lived in his car. He described how the police would charge him

if he was messy or went to the bathroom around his car because "you know, there isn't a bathroom in my car; usually I just go in the Safeway [a local grocery store] when I have to use the bathroom." Although my initial inclination was to pity Elton, I realized this reaction was misplaced; as he shared his story, he was also sharing his capacity for agency and generosity. He offered his car to people who needed a place to sleep, including one man in the community room who hoped to leave the SJI early that night so he could secure a room in a single-resident occupancy hotel. Yet in addition to generosity, Elton also demonstrated acceptance and nonjudgment I have seen in few other places. As Elton was telling people about his car, Sam, a thin man dozing on a chair in the corner, piped in: "I have AIDS, you know." Elton, who knew Sam and had shared his car with him on previous occasions, said he did not know this. But he did not tell Sam that he was unwelcome in his car. Instead, he told Sam "not to bring needles into my car like before" because he (Elton) "can get busted for that."

Of course, client interactions are not always harmonious. The SJI, like many nonprofits, gathers a diverse community, whose members have different capacities to interact and negotiate conflict. When I visited the clinic one night in January 2007, two women, Kimberly and Anastacia, started bickering, and one threatened to "smack" the other, leading Catherine, the evening's receptionist, to intervene and state that "no one smacks anyone in my clinic" and then tell them not to speak to each other for the rest of the night. Many of the other clients in the waiting area were clearly uncomfortable; at one point, one woman asked her partner if "she will be okay out here" while she goes in for her appointment (her partner replied that yes, she would). However, Tanesha cleared the air by asking if anyone knew how to care for a poinsettia plant, and she also told the others "not to be shy about helping themselves to the food."

Creating and providing a safe space where a marginalized community may gather and speak freely about their lives is also essential to the SJI's service-delivery practices. Many members of the sex-worker community will not disclose their profession to their health-care providers for fear of arrest or of receiving inadequate care, among other concerns (Alexander 1995a, 1998; Cohan et al. 2004, 2006; Zalduondo, Hernandez-Avila, and Uribe-Zuniga 1991). At the SJI, as Dr. Cohan explained to me (Interview, 19 December 2006), this fear of health-service providers is minimized. By the time she sees the patient, they have already gone through intake and met with a peer counselor; they already know they can trust the doctor, which means there is "no bullshit" and they can get to their health issues immediately. To illustrate, Co-

han told me about a patient she saw in her private practice who she thought she knew well: however, it was not until the SJI opened in 1999 and this same patient came in for services that Cohan learned she was a sex worker. The patient's disclosure about her sex work helped her be more honest with Cohan who, in turn, could better meet her occupational health and safety needs. When this patient came to her recently with a shoulder injury from fisting, they joked about listing it as "repetitive stress" on the intake form. As Cohan notes, "You cannot replicate such honesty in a clinic, no matter how hip" (Interview, 19 December 2006).

Over coffee one morning, Sarah, a white woman in her early thirties who works as a professional dominatrix in the Bay Area, explained to me how this honest environment helped her with her own health issues (Interview, 17 October 2006). She heard about the SJI through a colleague at the domination house where she once worked and, at the time of our meeting, had been using the SJI's services for five years. She told me that a few years ago she found out that she had cancer and had to seek care at other facilities; however, she never disclosed her sex work to her cancer doctors because she believed "they [would] be judgmental." However, she added, the SJI "has been great through all of my medical stuff, even when I was in chemo and bald," especially because, she added, "you can ask them a specific question and you won't feel judged." Ashly, a woman in her late twenties who worked as an exotic dancer and as a peer counselor at the SJI reiterated how empowering this open environment can be for sex workers (Interview, 30 July 2010). She described how she often saw a "shift" happen in people at the SJI when they had their first counseling session and talked about their sex work with a counselor "who is not delegitimizing or judging them" but instead "acknowledges to people at the SJI how capable they are of surviving." She also described how in these sessions, people say, "I'm strong—I'm tough" and "they let the shame go."

The Limits of Habitats: Fostering Solidarity and Empowering a Diverse Community

The SJI and CAL-PEP provide safe and nonjudgmental spaces for sex workers to gather and receive services. But while these environments may be empowering for individuals, how may they also potentially foster broader community solidarity (and even advance the sex-worker rights movement)? In many ways, demographics may limit this ability. At the SJI, for example,

many longtime clinic staff members readily acknowledge that their clientele is becoming increasingly service dependent. As David (Interview, 10 November 2006), a former SJI staff member stated, while the SJI's clients have always been predominantly homeless or very poor, "with a smattering of white, educated former strippers and female sex workers who thought this was a cool idea," transgender or street-based sex workers are the fastest-growing groups at the SJI. These individuals also disproportionately face issues of substance abuse, mental health, employment, and housing challenges, and so they demand more of the SJI's resources.[8]

But as the SJI serves this narrower slice of the sex-worker population, it also becomes more difficult for the clinic to gather and create community among the broader sex-worker community. As the late Robyn Few, a Bay Area sex-worker activist stated (Interview, 20 October 2006), "Although they [the SJI] do great work offering services, many other sex workers will not go to SJI because they do not feel welcome there, mainly because of the long wait and the 'bitchy trannies' that make it less appealing." However, it is not only these incidences that prevent sex workers with more resources from coming to the clinic; like many others, they would rather receive care in a private clinic (with shorter wait times) or in spaces that do not remind them of their position within a stigmatized community. As Melania, a former SJI program director, who has also worked in the indoor sector as a dancer and escort told me, "Some [sex workers] also will not come to the clinic because of pride. I know women charging $2,000 per hour (with a two-hour minimum) who would never come here because they are too invested in *not* being whores and would feel like one if they came to the clinic. For them to come here would be to maybe confront the reality that some are not as well off as you are" (Interview, 19 December 2006).

For many sex workers who are committed to the SJI's broader belief in sex-worker rights, this reality is disappointing. As Vicki, a college-educated woman who worked as an exotic dancer and has been a longtime client and volunteer at the SJI stated to me, "It is unfortunate that the different levels in the sex industry do not interact as much here anymore because this was part of the nonjudgmental atmosphere at the clinic, which really broke down hierarchies and barriers between those in the higher and lower ends of the sex industry." For this reason, she said that she has continued coming to the SJI, even though she has private health insurance. She added that while "some of the clients have challenged her," she is committed to receiving services here and volunteering because she "can take the bitchiness in stride. . . . This is part

of the container the SJI creates, and it's a place these people can go, and I am cool with and glad that they are here" (Interview, 1 November 2006).

For those who do gather at the SJI, like any other community, they are often as divided about sex work as a legitimate occupational choice as they are along class lines. As Ashly explained, "People have different opinions about legalization and decriminalization [of prostitution], and the SJI is a good place to come to look for either one" (Interview, 31 January 2007). And so even within a clinic committed to prostitutes' rights, some sex workers that gather here do not see it as a legitimate occupational choice. In fact, among the forty sex workers I interviewed, twelve supported the criminalization of prostitution, even if they had been arrested. Tanesha, an African American transgender woman who had struggled with homelessness and addiction, discussed this attitude with me. She explained how she had exchanged sex for money and drugs over many years. When I asked her to reflect on her experiences in the sex industry, she stated, "Honestly? I would not change a thing. I'm glad that I had the experience because it taught me . . . a lot about the streets. I'm not naïve to things that go on out here now. I met some really good friends, people that at first I would just call an associate, but I've actually met really good friends." However, when I asked her about prostitution laws, she very firmly stated, "I do not think, I will never think that it should be legal. I don't. I really don't. . . . That kind of encourages a person to go on out there, and I truly feel that they should have more. Transgenders such as myself and other individuals that have totally come out of that lifestyle . . . they're trying to make something of themselves within the workforce, within society. You know? Show the girls that there is another way besides standing on the street corner or putting your picture on the Internet" (Interview, 13 November 2006).

Many other transgender and street-based sex workers I spoke with were similarly ambivalent about their sex work experiences and were not comfortable with decriminalizing or legalizing prostitution; however, many others held the opposite opinion. In fact, twenty-five sex workers I interviewed believed prostitution should be legalized or decriminalized in some way, a finding commensurate with one of the only studies examining sex workers' opinions about different legal regimes. This study showed that the majority of interviewees preferred removing statutes criminalizing sex work so that they could have the legal right to seek help from the police if they were victims of violence (Lutnick and Cohan 2009).

But different opinions among members of a social movement–borne

nonprofit's constituency does not preclude the organization's potential for fostering solidarity and, by extension, political empowerment and engagement. As Vicki explained to me, "It is hard to mobilize the populations who are at the SJI and just scraping by: if you don't have your basic needs met, you cannot do justice work, especially when there is no justice in your own life . . . although sometimes people who are denied justice are also the most motivated" (Interview, 1 November 2006). And so Ashly explained, the "best way to give or get political is to get resources—helping people get housed and fed will lead them to take to the streets instead of being on the streets. At a certain point, surviving is a political act" (Interview, 31 January 2007). And many SJI clients stated that being at the SJI encouraged them to get more involved in political and community life about issues that were personally important to them, such as transgender rights or the continuation of service provision at the SJI. Regarding transgender rights, Shaquaneequa, a transgender sex worker in her thirties "who has never even voted in my life because I am just not into that" stated, "The SJI has made me want to become more politically active in some ways; for example, when I see someone make a bad choice or discriminate, I like to educate them about it. For example, when kids say, 'Ew, you're a man,' I say, 'Yes, I am a man, but I am TG [transgender], and there are people like that here.' I have felt more political this way because of how much the SJI talks about being open-minded and about unity, and unity is something a lot of TGs don't have" (Interview, 2 November 2006).

In another example, Monica, a female transgender sex worker, noted that she sometimes attends demonstrations in San Francisco against the war in Iraq and candlelight vigils for those who have died from AIDS. For her, the Transgender Day of Remembrance is especially important because, as she stated, "It could be me." She explained that she feels she has put herself at risk for being a victim of a hate crime by cross-dressing and feels "this has to stop." She has also testified on behalf of the Native American AIDS project at the Board of Supervisors meeting, where she also shared how valuable her experience at the SJI has been for her (Interview, 25 October 2006).

Conclusion

Both CAL-PEP and the SJI indicate that it is possible for activists to implement oppositional political commitments within the physical spaces and service-delivery practices of their nonprofit organizations. Even as they op-

erate in a broader political climate that has largely evinced hostility toward noncriminalizing approaches to prostitution, they have drawn on other, more favorable local political-institutional opportunities for health-service delivery to do this. Clearly, they offer services in a way no mainstream government agency can replicate, and as a result, they are valuable coproducers of government programs. And both organizations very clearly provide places where marginalized communities receive services and can gather and be open about their lives. Since so many aspects of the SJI's and CAL-PEP's clients' lives are criminalized, providing space for such communities to gather is a radical act, even if their capacity to gather sex workers does not always lead to vibrant, politically mobilizing conversations and action. However, creating habitats for their community does not only involve providing a safe and open space. The next chapter discusses how, through the process of community engagement, the SJI and CAL-PEP offer their constituency opportunities to develop the skills and capacity to participate in broader civic and political life.

Community Engagement

In the early 1980s, Gloria Lockett appeared on *Geraldo* in her capacity as a COYOTE member to talk about the importance of decriminalizing prostitution. A few years later, an article in the *San Francisco Chronicle* titled "Former Hookers Help Themselves" (Olszewski 1988) described Lockett on a CAL-PEP outreach excursion in the city's Tenderloin neighborhood, where she handed out condoms without judgment to Beti, a transgender sex worker who struggled with a speed addiction. Over twenty years later, one Monday morning, I walked into the CAL-PEP offices to find Lockett, now in her mid-sixties, sitting at the table in her small, cluttered but bright office. She was signing various forms with titles like "Community Based Organizations Master Contract Exhibit A and B." These would finalize CAL-PEP's grant with the Alameda County Public Health Department (ACPHD) to carry out various HIV/AIDS prevention and education services to sex workers and other street-based populations in the area. Lockett was in a hurry to sign the forms; the county expected a report on CAL-PEP's progress with the grant by Friday. As Lockett signed the last form, I asked her whether—after all of her years as a sex worker, activist, and outreach worker—she ever thought she would be in this position, signing contracts with Alameda County. "No," she answered. "Just one word: no."

If this meeting had been my first with Lockett, her answer would have surprised me. Watching her fly effortlessly through the convoluted paperwork on her desk, one could easily assume she had advanced degrees and training in public health or nonprofit management. And looking around her office, it is clear that Lockett excels at what she does, and she has been recognized as a community leader for her efforts. The walls are covered in plaques from organizations like the San Francisco Coalition on AIDS (for the 1990 Community Service Award), the 1991 Northern California African American

Women and AIDS Conference ("in recognition of your leading the way for community survival around HIV"), and the Alameda County Office of AIDS Administration (for the 1996 HIV/AIDS Community Service Award).

Although it is not common to hear stories in the mainstream media of women in prostitution with experiences like Lockett's, its general trajectory is familiar to many social-movement observers. Here, an individual formerly engaged in the informal economy turned to activism and is now a professional (and decorated) manager of a nonprofit service organization that carries out services for multiple government agencies. While many may quickly dismiss this as a story of cooptation, Lockett's example and others in this chapter indicate how activists may in fact maintain their oppositional political commitments within nonprofit institutional contexts. Specifically, through a practice I term community engagement, they involve their constituents in organizational management and service delivery. Although this practice is not without limits, it shows how social movement–borne nonprofits may provide members of marginalized groups with the opportunity to develop civic skills that they may translate to broader community and political involvement.

Mainstream Institutional Responses to Prostitution in the United States

If one briefly surveys the historical record, it is clear that mainstream institutional approaches to sex-worker health in the United States have largely focused on suppressing and eliminating prostitution. Between 1900 and 1920, Americans began to exhibit the most widespread concern about prostitution and the alleged health risks it posed to the population, as immigration increased and the nation grew more urban and industrialized. At this time, Americans employed the government for the first time for, among other things, "trust busting" expanding American business interests, regulating and rationalizing an increasingly racially and ethnically pluralistic nation, and legislating morality (Luker 1998). New sex and gender ideologies were also forming as women, who were more visible in the public sphere and in the workplace, began demanding political rights (e.g., suffrage) and social equality, particularly regarding sexual behavior. Angered by what they believed was the "sexual double standard" in society (whereby men could have sex outside marriage, without social or other penalty, while women could not), social purity groups, such as the Women's Christian Temperance Union's Committee for Work with Fallen

Women, mounted vigorous campaigns for legal reform that would enforce a single standard of moral purity for men and women (Abramson, Pinkerton, and Huppin 2003; Morse 1997; D'Emilio and Freedman 1997). These ideas about the (expanded) role of government and about sex, gender, and morality coincided with the social-hygiene movement's emergence. Leaders of this movement conducted an "unrelenting campaign of education to wipe out the ignorance and the prejudices that allowed venereal diseases to infect the nation" (D'Emilio and Freedman 1997: 205).

Together, the efforts of those campaigns resulted in the broadest and most coherent governmental effort to eliminate prostitution in American history. From 1900 to 1920, new laws were written by these social reformers in cities nationwide to eradicate prostitution, and they were institutionalized through an array of enforcement mechanisms (such as closing red-light districts in almost every major American city and creating new penal institutions for women). Social reformers also feared immigrant vulnerability to and perpetuation of prostitution, reflecting broader anxieties about the increasing numbers of "wayward" (read as single and nonwhite) women in the public sphere. Specifically, reformers were concerned that these women would spread venereal diseases, and so they provided various social services, such as settlement houses, to young, working-class and immigrant women to prevent them from entering prostitution (Abrams 2000).[1]

These national trends were clearly reflected in California, particularly in the San Francisco Bay area, where a brief window of toleration was overshadowed by government responses that would suppress prostitution and contain the infectious diseases it allegedly spread. In response to the demands of the prominent physician Dr. Julius Rosenstirn, who advocated a supervisory approach to prostitution, the San Francisco Board of Health opened a clinic in 1911, which effectively legalized prostitution in the city by forcing all prostitutes to confine themselves to a district and submit to regular medical exams (Shumsky and Springer 1981; Rosenstirn 1913). But the opportunity to continue and expand this legal regulation of prostitution was brief (Shumsky and Springer 1981: 82; Kerr 1994). The clinic system soon came under strong attack by doctors who did not believe it lessened the spread of venereal diseases and by social reformers and religious leaders who thought the clinic encouraged immorality. However, many of these measures did not go uncontested: in 1917, Reverend Paul J. Smith, a notorious antivice crusader in San Francisco, proposed sending prostitutes to "state farms" for rehabilitation, leading three hundred prostitutes to march in front of his office in protest (Schiller 2011).

But despite these efforts to suppress prostitution in San Francisco (and elsewhere), the practice did not disappear. By 1920, although women had the right to vote, they did not have universal access to well-paying jobs. In San Francisco, as Elizabeth Bernstein documents, "Very few prostitutes chose to abandon the sex trade, despite offers from groups like the YWCA and the Civic League to help them find other vocations" (2010: 27). Consequently, governmental efforts to eradicate prostitution merely dispersed it to other locations. Closing the red-light districts drove many women to work underground, often in brothels or for pimps (Connelly 1980; Meil-Hobson 1987), or in cabarets and taxi-dance halls (Reckless 1933). Street prostitution also moved to other, less strictly policed areas (Shumsky and Springer 1981). For example, when the city abolished the Barbary Coast in 1917, prostitutes moved to the Tenderloin, which was close to the city's growing hotel and entertainment district, making it the city's main location for street prostitution until the mid-1990s (Bernstein 2007: 28).

These responses to prostitution firmly entrenched understandings among the public and lawmakers alike that it was a dangerous and immoral activity that was largely responsible for the spread of disease (Connelly 1980; Meil-Hobson 1987). Although World War I and II raised concerns about the impact of prostitution on troop morale and health, the Great Depression and the complacency of the quietistic 1950s diminished public and legislative attention to prostitution. However, support for it did not increase, particularly with Ronald Reagan's election and the emergence of the AIDS epidemic, which instigated another round of health policies and practices that aimed to suppress and eliminate prostitution. Similar to the disease panics of the Progressive Era, women working as prostitutes became an easy and obvious target for fears about the spread of HIV/AIDS, even though their rates of infection and transmission were not higher (and in some cases were lower) than those for the general population (Darrow 1990). Across the United States, legislators passed numerous laws that targeted prostitutes as transmitters of HIV. As Zita Lazzarini (2004: 181–82) writes, between 1988 and 1996, twenty-four states passed legislation criminalizing HIV transmission generally or through some form of specific behavior, including spitting, donating blood, or sexual intercourse. She also found that fifteen states passed statutes concerning acts that were already crimes (such as prostitution, rape, and assaulting a peace officer), which punish the perpetrator separately or more severely when he or she knows she or he is HIV positive. Specifically, California, Colorado, Florida, Georgia, Kentucky, Ohio, Oklahoma, Pennsylvania, South Carolina,

Tennessee, and Utah enacted "enhancement statutes" that would increase the severity of charges against prostitutes from a misdemeanor to a felony when the prostitute knows she has (or is known to have) HIV (Wolf and Vezina 2004: 856). Although the police rarely enforce these laws, California has had 216 prosecutions under its law (Mitchell 2002: 3).

Within this context, by treating prostitutes as legitimate workers who are responsible for and capable of providing their own health care, CAL-PEP and the SJI radically resist the historical tendency of mainstream institutions to create policies that aim to suppress or eliminate prostitution. The COYOTE activists who formed these organizations understood from their own particular experiences with self-care (by using condoms and avoiding excessive substance use, for example) and with public authorities (such as the police) that their peers would be more likely to access services that did not condemn prostitution as an economic option. Instead, they wanted to empower sex workers by acknowledging their activities as work and protecting their health through the provision of condoms, counseling, and other support services (Weitzer 2007; Gozdziak and Collett 2005). To provide such empowerment, they hired and trained sex workers as health-service professionals, thereby implementing a "peer model" of service delivery that provides sex workers with opportunities to attain skills they may employ in the broader economic, civic and political arena. As the SJI's mission declares (about sex-worker hiring), "Putting ourselves in charge of health care delivery is a powerful revolution in the way American clinics are run" (SJI 2008: 2).

Defining Professionalism: Credentials and Data Collection at CAL-PEP and the SJI

Today, CAL-PEP and the SJI demonstrate how social movement–borne nonprofits engage in oppositional commitment maintenance through their own institutional practices of community engagement: by hiring members of their constituency as service providers. At the SJI, the licensed medical and holistic-service providers (the medical director, on-staff doctor and nurses, and acupuncture and reiki practitioners) often do not have sex-work histories. However, the remaining paid and volunteer staff—including the executive director and her assistant, the fundraising director, registration staff, and the various harm-reduction, transgender-services, outreach, and needle-exchange coordinators—are current, former, or transitioning sex workers.

And at CAL-PEP, while some staff members (such as Gloria Lockett) are former sex workers, the majority of CAL-PEP's program coordinators, peer counselors, and treatment advocates, and accounting and data-collection staff are African American women who may have lived in the Oakland area CAL-PEP serves or are friends and family of current and former CAL-PEP staff. Similar to the clients they serve, some of these individuals have criminal records and have spent time in prison or struggled with substance abuse.

In fact, Lockett told me she had been arrested "hundreds of times" on prostitution charges, most notably with former CAL-PEP board member Ralph Washington, who managed Lockett and a number of other women when they worked as prostitutes. He and Lockett were arrested in 1978 for prostitution and conspiracy to promote prostitution, the latter of which brought a potential felony conviction.[2] After a year in court, they were found guilty of only being in a house of prostitution, for which she and her coworkers served six months' probation. However, as Lockett discussed, the police were angry about this outcome and "so they stayed after us," and in 1982, Lockett and Ralph Washington were arrested again and charged with "every felony there was" (Lockett, 1994: 208). Lockett won her case, and Washington was sentenced to twenty years in prison for twelve counts of prostitution-related charges but on appeal was released in 1986 (Stoller 1998; *United States of America v. Ralph H. Washington*, 1984).

By hiring individuals with criminal histories as peer service providers, CAL-PEP and the SJI are also expressing their oppositional political commitments that sex workers are not criminals but workers with legitimate occupational health and safety needs. However, these hiring practices also place them under a scrutiny that organizations run by "straight" populations rarely face. As Nancy Stoller wrote to explain this phenomenon, "CAL-PEP's leading staff person [is] an assertive, street-savvy African American prostitute, an identity practically guaranteed to cause anxiety in a white middle class bureaucrat—especially one who hears his or her money is in the hands of such a woman" (1998: 93). And certainly, to some, Lockett's history may not inspire confidence. Therefore, to sustain their services and commitments to prostitutes' rights, CAL-PEP and the SJI must negotiate the "usual" challenges of maintaining their nonprofit status and grant agreement alongside popular perceptions of the community they serve. To do this, they have made a strategic choice to run their organizations professionally, by developing and implementing two particular institutional practices to this end: credentialism and data collection.

Credentialism

This practice refers to how CAL-PEP and the SJI provide peer staff with opportunities to obtain training and qualifications so that they may serve their peers in a safe, effective manner. As Johanna Breyer, a former dancer and the SJI's first executive director explained to me, "While the SJI is peer based, it is also professionalized in that they need policies, procedures, protocols, namely because it is a health clinic, and confidentiality and creating a safe space is important" (Interview, 23 October 2006). And so both organizations have extensive operations manuals that outline in great detail the various client registration, testing, counseling, and administrative guidelines that all staff members must follow to ensure services are delivered safely, efficiently, and effectively (CAL-PEP 2004; SJI 2009a, 2009b).

CAL-PEP and the SJI also provide their staff with opportunities to obtain training externally, as needed. But this practice does not spell cooptation; instead, it allows these organizations to continue their movement goals. By attaining these credentials, sex workers' qualifications supersede any value judgments about what they do outside of CAL-PEP and the SJI. Put differently, to deliver services, health authorities can no longer assume an individual with these credentials is not qualified or capable of this work because he or she is a sex worker.

PHLEBOTOMY (BLOOD DRAW) CERTIFICATION

Some peer service providers at the SJI and CAL-PEP conduct blood draws for HIV and sexually transmitted infection testing. These activities require training and certification to ensure they are done correctly, without harm to the patient. Although many organizations in the Bay Area offer this certification, City College in San Francisco is a major resource for this training.[3] According to the program information, the "certificate program in phlebotomy . . . takes between four and five months to complete and offers a rigorous curriculum that includes collecting samples and completing an externship. On completing certificate requirements, students are able to apply for certification through the California Department of Public Health's Laboratory Field Services division, allowing them to practice phlebotomy legally anywhere within the state" (Phlebotomy Certification Center 2011: 1).

HIV COUNSELING

According to the CDC, HIV counseling involves providing information to patients about the type of HIV test they receive (standard blood draw or

rapid [oral]) and its benefits and consequences; the ways HIV is transmitted and how it can be prevented; the meaning of the test results; and where to obtain further information, services, and treatment if needed (CDC 2011). Although the CDC no longer requires HIV counseling in traditional health-care settings, they do support this type of counseling for organizations working with high-risk populations and in nonmedical settings (for example, on the streets). The majority of CAL-PEP's and the SJI's staff received this HIV counselor training through the AIDS Health Project at the University of California, San Francisco. According to their website, this training "seeks to help providers become skilled at the appropriate level of assessment and result disclosures for both conventional (two-session) counseling and testing and rapid (single-session) counseling and testing. The trainings combine information-based modules with experiential values-clarification exercises, role-playing, and other practice. All trainings encourage a neutral stance and build skills around results disclosure, client-centered counseling, behavior change and sociocultural theories, and harm reduction theory" (University of California, San Francisco, 2011b).

HARM-REDUCTION TRAINING

CAL-PEP's and the SJI's staff attend yearly harm-reduction training offered by organizations like the AIDS Health Project and the Harm Reduction Coalition. According to the AIDS Health Project's website, this involves a "two-day training . . . to build client-centered prevention counseling skills. It reviews behavior change theory, increases HIV knowledge to enhance the ability to assess a client's HIV-related concerns, and helps participants develop skills to aid clients in creating meaningful and achievable risk reduction steps" (University of California, San Francisco, 2011a).

ACUPUNCTURE AND MASSAGE

Volunteers offer these services at the SJI, and according to Naomi Akers, the executive director, these individuals also "have to be trained and certified just like a phlebotomist. But they can receive their training anywhere, as long as they have a valid state certification, that we do verify" (Akers, e-mail correspondence, 30 November 2011).

SJI'S INTERNAL TRAINING FOR ALL STAFF AND VOLUNTEERS

This type of training covers universal precautions, the clinic's emergency and disaster plan, the federal Health Insurance Portability and Account-

ability Act of 1996's Privacy and Security Rules, gender and cultural sensitivity, harm reduction "101" and harm reduction with sex workers, and a history and overview of the clinic (Akers, e-mail correspondence, 30 November 2011).

TECHNICAL TRAINING

Occasionally, staff at both CAL-PEP and the SJI will attend trainings at Compass Point, which works to "intensif[y] the impact of fellow nonprofit leaders, organizations, and networks . . . by guiding nonprofits as they become better managed, more adaptive, and achieve higher impact" (CompassPoint, 2013). Training sessions at Compass Point help staff build skills with such programs as Excel and PowerPoint, grant writing, and volunteer program development.

Data Collection

The SJI and CAL-PEP have also implemented data-collection activities as part of their professional practices. The motivation for data collection is twofold: government funders now demand more accountability from the nonprofits they fund, particularly in the field of HIV/AIDS prevention, and the services CAL-PEP and the SJI deliver are more complex and require more paperwork. Therefore, by both necessity and choice, CAL-PEP and the SJI have institutionalized various data-collection activities in their organizational operations and practices. According to Akers (e-mail correspondence, 2 November 2007), the SJI has collected data from its inception, mainly to support their programs (in grant applications, etc.) and to better understand the community they serve. Similar to CAL-PEP, she notes that much of their data collection has become more onerous at the SJI in recent years as the federal government (particularly under the George W. Bush administration) grew more concerned about the cost of providing medical and health-care solutions for HIV/AIDS. Today, according to Akers (e-mail correspondence, 2 November 2007, and Interview, 25 March 2008), the SJI collects two types of data about their activities and clients (aside from medical chart information, which is common at any clinic) for submission to various local and state agencies: core variables and data for the California State Office of AIDS.

Core variables are required for their SFDPH's AIDS Office contracts

for HIV prevention activities, not inclusive of HIV testing (which re-
quires a different form, described below). Core variables include date of
birth or age, zip code, race or ethnicity, gender, gender of sex partners,
whether there has been injection-drug use in the last six months (and, if
yes, whether they shared needles), and whether there has been sex without
a condom in the last month. They also document the date, type of ser-
vice the client received, and how many minutes of service. Core variables
are collected on forms distributed to clients while they wait for services
on clinic nights and after groups. The forms are submitted to the relevant
program coordinator (the individual in charge of clinic night or the par-
ticular group), who in turn makes sure they were filled out properly. The
coordinator then submits the forms to the SJI's data-entry clerk, who en-
ters all the core variables into the SFDPH database. The San Francisco HIV
Prevention and Planning Council then uses this data to evaluate programs
to understand HIV risk in the city and make plans and set priorities for
future HIV prevention work.

The SJI also collects data for the California Office of AIDS, through the
state's Counseling Information Form, which asks for a range of variables re-
garding HIV risk assessment, such as presence of tattoos (which might indi-
cate exposure to HIV-infected needles). This data is collected at the close of
each HIV testing and counseling session. The form remains on site (at the SJI)
for thirty days and is "for reimbursement and data gathering about HIV test
clients throughout the State of California" (Fecente et al. 2007: 1). Accord-
ing to Akers (Interview, 25 March 2008), since the SJI is contracted by the
SFDPH (City Clinic) to do HIV testing, they collect this information and are
reimbursed by the state through their contract with City Clinic. The SJI does
not actually have to enter the data collected on the forms into any system;
instead, the forms are collected periodically by a representative of City Clinic,
who in turn submits them to the San Francisco AIDS Office for submission to
the State Office of AIDS.

As the older and larger of the two organizations, CAL-PEP illustrates the
extensive data-collection activities HIV/AIDS service nonprofits often en-
gage in as part of their professional practices. Since beginning my research
with CAL-PEP, they have (depending on the grant), used at least six of the
following forms outlined in Table 1 to collect a range of demographic, sub-
stance use, and HIV prevention information about their clients.[4] They also
collect data about their program activities, such as the number of HIV tests
administered. All this data is variously submitted to the City of Oakland, the

Alameda County Public Health Department (ACPHD), the California State Office of AIDS, the Substance Abuse and Mental Health Services Administration, and the CDC. CAL-PEP also must process and analyze this data for the two reports per year (four in total) that the CDC and the ACPHD requires from them.

CAL-PEP and the SJI benefit from these data-collection activities because they help them maintain funding for the services they offer their constituencies. Akers described how "the data entry is paying off in the time I am saving to run reports for billing and evaluation. I also use the reports for every grant we apply for" (e-mail correspondence, 2 November 2007).[5] She also believes there is a lot of utility in the core variables, noting here that although collecting the data requires more staff time, the forms are a valuable tool for keeping the SJI clients occupied while they wait for services, and many clients also enjoy filling them out because it makes the clinic feel more "official" (Akers, Interview, 25 March 2008). CAL-PEP's leadership expressed similar sentiments about data collection for program maintenance—as Dillard Smith noted, "We are often first in line for funding and programs because we test, document, report, and evaluate what we do" (Interview, 3 November 2006).

CAL-PEP and the SJI: Engaging a Diverse Community

These credentialing and data-collection activities have a professionalizing effect on CAL-PEP and the SJI that is not unique to them: many nonprofit service providers across fields have similar practices. But for social movement–borne nonprofits committed to maintaining their oppositional political stances, these practices present both opportunities and constraints, particularly regarding their capacities for community engagement. With so many credential and data collection–related requirements, it is not surprising that both organizations have hierarchal structures, with executive and deputy directors at the top, program coordinators in the middle, and service staff at the bottom. Moreover, it appears that those occupying positions in or entering this structure are—as the extensive research on civic engagement and political participation indicates—those who are educated, employed, and more likely to have various skills and be involved in civic organizations (Fiorina 1999; Galston 2001, 2007; Skocpol 2003, 2004; Skocpol and Fiorina 1999).

Table 1. CAL-PEP's Data Collection Activities

Form	Data variables	Where data is submitted	Programs forms collected for
CAL-PEP log sheet (created in-house)	Name, age, sex, race, location, number of condoms and bleach kits, population (prostitute, etc), previous contact with CAL-PEP and commitment to information, frequency of condom and needle use, referrals given	City of Oakland, CDC	SISTA[a], Measure Y, all HIV prevention activities: street outreach, workshops, one-on-one meetings, prevention case management, testing
CAL-PEP intake form (created in-house)	Personal info (name, age, date of birth, etc), government services received, employment, medical information, mental health information, housing information, substance-use history, legal information, social network/support information	Alameda County	HIV prevention case management
Evaluating Local Interventions forms (group check sheets, individual level interventions forms, outreach check sheet, outreach short form, prevention case management form)	HIV behavioral risk population, race, age, gender, sexual orientation, HIV status, health, hepatitis, sexually transmitted infection, drug-use histories	California State Office of AIDS via the ACPHD[b] (ACPHD collects forms from CAL-PEP and enters them for submission to the state)	HIV prevention activities: street outreach, workshops, one-on-one meetings, prevention case management, testing

Form	Data variables	Where data is submitted	Programs forms collected for
HIV counseling information form	Client information (race, ethnicity, etc), HIV testing history, risk-reduction steps, counselor's notes and review/assessment of testing issues, client referrals	Alameda County Office of AIDS (which submits the information to the state)	HIV counseling
GPRA forms[b]	General demographics, kind and extent of drugs used, number of times arrested, and number and types of sex partners	SAMHSA (although no longer required, CAL-PEP still collects the data for its own records)	G-Spot[c]
G-Spot intake form (in-house document)	Name, age, address, date of birth, race/ethnicity, incarceration history, type of housing, schooling, use of legal and health services, HIV/sexually transmitted infection test histories, status and risk factors, drug, alcohol, and tobacco use, drug treatment, mental health assessment	SAMHSA	G-Spot

[a] SISTA: Sisters Informing Sisters About Topics on AIDS.
[b] GPRA: Government Performance and Results Act.
[c] G-Spot: Girl-Spot.

Professionalism and the Challenge of Diversity

At CAL-PEP and the SJI, many of their management and staff members and volunteers are highly educated and thus already likely to be civically engaged, which contrasts with the very marginalized individuals these organizations serve. With the exception of Gloria Lockett (who did not finish high school), the executive directors at both organizations have advanced degrees and often come from more privileged sectors of the sex industry. Carla Dillard Smith, CAL-PEP's executive director, is an African American woman with no history of sex work, but she has a master's degree in public administration from the University of California, Berkeley. Johanna Breyer, CAL-PEP's first executive director, and Naomi Akers, the current director are white women with master's degrees in social welfare and public health, from the University of California, Berkeley, and San Francisco State, respectively. Furthermore, many of CAL-PEP's and the SJI's staff members have high levels of education. At CAL-PEP, the data-entry clerk had a bachelor's degree, and two other women serving as program coordinators had master's degrees in public health. And at the SJI, the majority of the fifteen paid staff I interviewed had at least a bachelor's degree, and all but one were Caucasian.

Many of CAL-PEP's and the SJI's volunteers were also highly skilled, and they were involved with these organizations as an extension of their other goals and commitments. At CAL-PEP, volunteers were most often white and Asian college students at Berkeley. And at the SJI, many of the volunteers, including me, were not sex workers, or, if they were, they had bachelor's or other advanced degrees. One of these volunteers was Reanna, a tiny blond exotic dancer from the Northeast, with a degree from an elite college. Although she was, at the time, still traveling to clubs in Nevada on weekends to dance, she was a full-time student and planned to fully transition from the sex industry when she attained her next degree. She was at the SJI to shadow the physicians' assistant and was already on a sure-footed path to her next career. Similarly, another volunteer, Shirley, was completing an advanced degree in women's studies and ran an online magazine that engaged with feminist and social-justice issues. She did not volunteer at the SJI to gain job skills (she already had plenty of writing and communication skills) but because she believed in the clinic's mission and wanted to help as part of her feminist commitment.

At both organizations, the staff's socioeconomic status and skill levels often contrasted sharply with that of their clients. On many of the nights I volunteered at the SJI, for example, I often would help the staff fill bags with

donations from the food bank, which we would set out in the community room. But many clients began taking as many bags as they could, leaving few or none for their peers who came later. The staff discussed this issue one night after clinic hours and decided to implement a practice where one volunteer in the community room watched the food bags and made sure everyone had their fair share. A similar issue also arose with bathroom use (many of the SJI's homeless clientele do not have access to a bathroom on a regular basis outside of the clinic). During many of the clinic nights, some clients would be in the bathroom for long periods, which made it difficult for others to use the bathroom. Consequently, the staff member leading the clinic one night told us to "watch out" for certain clients when they went into the bathroom.

At times, clients grew angry about these practices, especially with the food, which seemed to reinforce the distinction between the more and less privileged peers in the space. Jennifer, a female street-based sex worker and longtime SJI client who struggled with addiction and multiple arrests, explained to me that she felt some of the staff providing services have "attitudes" toward those who are in less privileged sectors of the sex industry. "Different types of sex work have different dangers, and street is the most dangerous," she said, adding that "if there were more people at the St. James who worked on the street, it could be better because a lot of staff who have worked as escorts and dancers have attitude problems, and you can't have attitude on the street" (Interview, 23 October 2006).

Statements like this should not minimize the broader fact that sex workers at both the SJI and CAL-PEP overwhelmingly favored the peer model of service provision and were enthusiastic about how these organizations served them. (When asked how they would rate CAL-PEP/the SJI on a scale of one to five—with one being the least satisfied and five being the most satisfied—all but two of the forty sex workers interviewed gave them an overwhelming five, with two rating them a four because "there's always room for improvement.") But the socioeconomic distinction Jennifer's comment identifies indicates an ongoing challenge for these organizations as they work to serve and engage their community. As Naomi Akers, the SJI's executive director, indicated, "There is an assumption that one peer can represent the community, and this is not really true because the community is so diverse. . . . For sex workers, there are different types of experiences, and some here are in recovery and this is their first real job, or they had a bad sex-work experience, so we really have to try to get peer staff to be open to all types of experiences with sex work" (Interview, 5 December 2006). And so like many other similar organizations, the SJI's management

constantly works with staff to promote diversity, especially since many of the sex workers receiving services at the SJI are not from the more privileged sectors of the industry. David, a former staff member explained to me that he was happy to see more staff of color with a recent hiring wave, including a new outreach director, a Latina woman who had done lots of work in the Mission. He explained to me that she is valuable to the clinic because "the SJI has never had that someone with an inroad into the neighborhood's largely Latino/a population" (Interview, 10 November 2006). When I returned to the SJI in July 2010, an African American transgender woman was also working as the receptionist.

Yet the leaders at these organizations must also confront the reality that they also need highly skilled management, staff members, and volunteers to complete the administrative and data-collection requirements that sustain their services. As Amy, a former CAL-PEP staff member noted to me, "They [CAL-PEP] aren't just handing out condoms and having brief chats about HIV anymore, which anyone can do" (Interview, 20 October 2006). Instead, they are fulfilling complex contract agreements, like their CDC Contract #04064 "Human Immunodeficiency Virus (HIV) Prevention Projects for Community-Based Organizations" (CDC 2004). This contract, which funds their HIV testing and prevention projects, requires them to document treatment activities they complete for the CDC, such as numbers of HIV tests administered and prevention-outreach contacts, and discuss whether they reached their projected targets for these, among other items.[6] Although both Dillard Smith and Lockett believe in evaluating their programs, they stated that reporting to the CDC has grown more complex and time consuming, especially as the reports they submit often run over one hundred pages in length, which they likened to "writing a dissertation." As a result, it is difficult to obtain and maintain these grants and reports without a highly skilled staff. As Lockett remarked, "Can you imagine what it [reporting] is like for newcomers [small nonprofits that receive CDC grants for the first time]? It makes it so the grant process totally favors organizations where people have Ph.D.s and M.A.s. We are really returning to more of a medical model of HIV prevention, where the government prefers to fund bigger organizations like the Red Cross with more professional staff, not smaller nonprofits" (Interview, Dillard Smith and Lockett, 25 March 2008).

Consequently, these professionalization pressures often mean nonprofits like CAL-PEP and the SJI must balance a commitment to engaging their community broadly (including those who are less privileged and less educated) against pressures to formalize and entirely professionalize their opera-

tions. As Dr. Cohan explained, "All of this [data collection] puts nonprofits in a bind: they start as nonprofits because of their community commitment and they don't want to be a government bureaucracy, yet for them to survive they have to become more bureaucratic, gather numbers etc. . . . So the real dilemma is how to maintain the integrity as a community-based nonprofit, when the game is controlled by people who don't respect that work" (Interview, 8 July 2010). And at both organizations, staff members struggle to balance serving and engaging their community with completing their data-collection requirements, which often frustrates the staff. Ashly, a former program coordinator and peer counselor at the SJI, conceded here that "the SJI is the only place for sex workers, so they have to work hard to make sure they look good" in order to keep the SJI funded and open for service provision. However, she expressed frustration with the bureaucratic (data collection) aspect of this work, stating that in order for the SJI "to serve their population, they have to do the research to prove their needs to get money to do the work." This meant she spent a lot of time "counting and collecting arbitrary numbers for the San Francisco Public Health Department" when she could have "spent the time testing someone instead" (Interview, 31 January 2007). Similarly, at CAL-PEP, the staff members often questioned whether they are "serving people or collecting numbers" (Dillard Smith, Interview, 29 November 2006). One CAL-PEP staff member (Interview, 9 November 2006) described a testing day where the management hoped they would test a certain number of people, and when the staff tested far fewer, they were disappointed. However, the staff member stated that the testing and counseling, combined with all the required paperwork, took too much time, and so there was no way they could test the desired number of individuals, let alone empower or educate them about broader political issues and struggles relevant to them.[7]

The Possibilities for Engagement

For all of these challenges, the SJI and CAL-PEP indicate how nonprofits' community-engagement practices can empower members of marginalized communities served by social movement–borne nonprofits. And certainly the clients at CAL-PEP and the SJI are receptive to and inspired by their peers, like Naomi Akers. Akers began working in the sex industry at a young age, and she described to me how her experiences familiarized her with the violence, arrest, and health risks that many sex workers face. On her

own at age fourteen, she worked at a peep show in the Tenderloin to support herself until she was arrested for assault and placed in foster care until she was eighteen. She then relocated to Reno, Nevada, and "stayed with an aunt working different jobs—Wendy's, Motel 6, Eldorado Casino, weighing dirt samples at a mining company." Tired of the inconsistent hours and low pay in many of these jobs, she moved on to a strip club and then to the Nevada brothels, working at the Sagebrush, the Kit Kat Ranch, the Old Bridge Ranch, and the Mustang Ranch. Akers said she "liked the brothel work overall." In comparison to the street-based work she did later in Los Angeles, which she described as "crazy dangerous," she felt brothels were much safer and provided better working conditions. Although she did not like some aspects of them—"like how they would try to fine you if you missed a lineup"—she appreciated that "they [brothel staff] cleaned for you and a doctor came weekly and [I] was never assaulted or robbed."

She eventually left the brothels and ended up in San Francisco, where she was arrested and court-mandated to enter drug treatment at Walden House, a facility in the city. With nowhere else to go, she finished the program and was clean for seven years, working as a grocery clerk and going to school. She also started volunteering at PROMISE, a nonprofit focused on getting women to leave the sex industry. Staff there told her about the SJI, and lacking health insurance, she "came to the SJI all the time for medical care and peer counseling." By 2002, she was volunteering at the SJI, first doing intake, setting up the lobby and community room, and cleaning up. She then completed the HIV peer counselor training and also became an STI (sexually transmitted infection) counselor and risk assessor. She finished her M.A. degree in public health in 2007 and became the SJI's new executive director (Interview, 5 December 2006).

Stories like Akers's indicate that even when nonprofits struggle with socioeconomic distinctions between their staff and clients, the peer model of service provision does inspire even the most marginal community members to get involved. As Bethanne, a program coordinator at CAL-PEP stated, clients feel more hopeful when they see someone they "ran with back in the day get out of the life and give back to the community" (Interview, 1 November 2007). Such was the case with Shane, a small woman with long, dark hair and tired eyes who immigrated to the United States from El Salvador as a child. When I met Shane, she was at Walden House in San Francisco for drug and alcohol treatment. Her first experience with sex work was on the streets when she was eighteen and homeless. She exchanged sex with men for shelter and food when her boyfriend at the time, who was "twenty years her senior," bribed her to turn

tricks to make money for him. When he learned that her visa had expired, he "threatened that he would go to immigration and that they would deport me." After a year, she found a social-services agency in the city "and told a counselor about her problems and the boyfriend's threats." They helped her get a restraining order and wanted to arrest him, but he disappeared. Shane heard about the SJI through a counselor at Walden House, and, when I spoke to her, she had been using the clinic for three months for clinical services, acupuncture, massage, a Thursday support group, and food. For her, "It helps [at the SJI] that others there are in the sex industry because there is a big difference between people who've gone through similar things as I have and those who haven't. Not everyone can understand everything." Because of this experience, she told me she "is interested in getting involved at the clinic and will do anything and likes to help people in any way" she can (Interview, 14 November 2006).

For an individual in Shane's position, organizations like the SJI and CAL-PEP provide many opportunities for involvement. As Alexandra explained, sex workers may use the SJI "as a way to get something (legal) on their resumes and gain other job skills." She added that gaining such credentials is useful for sex workers who want to transition to other employment, as many are doing something that is illegal or that carries a stigma, which makes them reluctant to disclose their sex work (and any skills they gained from it) to a potential employer (Interview, 18 July 2006). And so through CAL-PEP and the SJI, sex workers may develop a variety of health care, administrative, and interpersonal skills.

But, as Gina, Don, Leann, and Grant's stories below also indicate, social movement–borne nonprofits may offer their constituents much more than job skills. Since individuals like Gina, Don, Leann, and Grant have been sex workers or have criminal histories, mainstream health agencies would not traditionally trust them to conduct health-care work. Therefore, by hiring and training them to gain professional skills and to conduct sensitive, highly complex medical-service delivery with marginalized populations, CAL-PEP and the SJI make an oppositional political statement. Specifically, they challenge the idea that sex workers cannot be credible health-care providers with a stake in the broader community and political life.

GINA

I met Gina, an African American woman in her thirties, at a coffee shop on Market Street in San Francisco. Originally from the Midwest, Gina has a college degree and was an avid burlesque performer who also worked as an escort and ran a phone-sex business. After selling this business, she moved to

Sacramento in the mid-1990s and became ill. Although she had private health insurance and was up-front with her doctor about her sex work, she found him dismissive because he assumed her illness was the result of a sexually transmitted infection (which was not the case). Through friends, she heard about the SJI and went there, and within twenty-four hours was diagnosed properly. She returned to Sacramento and "told my friends about the place and how impressed I was and that I wanted to move here to San Francisco and volunteer with them. I was blown away by the comprehensive care and went there for it, although I had private insurance" (Interview, 17 October 2006).

Upon moving to San Francisco, Gina began volunteering at the SJI and trained as a harm-reduction counselor. She ran the Positive SHE program for women and transgender persons newly diagnosed with HIV/AIDS, and she facilitated various other groups at the infirmary. As she described it, "Most sex workers come into the infirmary without any health skills to work in a hospital, and it was through the infirmary that I got such training." To illustrate these skills and how effective this seemingly radical model of peer-based health-service delivery is, she told me about when she counseled a male client of a sex worker (or "john"). He came to her and told her "he had barebacked [not used a condom] with a hooker and was worried and wanted information." As opposed to chastising him for his actions, she instead focused on his concerns and gave him statistics and information about HIV/AIDS prevention; she offered him some tests, and "he walked away happy, and I walked away feeling like I helped someone." Reflecting on her experience, Gina added, "It was through the [St. James] infirmary that I got such [health] training. I believe the founders [of the SJI] thought providing such training to sex workers would be a good way to show sex workers had brains and also have the skills to help other sex workers" (Interview, 17 October 2006).

DON

Across the bay one afternoon in July 2010, I visited CAL-PEP's mobile van (Figure 5), which was parked near Frank Ogawa Plaza in downtown Oakland. Here I met Don, a short, muscular Latino man covered in tattoos, who was conducting tests for CAL-PEP that day. Although he had never been a sex worker, Don was involved with gangs in Southern California and had been in and out of prison since he was nineteen. Hard working and extremely efficient, Don told me he had also been a heroin addict and had gone to prison for a number of crimes ranging from heroin trafficking to theft. When he was released the last time, he discovered that his niece had contracted

Figure 5. CAL-PEP's mobile testing van. Photo by author (2010).

HIV from intravenous drug use, which was "his wake-up call to get clean and do something to help prevent HIV transmission." One day in 2005, the CAL-PEP van was testing in his neighborhood "with a barbecue and everything." He needed employment and was concerned about HIV, so he went up to one of the staff mentors and "asked what they were doing and if they were hiring." Although Don had some employable skills (he completed machining and plumbing programs in prison), with his criminal record, he was not eligible for many jobs. CAL-PEP provided a way for him to attain skills and employment. Don became a certified HIV tester and counselor, and when I met him, he had already worked with CAL-PEP for five years, driving the mobile van and conducting HIV testing and counseling on a full-time basis (Interview, 29 July 2010).

While Don was busy testing people, I spoke with Bill, a tall African American male with a big smile and easy manner who supervises testing for CAL-PEP. Bill explained to me the extensive communication, organization, and administrative skills Don needed to complete CAL-PEP's testing process. Don first had to ask each individual he tested if he or she had ever an HIV test (and if so, what was the last result). He then would explain the test (Ora-Quick, which swabs the inside of the mouth) and its accuracy (99 percent).

Next, he would have the individual sign both a consent form confirming his or her permission to test and a voucher form if CAL-PEP offered an incentive for the test. Don would then swab the inside of the individual's mouth and tell him or her to return twenty minutes later for the result. If the test were positive, Don would explain what the result meant and take another confirmatory test (which he would send to the ACPHD for analysis). He would then schedule a follow-up appointment with a CAL-PEP staff member to confirm this result. He would also make sure he connected the individual to a clinic. In addition to all of this highly sensitive and potentially stressful work, Don would have to complete two data-collection forms: one for the CDC, which Bill described as "short and easy," and another one for Alameda County, which is longer and more in-depth.

Without a doubt, HIV testing is highly sensitive and potentially stressful work, especially in the high-risk communities where CAL-PEP operates. And certainly, the credentials and data-collection skills Don attained through the various training programs noted earlier enabled him to follow the protocols and complete this work efficiently and effectively. However, an individual like Don is not "just" conducting HIV tests: he is engaging with members of the community, offering them information, and connecting them to other services. All of these tasks require and translate to the communication, organizational, and administrative skills that civic-engagement scholars find people develop in more traditional civic organizations. In our casual conversation, Don did not mention to me that he engaged in other civic or political activities (outside of CAL-PEP), but it was clear that his testing work constituted an important form of civic engagement. His story also indicates that by engaging members of marginalized communities as service providers to their peers, nonprofit organizations like CAL-PEP (and the SJI) are continuing their political work. By hiring individuals like Don to do sensitive, skilled health-care work, they illustrate that sex workers and other marginalized people may be engaged in their own communities and responsible for their own health and safety and that of others.

LEANN

The civic skills that nonprofit constituents develop as peer health-service providers may also foster their broader civic and democratic engagement, especially when civic engagement is part of the job. I witnessed this firsthand with Leann, one of CAL-PEP's case managers and peer counselors. A middle-aged, African American woman, Leann described herself as "from the streets and having some of the experiences and risks as her clients had" (she did not elabo-

rate these further). One evening I joined Leann and Lanie (a single mother of two who also works as a peer counselor at CAL-PEP) for a trip to Leann's daughter's house for a CAL-PEP "house party." Modeled on CAL-PEP's gatherings in hotel rooms for sex workers during their early days with Project AWARE, house parties gather a group of individuals from the neighborhood to eat pizza, drink soda, and learn about HIV/AIDS prevention. Lanie and Leann told me that they found house parties effective because they are "casual and people could easily talk and make jokes." I asked if anyone at this evening's house party were sex workers, and Lanie said "some might have exchanged sex for something, but they would probably not identify as such."

When we arrived two African American men and three African American women in their mid-twenties, along with Leann's daughter and three grandchildren, were gathered for the party. A delivery man brought food that we set out on the dining-room table, and as everyone settled in, the children crawled around and one sat next to me to color with some pens I gave her. As Leann, clad in running shoes and jeans, began the party, it was immediately clear that she needed—and had—a number of civic skills to run such an event. Immediately—and effortlessly—Leann took control of the room and began the party with a discussion, where everyone stated their names and one thing they knew about HIV (everyone knew something). She then administered a quiz containing multiple-choice questions about condom use, sexually transmitted infections, and HIV. Leann then asked the group to name any other sexually transmitted infections they knew, and some people at the party shared personal experiences. One young woman told the groups about her uncle "who never went to the doctor" and discovered when he finally did go that "he had full-blown AIDS." In an engaging and accessible manner, Leann effortlessly used this story to transition into a discussion about the science of HIV. "It infects your body like soldiers, and your blood cells lose a fight with it over time," she said. And in deference to the community gathered, she added, "African Americans are not likely to go to the doctor and then won't find out [that they have HIV]".

Leann continued to masterfully facilitate a discussion about HIV/AIDS testing and prevention, passing around graphic pictures of how sexually transmitted infections affect the body, demonstrating how to put a condom on, and breaking down barriers and fears about testing by sharing a story about a sex worker she encountered during her street-outreach work who tested positive for AIDS. When one of the house-party guests asked, "Do you contact the CDC if you get a person like that?" Leann explained that CAL-PEP reports the test

to Alameda County, which reports the data to the CDC. I asked what would happen to someone who got a positive result but did not have health insurance, and Leann said it would not matter because that person would be referred to charitable services, like the Magic Johnson Foundation.

Leann's facilitation skills and the participants' comfort in the house-party setting turned a potentially tedious and fear-inducing discussion into a community-building, empowering experience. Through her training in HIV/AIDS prevention, counseling, and testing, Leann clearly employed a well-honed variety of civic skills, most notably meeting organization and facilitation. She also used the house party to raise awareness about the prevalence of the HIV/AIDS epidemic and its impact on the African American community. She noted (much to the group's surprise) that "lots of schools would not let CAL-PEP in to do talks and that a lot of parents thought it was absurd to bring condoms in to elementary schools." In response, everyone at the house party exclaimed that CAL-PEP should conduct sex education in elementary schools. Leann proceeded to discuss the 1998 State of Emergency that Alameda County declared regarding HIV/AIDS in the African American community, stating "Oakland is the neon light for infection in Alameda County." She added that African Americans are "12 percent of the California population, but 53 percent of them are in jail." In a tone suggesting resignation, a participant called out, "That's half our population." Leann also addressed the issue of condom distribution in jails, sparking a lively discussion among the partygoers that condoms should be there because "all the same stuff that happens on the outside happens in prison" and "it's a good idea to put condom machines in jails." Leann added that jails do not want to test people for HIV because then they would be responsible for their care. As the party came to a close, everyone applauded Leann's work. Before we left, there was a raffle (with a $50 cash prize), and then Leann and Lanie handed out the safe-sex kits, complete with male and female condoms, and information about HIV/AIDS. We left the group as they enjoyed the pizza, chicken, and sodas that CAL-PEP provided.

As I thought about the house party on my way home, it was clear that the participants (and I) learned a lot about HIV/AIDS prevention, largely because of the wide range of civic skills Leann had developed and deployed to run this party. However, I also wondered whether she would ever put these skills to use outside of her HIV/AIDS prevention work. I asked Leann about this, and she told me that she was "never political before CAL-PEP, though I had always voted." Since joining the organization, however, she has participated in the AIDS Lobby Day in Sacramento, where she deployed her communication skills dur-

ing her visit to a state congressman's office. She was upset that "they [the state government] were cutting [HIV] prevention money and wanted to spend it on treatment instead," and she told the congressman she met with that she believed this was "backwards" because prevention is less costly in the long run than treatment. She told me that "at first I thought I would not be heard, but you never know the outcome if you don't try." Although she much prefers "being on the ground [delivering services]," she found the experience in Sacramento inspiring. For her, it was "very touching to see people infected with HIV demand funding so they could get treatment" (Interview, 21 July 2010).

GRANT

Both CAL-PEP and the SJI illustrate that by incorporating opportunities for skills development into their operations and methods of service provision, social movement–borne nonprofits may create the conditions (and provide the skills) that connect their staff and clients to broader political-institutional structures. In fact, the majority of the staff and clients I interviewed at CAL-PEP and the SJI stated that they have drawn on the self-efficacy developed here to also become more active in some way in the formal political arena. Grant, a former CAL-PEP outreach worker, demonstrated this link between nonprofits, civic-skills development, and political engagement. In many ways, Grant characterized the least likely citizen to engage in political life. Before working for CAL-PEP, Grant, an African American male, sold drugs and said he had "one foot in the grave and one foot in the pen [prison]."

He had seen CAL-PEP in his neighborhood over the years handing out condoms, but his attitude toward them was "okay, I'll take the condoms and move on because you're interfering with my [drug] business." He also "had a negative image of working with people who were gay and/or had HIV." However, Grant's attitude changed after spending time in prison on charges for drug and gun sales and possession, which made it difficult for him to find work. He wanted to change his life and "give back to the community I had affected through drug dealing." And so he applied to work at CAL-PEP when they were doing outreach in his neighborhood, and he was hired as an outreach worker. After six months he was state certified as an HIV-testing counselor.

I spent time with Grant during an outing with CAL-PEP's mobile van one morning in November 2006, and as we walked around the neighborhood, it was clear to me that Grant had come a long way from his days selling drugs. He told me that he worked for CAL-PEP during the day, and at night he stocked shelves at a local discount store. He also told me about his daugh-

ter, who was an A student in a number of enrichment programs at her school, which he hoped would help her get into a good college one day.

Through his work distributing condoms, Grant used his communication and organizational skills, engaging easily in conversations with the many homeless and marginally housed individuals who congregated in the area. He also made sure they all had HIV/AIDS prevention brochures. As Grant explained to me, good communication was very important for his work because so many of the people CAL-PEP serves do not have a lot of education and information about HIV. He said, "The biggest challenge is conspiracy theories. People think that 'y'all [CAL-PEP] are out here giving people HIV with these tests because the government wants to kill off blacks and the poor.'" To correct these misconceptions, Grant told me, he asks them "how that theory would benefit them if it were true" and he "tells them about Gloria [Lockett]'s past [as a prostitute]." He also encourages those he encounters through outreach to learn more about the issues facing their communities by "read[ing] the paper and watch[ing] the news because laws are being passed [such as antiloitering bylaws] that they don't know about, and then they wonder why they're in jail."

For Grant, the communication skills he has honed through CAL-PEP have also served him well in the broader political arena. Like Leann, Grant also participated in the AIDS Lobby Day in Sacramento, where nonprofits and other service providers are invited to inform lawmakers about their work and advocate for funding. As Grant said to me, "I am proof that you can change your life," and with CAL-PEP he wanted to give back to the community that he had affected by his drug dealing. Grant described how he wore his "street" clothes—baggy jeans, a sweatshirt, and a cap—to speak to the State Congress at AIDS Lobby Day and show he was an advocate for HIV funding, as the "voice from the street." He said that despite his appearance, his presentation showed the legislature that "he had the language to state what his community wants and needs to be safe." Grant described CAL-PEP as his "bullhorn" that gave him the skills and the chance to "go out and speak and wake up the community and the world" (Interview, 1 February 2007).

Negotiating the Challenges of Community Engagement Through Peer Service Provision

As the stories of Gina, Don, Leann, and Grant indicate, the peer model of service provision provides an effective way for social movement–borne (and

other) nonprofits to engage and empower their community in civic and political life. But peer service delivery is not flawless, and these organizations must constantly balance their desire to hire community members and empower them with the many challenges such activities will bring. For organizations serving sex workers, they must contend with the fact that some sex workers understand "work" in a way that may not align with the more professionalized nonprofit environment. As Lockett explained to me, "For many people at CAL-PEP, this job is their first regular job, and they don't get the work ethic [to be on time, etc.]" (Interview, 18 July 2010). Johanna Breyer echoed this sentiment, explaining that, like CAL-PEP, the SJI draws from a community of workers that often has no traditional, or "straight," work experience, and so "sometimes just telling someone they have to be there at a certain time on a certain schedule is hard because their sex-work hours are often unpredictable" (Interview, 23 October 2006). Dr. Cohan, the former medical director, added that it has always been a struggle for the clinic to ensure their staff turns up on time to offer services (Interview, 19 December 2006). To mitigate against this, but also to educate and train their workers with skills that may transfer elsewhere, the SJI has published an *Employee Handbook* that explains in detail such topics as "Administrative Procedures" (emphasizing, among other things, the importance of staff-meeting attendance) and "Office Policies and Procedures" (which reinforces, on page 11, that employees may take a one-hour break for lunch on shifts of eight hours or more and that "consistent tardiness or other unscheduled absence during the workday without good reason, or without notice will result in disciplinary action") (SJI 2009a).

Many peer staff members at CAL-PEP and the SJI have also struggled with substance abuse, which can make community engagement more difficult. Johanna Breyer explained to me that since the SJI is a harm-reduction organization, "they have sometimes had to deal with people working while using [substances]" (Interview, 23 October 2006). Similarly at CAL-PEP, as Dillard Smith noted (Interview, 3 November 2006), since some of their peer staff members are former substance users, returning to their communities during outreach puts them in contact with substances again, and sometimes they relapse.

I witnessed the impact of such challenges firsthand when I returned to CAL-PEP in 2010. When Gloria and I were talking one day, I asked her where Grant (described previously) was and she sighed sadly. Despite his success as an outreach worker and political advocate, he struggled to stay sober and

eventually relapsed. Although he had access to treatment through CAL-PEP's health-insurance plan, he was not able to maintain sobriety, and they had to let him go. I discussed this issue of substance use for peer service providers further with Tammy, an energetic middle-aged African American woman who worked at CAL-PEP. She struggled previously with a crack-cocaine addiction and was hospitalized for pneumonia; while she was recovering, she learned that a close friend was diagnosed with HIV. Tammy worried that she was at risk for contracting HIV as well, and so she decided to take the test; the results came back negative. But while she was waiting for the results, she prayed and "told God [if she was negative] she would go to the field and tell her story." When she recovered, a friend told her about CAL-PEP, and Tammy worked there for a number of years in outreach and HIV testing and counseling before leaving to complete a college degree. As she reflected on her work, Tammy told me that the main advantage organizations like CAL-PEP have is that "they have an understanding of peoples' needs . . . because the community they serve is the community they also hire from." But, she added, "There are also some problems with hiring from the community, especially for ex-users who need time under their belt because it is tempting for them to use again when they go back into the community" (Interview, 29 November 2006).

In light of this problem, CAL-PEP and the SJI eventually had to institute policies to help them retain employees who can work consistently with the organization, such as hiring people who had demonstrated two years of sobriety. CAL-PEP now has a staff support policy that requires staff who relapse to do counseling through the organization's medical plan and then remain consistently clean; if they fail, they are let go. And Breyer explained (Interview, 23 October 2006) that the SJI also has a sobriety policy that states a person cannot work at the clinic if they have used a substance within a certain number of hours before work. There is evidence that these policies are effective. CAL-PEP, as the older organization, has had many staff members stay for up to fifteen years—a great feat considering the high turnover and low retention rates in the nonprofit sector (Peters et al. 2002). However, CAL-PEP has also seen many come and go, including those who gained skills that, one may assume, would help them lead safer and more productive lives. Breyer told me how at the SJI it has also been hard to keep a core group working and volunteering "because people need money, and often if more lucrative opportunities come around, people will take them" (Interview, 23 October 2008).

Conclusion

While mainstream institutions have long focused on suppressing and eliminating prostitution, CAL-PEP and the SJI were founded to support sex work as a legitimate occupational choice. Today, CAL-PEP and the SJI are professionally run organizations; they collect extensive amounts of data to remain accountable to their funders, and they require their staff to complete varied extensive training sessions. But all of this does not indicate sex workers' cooptation as mere subcontractors for the state. Instead, CAL-PEP and the SJI maintain their commitment to resisting sex workers' marginalization and stigmatization in society through the practice of community engagement, where they have implemented peer-hiring practices that directly challenge the long-institutionalized notion that sex workers are irresponsible regarding their own health and that of the larger community. And as the stories of Gina, Don, Leann, and Grant indicate, the activities of CAL-PEP and the SJI have also provided sex workers and others with a variety of civic skills that they may (and do) transfer to broader community and political life.

Although community engagement through peer hiring is not flawless and poses many operational challenges to these organizations, the benefits outweigh the disadvantages: CAL-PEP and the SJI are more able to provide sex workers (and other marginalized individuals) with essential health services and civic skills. But since there is no guarantee that all peer staff at these organizations will engage in civic activities—particularly in the service of the sex-worker rights movement—the next chapter considers how these organizations negotiate the constraints of nonprofit status and data collection to promote the rights of sex workers in the broader public and political sphere.

Claims-Making Activities

CAL-PEP and the SJI provide spaces for one of the most marginalized communities in the United States to gather, receive, and deliver services, and develop civic and political skills. In so doing, they maintain the resistance of the prostitutes' rights movement by recognizing and treating sex workers as *workers*. But how does all of this affect the laws, policies, and public discourses that define the conditions that sex workers live and work under? Numerous studies suggest that decriminalizing prostitution will lead to better health and safety outcomes for this population by, for example, making it easier for them to call the police if they experience violence at the hands of clients (Alexander 1995a, 1998; Cohen and Alexander 1995; Cohan et al., 2006; Lutnick and Cohan 2009; Scoular 2010; Sullivan 2010). And when they operated apart from government, CAL-PEP and the SJI's founders were able to challenge laws and policies that marginalized their community by focusing their efforts on decriminalizing prostitution.

But today, although CAL-PEP and the SJI reflect and implement these early political commitments and have the affected population (sex workers) gathered inside their doors, they are first and foremost service organizations. As such, like many social movement–borne nonprofits, they are enmeshed within an institutional nexus where nonprofit law and funding agreements shape how they govern themselves and act. However, recalling the central insight of neoinstitutional theory—that individuals also interact with and shape institutions, including those of their own creation—we see that they are not precluded from advocating for broader legal and policy changes. As Kristen Gronbjerg and Steven R. Smith (2006) theorize, there is frequently a mutual synergy between government and nonprofits, and a closer examination of this relationship reveals that social movement–borne nonprofits often do continue their political commitments and influence policy in a myriad of ways.

Drawing on CAL-PEP and the SJI's experiences, this chapter therefore explores how these nonprofits may do this through "claims-making" activities, whereby they negotiate the constraints that nonprofit tax status and funding agreements impose on them to challenge government policy and the socio-moral order it reflects in a variety of state- and nonstate-directed ways. The first way is through *knowledge production,* where they conduct, publish, and disseminate nonpartisan-issue research and analysis to inform the public and policy makers about their constituents' needs. And the second is through *policy advocacy* activities permitted by nonprofit law, which I identify as individual actions, permitted lobbying, public awareness, and international (health) advocacy. These claims-making activities constitute acts of resistance against societal and governmental institutional practices toward sex workers and thus the broader moral-legal regime that regulates prostitution today.

Knowledge Production

Social movements representing stigmatized and marginalized groups often engage in struggles for meaning, to redefine for the public how their community is perceived or "socially constructed" (Cohen 1985; Gamson 1995; Gamson and Meyer 1996; Schneider 1985). Working within this frame, Valerie Jenness documented how the early protests of the prostitutes' rights movement sought to socially (re)construct public understandings of prostitution by discussing openly how this and other forms of sex work were similar to many other service professions. The sex workers involved with COYOTE drew on their experiences to show that laws criminalizing prostitution did not help sex workers stay safe and healthy, let alone make a transition to other work (Jenness 1990, 1993). Yet despite these efforts, COYOTE's successors still operate within a broader-issue context that is largely hostile to noncriminalizing approaches to prostitution, and so to eventually change laws, they must continue their efforts to reconstruct sex workers in a more agentic light. Although such organizations as the Sex Workers Outreach Project continue this project at times through protests and public demonstrations, CAL-PEP and the SJI take a different path. As COYOTE founder Margo St. James declared, "Basically, the way now for prostitutes to get respect is to have a clinic and publish research and information out of it" (Interview, 25 October 2006). And CAL-PEP and the SJI are certainly following this advice, illustrating how nonprofits may promote broader social

(and by extension, legal and policy) change by producing research to influence and inform the public and policy makers.

Sex Workers and the Politics of Knowledge Production

To date, the bulk of knowledge produced about sex work has focused largely on its negative aspects. As Ine Vanwesenbeck documents, the first studies of prostitution focused largely on "the problem of prostitution," examining biological and pathological explanations for the presumed "evil characteristics" and "sick personalities" of women in prostitution within the psychoanalytic tradition of the twentieth century. From the 1970s onward, research continued on this trajectory, but it focused on revealing associations between participation in prostitution and sexual trauma and psychological or psychiatric disorders. In the 1980s, reflecting COYOTE's influence, research emerged that focused on identifying occupational hazards in prostitution, but this material was often related to prostitutes' role in HIV/AIDS transmission and infection. Research in the 1990s continued this trend, but it also focused on sex workers' occupational health and safety issues more broadly, such as working routines, stresses, and risks other than HIV (Vanwesenbeck, 2001).

Today, however, Ronald Weitzer has documented extensively that a large body of research has emerged that reflects and employs the "oppression paradigm." Employed most often by researchers who adopt the abolitionist position toward prostitution, this analytic frame understands prostitution as an inherently violent and exploitative activity. Media reporting on the sex industry is particularly prone to publishing this research, and government officials in the United States, Europe, and elsewhere are also prone to articulating it (Weitzer 2010b). Melissa Farley, a clinical psychologist who founded the nonprofit Prostitution Research and Education, is one of the most notable and cited researchers working within the oppression paradigm. According to her Prostitution Research and Education website, her organization's "goal is to abolish the institution of prostitution while at the same time advocating for alternatives to trafficking and prostitution" (Farley 2010). Formally affiliated with the Pacific Graduate School in Psychology in Palo Alto, California, Prostitution Research and Education has received generous government funding for its work and is cited by many government agencies (Weitzer 2010c). Farley and her colleagues who share her perspective have also published their work about the harms of prostitution (which they equate with human trafficking) extensively in peer-

reviewed, self-published, and media sources (for some examples, see Farley 2005, 2007; Farley et al. 2003; Farley and Kelly 2000).

Taken at face value, Farley and colleagues' research findings are truly shocking. For example, the study "Prostitution and Trafficking in Nine Countries: An Update on Violence and Post-Traumatic Stress Disorder" (2003) involved data from 854 interviews with people "currently or recently in prostitution in nine countries" as diverse as Canada, Colombia, Germany, and Turkey. The study concluded that given the high rates of assault, psychological violence, and other harms these individuals experienced, prostitution was "multi-traumatic" (Farley et al. 2003: 33–34). It therefore is not surprising that Farley and colleagues are highly critical of nations that have decriminalized sex work, even though evidence exists in such regions as Nevada and New Zealand that legalization may in fact increase workers' safety (Hausbeck and Brents 2000, 2005; Hausbeck, Brents, and Jackson 2007; Plumridge and Abel 2001; Scoular 2010). Oppression-oriented research thus presents (an arguably powerful) counterpoint to the central message of the prostitutes' rights movement that prostitution can be meaningful work under the right social and legal conditions. And since these studies align with popular understandings of prostitution as an illegitimate employment option, they receive favorable hearings in government circles and are often cited by the mainstream media, most notably by the *New York Times* columnist Nicholas Kristof (Weitzer 2010a, 2010b).

No scholar or sex-worker rights activist will deny that sex work is potentially violent and dangerous, but many sex workers and academics have criticized these studies on methodological and perspectival grounds. Scholars and activists charge that researchers like Farley often fail to employ precise terminology and rigorous methods of scientific inquiry, such as unbiased subject recruitment and interview methods (Pinto 2011; Shaver 2005; Weitzer 2005, 2010b).[1] For example, Farley and colleagues' 2003 study, noted above, only interviewed women from locations where respondents are likely to report negative prostitution experiences: for example, a hundred women from Vancouver's notoriously dangerous downtown East Side and fifty-four women in Germany from a shelter for drug-addicted women (Farley et al. 2003: 37–38). Moreover, these studies often do not provide comparative data, leading many sex workers and academics to criticize them for failing to acknowledge or account for those who speak positively about their prostitution experiences or favor noncriminalizing approaches to prostitution, or both (Kessler 2002; Jeffreys 2005). For example, Melissa Farley stated, "I knew they would minimize how bad it was" when pre-

senting evidence that brothel-based sex workers stated their working condi-
tions were not oppressive (Farley 2007: 22). And when she encountered sex
workers who stated they would prefer the legalization or decriminalization of
prostitution, Farley concluded that they were deceived and could not form this
opinion on their own (Farley 2005; Weitzer 2010b).

For sex-worker rights advocates, oppression-oriented prostitution re-
search is problematic because it denies sex workers' agency and has con-
tributed to public policies that focus on eliminating prostitution as op-
posed to protecting and providing alternatives to workers (Weitzer 2010b).
Therefore, sex workers have begun to produce their own research. But not
surprisingly, sex-worker rights activists were initially (and understandably)
skeptical about participating in research projects, especially in the context
of HIV/AIDS. As Dennis Altman (1993) writes, the dark side to viewing
certain communities as particularly vulnerable to or at risk for HIV is that it
creates new communities and methods to bring them under surveillance of
the state. And certainly, he argues further, AIDS and AIDS research became
the new alibi for governments wanting to crack down on homosexuality,
drugs, and prostitution. Moreover, research often left the community stud-
ied with very little in the way of resources, skills, or materials that they
could use for their own projects. As Lockett explained, at CAL-PEP's incep-
tion, research was a "real nasty word" to her because she disliked how top-
down it appeared when (predominantly white) researchers "came to com-
munities of color, got their material, and then basically left the population
studied with nothing" (Interview, 18 July 2007).

Yet Lockett's (and other sex workers') reluctance to engage in research
changed when they saw how reciprocal the research process could be
through Project AWARE, discussed in Chapter 1. As Dr. Judith Cohen, who
ran Project AWARE, explained to me, "Prostitutes get blamed for every-
thing, and we did not buy that they were the cause of HIV. The opportuni-
ties were that money was available because the CDC got interested in wom-
en with AIDS (which they weren't before). We decided to go for the money
on our terms. All the CDC wanted was tubes of blood, and we wanted peer-
driven support services. So we would give the blood if we could design the
services needed" (Interview, 8 July 2010). But Project AWARE did more
than exchange "blood for services." It also fundamentally challenged the
tendency to exclude sex workers from the research process and to conceive
of them monolithically, as an exploited and victimized community. Proj-
ect AWARE included sex workers in the design and implementation of the

program, and it challenged the then conventional wisdom that they were "vectors of disease." In fact, their findings showed that sex workers were not major sources of disease transmission to the general population and that they took measures to protect themselves and their clients from HIV/AIDS (Darrow 1990).

CAL-PEP, the SJI, and Inclusive Research

Since Project AWARE, CAL-PEP and the SJI continue demonstrating how social movement–borne nonprofits may use the process of knowledge production to continue their oppositional goals and challenge mainstream conceptions of their community. Following Project AWARE in 1991, a doctor with the Alameda County Public Health Department approached CAL-PEP to apply for funds from the CDC to promote HIV prevention among women and infants through the Women and Infants Demonstration Project. This project ran from 1991 to 1995 and aimed to decrease pregnancy and increase condom use among women and their partners considered at high risk for HIV—namely, women aged fifteen to thirty-four who were sexually active, used crack cocaine, and exchanged sex for cash, drugs, or other trade and who were likely to have unprotected sex with multiple partners.

Lockett and CAL-PEP used the Demonstration Project to promote their political goals; they used its data-collection practices and program development and delivery methods to promote nonjudgmental, sex worker–positive approaches to the community's health and safety. The project involved CAL-PEP's staff (many of whom had histories of sex work and drug use themselves) in all aspects of the project's design and implementation, for everything from subject recruitment to peer counseling and service delivery. And the results, which were published in *AIDS Education and Prevention* (Terry et al. 1999), were even more remarkable for challenging status quo understandings of prostitution policy. The study found that noncriminalizing approaches to prostitution were particularly valuable for promoting sex workers' health and safety. By involving prostitutes in the implementation and diffusion of the project, prostitutes' stigma in the community was minimized, and they gained more knowledge about and confidence to adopt safer sex practices. Since publishing this study, CAL-PEP has bolstered its expert status in the HIV/AIDS prevention field by publishing research extensively in a range of peer-reviewed journals and edited volumes (for examples, see the following:

Bowser, Whittle, and Rosenbloom 2001; Bowser, Word, Lockett, and Dillard Smith 2001; Dorfman 1992; Dorfman et al. 1988; Lockett 2004; Oliva et al. 2005; Terry et al. 1999).

The SJI has followed CAL-PEP's example, using the process of knowledge production to challenge the utility of current (criminalizing) policy approaches to prostitution through the Sex Work Environmental Assessment Team (SWEAT) study. SWEAT, which began in 2003, was led by Dr. Cohan, at that time the SJI's medical director, and was a community-based research partnership between the Department of Obstetrics, Gynecology, and Reproductive Sciences at the University of California, San Francisco; the San Francisco Department of Public Health; and the SJI. The study examined three different areas that concerned the sex-worker community: "the individual-level psychological risk factors associated with the prevalence of HIV, sexually transmitted infections, and viral hepatitis among female sex workers in San Francisco; social capital among sub-populations of female sex workers in San Francisco; and whether diminished social capital is associated with an increased prevalence of HIV, sexually transmitted infections, and viral hepatitis" (Lutnick 2011: 6). To study these issues, SWEAT focused on sex workers (783 in total) of all genders.

What was particularly remarkable about the study, however, was that it involved the sex-worker community in nearly every step of the process. Sex workers were engaged in the "study design, serving as community advisory board members, data collection and analysis, and manuscript preparation" (Lutnick and Cohan 2009: 39). Because of the study design, subject recruitment did not occur solely in locations where sex workers were more (or less) likely to have negative experiences. Instead, women were recruited through word of mouth and community-based organizations serving sex workers.

Because SWEAT was driven by the needs of the community (as opposed to a particular analytic paradigm or understanding of prostitution), it was able to respond to issues that affected sex workers' current living and working conditions. As Alexandra Lutnick writes, when SWEAT began in 2004, Measure Q was on the ballot in Berkeley, California:

> If passed, Measure Q would have made enforcement of prostitution laws the lowest priority and required the Berkeley Police Department to provide semi-annual reporting about their prostitution-related enforcement activities. Despite a long history of prostitution policy reform efforts in the San Francisco Bay Area . . . there had been no studies conducted in California that examined sex workers' attitudes

about the various legal approaches to sex work. While a diverse group of constituents have supported attempts to decriminalize prostitution, others have criticized them for excluding the input of more marginalized sex workers. (2011: 6)

Since Measure Q would have had a major impact on sex workers' capacity to do business, the SWEAT research staff thought "it would be beneficial if the SWEAT study was also able to assess the participants' perspectives on the legal frameworks (criminalization, decriminalization, and legalization) that can be applied to sex work to ensure that a diverse group of female sex workers' opinions were represented, and that sex workers had the opportunity to speak for themselves" (Lutnick 2011: 7). Therefore, the SWEAT team added an additional goal to the SWEAT study: qualitatively assessing the preferred type of legal framework among their diverse sample of women, which for this portion included forty predominantly African American and Caucasian women with a median age of forty-one, who engaged in a range of sex work, from in call and out call (fifteen women) to street work (thirteen women).

The findings from this segment of the SWEAT study were published in the journal *Reproductive Health Matters* (Lutnick and Cohan 2009), and in many ways they challenged the abolitionist-oriented perspective about sex workers' legal and health and safety needs. Although 79 percent of interviewees experienced physical assault, and 72 percent experienced sexual assault during sex work, "the majority of the participants expressed support for certain tenets of the decriminalization model" (42). Specifically, female sex workers "prefer removing statutes that criminalize sex work in order to facilitate a social and political environment where they had legal rights and could seek help when they were victims of violence" (38). The study showed here that 71 percent agreed or strongly agreed that the courts should overturn laws that make sex work illegal, and a large portion felt they should be able to trade sex without penalty in massage parlors (68 percent), on the streets (77 percent), and in escort agencies and brothels (87 percent) (43). Most notably, "Ninety one percent wanted laws that protected the rights of sex workers" (44), revealing that female sex workers "prefer removing statutes that criminalize sex work in order to facilitate a social and political environment where they had legal rights and could seek help when they were victims of violence" (38).

In reviewing this research, one may criticize the SJI (and CAL-PEP, by extension) for producing knowledge biased in favor of the prostitutes' rights

movement (in the same way that one may criticize Prostitution Research and Education's research for simply reflecting and promoting an antiprostitution bias). However, the SJI's research and the knowledge it produces about sex workers is different in one key regard: it acknowledges a variety of sex-work experiences, and it does not discount sex workers who may disagree with the prostitutes' rights movement. Moreover, the data analysis did not deny the fact that for many sex workers, violence is part of their work experience. But unlike oppression-oriented research, the SWEAT study did not dismiss sex workers' negative and positive opinions about different legal regimes.

In so doing, the SJI indicates how nonprofits may use knowledge production to continue their social-movement goals, in this case by finding and publishing data that shows sex workers are not simply victims of exploitation but workers with diverse experiences and opinions. According to Lutnick (Interview, 18 July 2006), they published this (and other) material and made it available through conference presentations (see for some other examples, Cohan et al. 2006). Lutnick added that other individuals and groups could use this information to make their own political arguments in support of decriminalizing prostitution. Although Measure Q did not pass (with only 37 percent support), Proposition K, a similar ballot measure in San Francisco in 2009, received 42 percent of the vote. It is conceivable that this SWEAT study may inform and support subsequent arguments for decriminalization if and when another similar ballot measure is introduced.

The Limits of Knowledge Production

Although CAL-PEP's and the SJI's research acknowledges nonvictimizing experiences and explores support for noncriminalizing policy approaches to prostitution, it is produced in a broader political-institutional environment that largely resists this perspective. CAL-PEP's experience with their (now defunct) Day Treatment Program illustrates this dilemma. CAL-PEP developed this program to serve the most inaccessible and least likely of its clients to seek and receive treatment: African American or other women of color who actively used drugs and often traded sex for drugs and other resources to support themselves (Bowser et al. 2008). CAL-PEP knew from experience that abstinence-based drug treatment was either unavailable to these women or something they felt they could not do because of child-care

concerns, affordability, or other reasons (Bowser et al. 2008). So CAL-PEP decided to create a program to provide a middle ground between street outreach (which was possibly too brief) and formal, mainly abstinence-based drug treatment (which was too burdensome, too costly, or unavailable). They obtained a demonstration grant from the federal Department of Health and Human Service's Center for Substance Abuse Treatment to develop, provide, and study day treatment from April 2001 to March 2006.

From its inception, the Day Treatment Program firmly reflected COYOTE's belief that sex workers were more likely to be healthy if they were not forced to leave prostitution but instead were treated as workers with legitimate occupational health and safety needs. The program thus provided a safe, judgment-free space for a normally marginalized and criminalized population to improve their basic health (Bowser et al. 2008). It also provided an opportunity for CAL-PEP to study and publish the results of its approach. Day Treatment was open during the day and offered case management, HIV and drug risk–reduction education sessions, group discussions, one-on-one psychological counseling, and a laundry and shower facility and meals (CAL-PEP 2001, 2004). CAL-PEP outreach workers recruited clients in cohorts of fifty (per year) from street locations in Oakland where primarily African American sex traders and substance users congregated. Clients were directed to the house and could drop in and out as needed, although they were required to not use drugs on the premises and be sober enough to participate in the counseling and group sessions.

The program effectively demonstrated that treating sex workers nonjudgmentally, as workers, helped them lead healthier lives and work more safely. In the final evaluation of the program, the Day Treatment Program showed significant efficacy for CAL-PEP's clients in the areas indicated in Table 2.[2] Through day treatment, the participants' were less likely to be homeless, to spend time in jail, and to use drugs. They were also more likely to attain full-time employment. However, as Bowser and colleagues noted in an earlier working paper (2007), participants' HIV sexual-risk behavior did not change very much over the course of the program.[3] At intake, women who claimed to have more sexual partners had more unprotected sex with known intravenous drug users and spent more days using crack cocaine. But by the sixth month, while they continued to have multiple sex partners, they did so somewhat more safely, namely, by avoiding known intravenous drug users as partners (Bowser et al. 2007: 9). To probe this finding more deeply, CAL-PEP conducted focus groups that revealed that these risky

Table 2. Day Treatment Program Outcomes

	At intake	*After six months*	*After twelve months*
Full-time employment (percentage of day treatment participants)	7%	15%	19%
Living on streets (percentage of day treatment participants)	13%	5%	5%
Poly-drug and alcohol: days used (in the past thirty days)	27.7	15.1	16.9
Average number of nights spent in jail (over course of program)	2.4	1.2	0.9

Adapted from Bowser et al. (2008: 494 [Table 1]).

sexual practices continued because sex work was their primary source of income since many could not find employment (in the formal economy) that paid a living wage. And so to make enough money through sex work (and support their crack-cocaine addiction), they continued having multiple partners, although over the course of their participation in Day Treatment they avoided intravenous drug–using partners on a more regular basis.

Overall, the program demonstrated that by making it easy for sex workers to access services, this population—which is normally considered "hard to reach" by traditional public-health channels—could be reached. And once they were involved in the program, sex workers would respond to education and counseling (without having to abstain from substance abuse as a condition of receiving treatment and services). These findings led Bowser and his colleagues to conclude in their evaluation that "harm reduction treatment projects like the CAL-PEP Day Treatment effort are necessary to address the social and economic needs of women who trade sex for drugs and money" (Bowser et al. 2007: 12).

But despite this knowledge, a lack of funding forced CAL-PEP to discontinue the Day Treatment Program, thereby indicating how social movement–borne nonprofits' capacities to continue their oppositional political goals

through program development and research is often limited by the broader issue context. As Bowser and his colleagues stated,

> Center for Substance Abuse Treatment-funded projects that are innovative and that demonstrate effective ways to address drug treatment are funded with the understanding that they will be continued by state and local health departments. The Alameda County Public Health Department that serves Oakland, California, like so many city and county health departments, does not have the funds to support new prevention and treatment projects, but neither do they have the interest in seeking funds to do so. They reflect the same philosophical opposition to harm reduction that 50% of national treatment programs have. As a consequence, they end up reinforcing African American [especially female] marginalization in American society through continued neglect of services. (2007: 13)

Therefore, despite the efficacy of the program, it existed in a broader political-economic environment that limited CAL-PEP's capacity to continue program delivery and knowledge production that expressed a commitment to treating sex workers nonjudgmentally, as workers. This reality was reinforced in the winter of 2007, when CAL-PEP applied for a $300,000 Substance Abuse and Mental Health Services Administration (SAMHSA) grant to offer services to women of color who engage in substance use and other activities that could put them at risk for HIV/AIDS. This grant would help them restart the Day Treatment Program but this time for younger sex workers and other women "at risk" for entering the sex industry. I helped CAL-PEP apply for the SAMHSA grant, which was extremely time consuming, taxing the skills and resources of this peer-based organization. The request for proposals for this SAMHSA grant—which provides application directions and requirements for groups applying for the grant—was fifty-eight pages in length and called for extremely detailed research to demonstrate community need, program descriptions, discussions of evaluation processes, budgeting, predictions of outcomes, and letters of support from other community and local government groups, among a myriad of other requirements (it spent nearly three pages outlining the font and document-formatting requirements). And although CAL-PEP arguably had the data, skilled staff, and history of program success needed to win this grant, composing this particular SAMHSA grant took nearly two months to complete (in the end, the submitted application was 132 pages in length).

However, CAL-PEP failed to obtain the grant because SAMHSA resisted the philosophy of sex-worker rights embedded in the program. Although CAL-PEP was careful to remove any explicit reference to harm reduction and was able to provide adequate evidence of their success with their previous Day Treatment Program, they did not receive the grant. According to Gloria Lockett (Interview, 25 March 2008), an official from SAMHSA informed CAL-PEP that although its grant was "technically excellent" (meaning it was well-developed and had all of the required components), it would not receive the funding because CAL-PEP's method of reaching sex workers (i.e., not requiring them to leave the sex industry) "was not very popular with the [then current] federal administration."

Policy Advocacy

Social movement–borne nonprofits may produce and publish research to continue advancing their political goals, but research results alone will not often lead to broader legal and policy change. Most groups in America make claims on government and influence legislation through lobbying, but nonprofits are virtually silenced in this process through nonprofit law (Berry 2005). As Berry and Arons (2003) document, many nonprofits believe they cannot (and do not) engage in political activities like lobbying because such activities will compromise their nonprofit status and capacity to raise revenue and provide services. Since nonprofits are usually the only organizations serving and working with some of the most marginalized members of society, nonprofit law "works against the participation of the most disadvantaged in society" (Berry 2005: 568).

And certainly, CAL-PEP's and the SJI's staff and leadership share this reluctance to lobby or act politically in other ways. When asked directly if CAL-PEP engages in political activity, broadly defined, Deputy Director Carla Dillard Smith responded that "we do not do this because we get federal funding [from the CDC]" (Interview, 3 November 2007). The SJI staff also expressed similar reluctance. Although the SJI's informational flyer explicitly states, "The St. James Infirmary is fundamentally against the criminalizing of sex workers for their profession" (SJI 2008: 2), SJI staff members were largely unwilling to encourage or promote any political activities to this (or any other) end as an organization. The SJI's *Employee Handbook*'s "Standards of Conduct" section has a subsection titled "Political Activity Prohibited," which states:

The St. James Infirmary is a non-profit agency governed by federal guidelines and can lose its nonprofit 501c3 status if it is found that the organization engages in political activity. Therefore, no St. James Infirmary employee may participate in political organizing or political campaigns on St. James Infirmary time, but may do so on their own time. No St. James Infirmary funds may be used for political purposes. The St. James Infirmary will not take any political position or engage in political organizing. The St. James Infirmary may provide findings or research to a legislative body once it is determined by the Executive Director, Medical Director and Clinical Director that providing this information violates neither the spirit of this clause, nor the mission of the St. James Infirmary. Nothing in this policy is meant to prohibit St. James Infirmary employees or volunteers from exercising their first amendment rights to free speech, their right to freely assemble or their right to petition government for any reason, provided they do not do so on St. James Infirmary time. (SJI 2009a: 8)

My conversations with SJI staff members indicated that they take this statement seriously, and some were concerned that engaging in any political activity might jeopardize their charitable nonprofit status and, hence, ability to offer services. As David, a long-time peer staff member and volunteer at the clinic declared, "The SJI should stay out of political and community organizing completely because . . . this violates their agreement as a nonprofit, and is potentially dangerous to the organization because it kicks up dust. They should stay out of all of it and just do their job. Instead, the SJI can really be an incubator/meeting ground/community space for sex worker organizations and use the space in a way that does not involve the SJI in an administrative way, like a church, for example" (Interview, 10 November 2006). I discussed this position with Drew, another longtime peer staff member, who explained this reluctance by noting that the SJI seeks to provide a space for healthy opinion and debate "so people can think a bit differently when they leave than they did before"; he added, however, that they do not want to jeopardize their status as a 501c3 health-service provider (Interview, 15 December 2006). Therefore, he stressed later, sex workers who choose to engage in political activities "have to be clear: if you are here and committed to a cause, this is not a reflection of the agency where you seek services." He went on to express a common doubt among some staff members about the efficacy of participation in the formal political process: "To be political is to not get any-

thing done," he said. Instead, he emphasized that one should "never under-estimate small change on a daily basis . . . [if people] . . . show up, be present, and never underestimate the power of critical thinking, then the powers that be will listen" (Interview, 27 July 2011).

Even if the SJI staff members were more interested in political action on behalf of the SJI, the reality is—like many nonprofits—that they often lack the resources to engage in such actions. This lack was apparent when I discussed the H-election with CAL-PEP and the SJI's leadership. The H-election allows nonprofits to devote a specified portion of their resources to political activi-ties like lobbying, without risking their status. However, such measures require most nonprofits to overcome significant knowledge and resource constraints. In line with Berry and Arons's findings (2003), the SJI and CAL-PEP are among the 97.5 percent of nonprofits that have not made the H-election. At CAL-PEP, Lockett was not aware of the H-election, although she requested more infor-mation about it (Interview, 11 January 2010). And while SJI Executive Director Akers initially stated the SJI was planning with their board of directors to make the H-election in the future, when I asked her later if they had done so, she just laughed and said no. She explained that even if they did make the H-election, there was no money to devote to political activities since the City of San Francis-co had cut their funding recently (E-mail correspondence, 15 November 2007).

These sentiments and conditions surrounding nonprofits and political ac-tivity are not unique to CAL-PEP and the SJI, yet they are not entirely reflective of what nonprofits do (and can do) politically, especially if one broadens his or her conception of "political activity" beyond more traditional actions like lob-bying and campaign activities. In fact, a closer examination of CAL-PEP and the SJI indicates that nonprofits often do circumvent the constrictions of nonprofit status to resist and challenge the public's and policy makers' perceptions of their community. In short, there are many ways for nonprofits and their staff members to advocate and "act politically," and the remainder of this chapter identifies the following four claims-making activities: individual actions, permitted lobbying, public-awareness campaigns, and international (health) advocacy.

Individual Actions

Nonprofit leaders and their staffs understand how laws and policies affect their constituents, but they are often too focused on maintaining service provision to devote significant amounts of time and resources to chang-

ing these laws and policies. But their emphasis on service does not mean they are politically inactive. In fact, nonprofit staff and management may participate in governmental and legislative hearings and in political campaigns, as individuals, to advocate for policy change. Gloria Lockett did so in 1994 when she testified before the San Francisco Taskforce on Prostitution, which considered the impacts and efficacy of enforcing laws that criminalized prostitution. By this point, Lockett had been CAL-PEP's executive director for nearly ten years, but in her testimony, she stated immediately that she was not there in that capacity but as someone "representing myself as a black woman, a woman who worked as a prostitute for 18 years, ten years spent on the streets and the other eight in massage parlors and in hotels, motels, and bars." As a so-called "career prostitute," Lockett voiced her support for decriminalizing prostitution by explaining the negative impact that criminalization had on her capacity to earn a living and remain safe. She told the taskforce that she was arrested multiple times for pimping and prostitution, and the police often harassed her and her coworkers, particularly those who were women of color. To illustrate, she described an incident when she placed an ad in a local newspaper, and a man responded. She met him on a nearby corner, and he followed her back to her apartment; however, she "didn't like the way he was talking" to her, and before she could end the encounter, eight police officers came to the door. As Lockett described what followed, "It took eight policemen three hours to arrest me. . . . And when they finally got me to the jail, I bailed out and went home." She went on to describe this as "a waste of time and energy. . . . Our tax dollars are being spent paying police to sit on corners wasting their time with prostitutes because they know nothing's going to happen to them. It is a waste of money" (San Francisco Taskforce on Prostitution 1996). Lockett then told the taskforce about the negative implications that criminalizing prostitution had on sex workers' health. She drew on her experience at CAL-PEP to explain how she had done HIV prevention outreach in the massage parlors, where many of the women did not speak English. In addition to the language barrier, they were also scared of being arrested, and so they were not willing to accept condoms, all of which made it harder for CAL-PEP to do outreach and help the women work safely.

As individuals, nonprofit managers and staff may also participate in political campaigns to advance broader political claims and draw candidates' attention to the needs of their constituents. I discussed this with Ashly, a former peer counselor at the SJI. A tiny woman with dark hair, bright eyes, and

a degree in women's studies, she described herself when we first met as "passionate right now about foreign policy, HIV activism, and the decriminalization of HIV, and as a pro-queer sex worker" (Interview, 31 January 2007). When I met with her again in the summer of 2010, she was working in the office of a candidate running for a seat on the San Francisco Board of Supervisors. We moved to a nearby coffee shop to talk, and she described how she got into politics when she began attending hearings at the San Francisco Board of Supervisors to request more funding for health-service organizations, including the SJI. She told me that "as a nonprofit, the SJI can't endorse candidates, but even though [the SJI is] a niche organization, they had lots of people show up at the city budget hearings: it was an exciting moment to see we had the force to lobby for money." Through this experience, she met a group of nurses and other health-care professionals involved in the Coalition to Save Public Health in San Francisco, and she joined their steering committee in 2008. Here she met the candidate she would eventually work for, and he convinced her to join the Harvey Milk wing of the LGBT Democratic Club; when the candidate decided to run for the Board of Supervisors, he asked her to be his campaign manager. Although she "had not been convinced of the importance of electoral politics," when we met, the constant buzz of her Blackberry device made it clear that she was fully involved in her managerial role, "running the candidate's life," overseeing communications and phone banks, among other things (Interview, 30 July 2010).

Even though the days were long, she enjoyed building a coalition and getting people motivated around a common goal. And as a result of her work, she has been able to bring sex work issues to the candidate's attention: "[The candidate] understands sex work, and it will be a priority for the first time, and it never was before. I made him read the SJI's new resource guide, and . . . he also went to the December 17 International Day to End Violence Against Sex Workers event, and he stayed for the open mic because I put it on his calendar. That would not have happened in this district. I also gave him a tour of the SJI." For Ashly, working at the SJI motivated this involvement. She stated, "No one sees themselves as having political worth if they don't feel respected in society." She explained further that since the SJI grants sex workers respect by not delegitimizing or judging them and by hiring and training them to provide their own health care, "this makes them feel entitled to make decisions in the world that they didn't feel entitled to make. Political action requires a sense of entitlement" (Interview, 30 July 2010).

Permitted Lobbying

CAL-PEP and the SJI also indicate how nonprofits may circumvent restrictions on political activity to make claims on government through permitted lobbying—testifying before government bodies to educate policy makers and engaging in public-policy development processes in ways allowed by nonprofit law. If one takes a cynical view of these activities, it seems they may be motivated only by the organizations' desire to maintain their funding streams; however, they also show how social movement–borne nonprofits may continue advancing their broader political goals and raise awareness among policy makers about the constituencies they serve.

CAL-PEP, as the older and larger of the organizations, illustrates the possibilities for permitted lobbying. Today, CAL-PEP's leadership is active in various legislative arenas, where they advocate for the needs of their constituents, including sex workers and persons of color who are members of street-based populations. At the state level, as noted previously, CAL-PEP has always traveled to Sacramento for the AIDS Lobby Day, sending staff members to speak on various issues, such as the importance of providing health education to sex workers and women of color (CAL-PEP 1999/2000). Lockett and Dillard Smith have also been active in the highly politicized national and international AIDS awareness arenas, attending the National Conference on AIDS, hosted by the National Minority AIDS Council, which works to develop leadership among communities of color to fight AIDS.

However, one of CAL-PEP's most notable sustained lobbying and awareness efforts occurred through a multiagency project to promote broader political and policy goals. Dillard Smith explained to me (Interview, 3 November 2007) that in 1997, CAL-PEP and a number of other HIV/AIDS prevention nonprofits in the area lost significant funding from the CDC. Although each agency tried to negotiate with the CDC on its own to restore funding, they did not have much success, and so they joined forces to create CHAC (California HIV/AIDS Advocacy Coalition). In 1998, CHAC pressured the county to declare a state of emergency regarding the alarming number of newly diagnosed African Americans with HIV, which the county did when the Clinton administration announced that it would devote $156 million to address AIDS in ethnic and racial minority populations worldwide. Funding from this initiative allowed the county to create a State of Emergency Taskforce that sought to reduce HIV/AIDS in the African American community in

Alameda County by implementing programs to normalize and destigmatize discussions of AIDS; ensuring that government agencies provide and distribute adequate resources; integrating AIDS services into existing services in the county; and creating and implementing a local policy agenda that they hoped would influence the national and international AIDS prevention agendas (Alameda County 2003).

With its extensive experience delivering nonjudgmental, nonstigmatizing HIV/AIDS prevention services to African Americans considered at highest risk for the disease, CAL-PEP was one of three CHAC-affiliated agencies appointed to the taskforce's Steering Committee, which was charged with finding funding opportunities for service providers and other community organizations (Alameda County 2003). Steering Committee participation required CAL-PEP to advocate at the state legislature and to travel to Washington, D.C., where Dillard Smith participated in congressional hearings on HIV/AIDS. As Dillard Smith explained (Interview, 2 July 2010), from 1998 to 2008, CAL-PEP and CHAC's work with the State of Emergency Taskforce secured funding from Alameda County, the San Francisco Foundation, pharmaceutical companies, the Alameda County Board of Supervisors, and the federal government for public awareness and advocacy activities regarding the state of emergency. They also conducted testing days, publicized World AIDS Day, and held media events, all to increase awareness in the community about HIV/AIDS. In one particularly notable example, Lockett gathered a group of African American nonprofit executive directors to raise awareness by hosting a press event to "bury HIV": they rented and set out coffins, and gave a "eulogy" for HIV as the executive directors lay on the floor mimicking corpses.

CAL-PEP's efforts with CHAC show how nonprofits may "lobby" in permitted ways; however, they also illustrate the limits of their lobbying ability. I asked Dillard Smith to reflect on CAL-PEP's participation in CHAC and the State of Emergency Taskforce, and she explained that they "took on a lot, doing the work many elected officials are paid for" by, as she described it, "promot[ing] the African American state of emergency and basically staff[ing] the taskforce on this for free" (Interview, 3 November 2006). But for all of their efforts, over ten years later, the state of emergency was (and is still, technically) in effect: African Americans remain at the highest risk for HIV, a risk that has increased with poverty rates in the region. Alameda County's AIDS rate is 13 per 100,000, above the state rate, with African American women and men showing disproportionately higher rates than other ethnic

groups. During 2003–2004, the African-American AIDS rate was 3.5 times the county rate, and of the 6,860 total AIDS cases diagnosed among Alameda County residents from 1980 to 2005, 44 percent were African Americans (Alameda County Public Health Department 2009).

It is not surprising, then, that this advocacy left them tired. As Dillard Smith stated (Interview, 3 November 2006), while all of these activities were (and are) necessary, it pulled them from their core work, and they realized they must keep in mind that their first commitment is to their clients. Currently, aside from attending local planning council meetings, CAL-PEP is mainly focused on maintaining services by pursuing grant and funding opportunities as opposed to broader advocacy efforts. But even as CAL-PEP may appear politically exhausted, it has continued to engage with important public figures to maintain funding and continue advocating for broader political and policy change.

These examples of sustained advocacy indicate how nonprofits—even when they may claim to avoid "traditional" and "visible" actions, such as protests and lobbying—continue to make policy makers aware of their work and their constituents' needs. In addition to their CHAC work, Lockett and Dillard Smith have sat on the local HIV Health Services Prevention and Planning Council, which helps set the county's HIV/AIDS prevention budget and planning priorities in the East Bay. Composed of community activists, HIV professionals, and other interested citizens who meet regularly, the council administers the grants process for federal HIV prevention dollars, and produces three-year plans "to chart a course for the future of HIV services in Oakland [and] to use Ryan White Care Act Part A funds efficiently in order to make the greatest possible positive impact on the HIV/AIDS epidemic in our region" (Alameda County Public Health Department 2009: 3). An Alameda County public-health report acknowledges that "consumers of Ryan White services in the Oakland Transitional Grant Area are typically poor and persons of color who are marginalized due to sexual minority status, disability, race and other factors, and who in their daily lives confront a range of social inequities" (Alameda County Public Health Department 2009: 5). Therefore, it has always been important for CAL-PEP to maintain a presence on this council, as the majority of their clients fit this definition of "consumers." Lockett explained that in the case of persons recently released from prison, for example, CAL-PEP used its position in the Planning Council to inform the council about the difficulties this group has attaining housing, and CAL-PEP worked to ensure

there was funding for this group in the council's plan (Interview, 18 July 2006).

As important as this permitted lobbying work is for bringing their constituency's voices into the governing process, it is also time consuming for nonprofit organizations. Lockett indicated to me that while she once chaired the Planning Council, she eventually reduced her involvement because she no longer had the time for it. But Lockett, like many former activists-turned-nonprofit-leaders, is politically savvy, and she still attends Planning Council meetings when she can. I joined her for one of these in July 2010. The meeting was held that afternoon in a conference room at a senior citizen's center in Oakland, and as soon as we arrived, it was very clear that even though Lockett was not a regular board member, no one on the Planning Council forgot who she was. Clad in a sharp, gray pantsuit and kitten heels, Lockett entered the room, and numerous individuals came over to hug her and say hello. They all asked her multiple times when she would "come back and join them full time." In response, Lockett smiled but never said no, and she was there for the entire lengthy meeting.

But if Lockett's and CAL-PEP's political savvy was evident anywhere, it was at CAL-PEP's twenty-fifth anniversary in December 2009, which they celebrated with a Community Recognition Awards Dinner. Although this was not a political event per se, it had plenty of potential for "lobbying." I was not in Oakland at this time, but I received in the mail a copy of the program, which was artfully presented and described a classy event, complete with a cocktail hour, dinner, awards, and dancing (CAL-PEP 2009). Among the honorees were individuals who had worked closely with CAL-PEP over the years (often for little or no pay), such as Judith Cohen from Project AWARE and Ben Bowser, their evaluator. However, the longer list of honorees included a range of important political officials, including Warren Hewitt, the AIDS and Infectious Diseases Coordinator for the Center for Substance Abuse Treatment; State Assemblyman Sandre Swanson; Congresswoman Barbara Lee (D-CA); and David Kears, the retired director of the Alameda County Health Care Services Agency. Next to each honoree's photo was a gracious description of his or her many accomplishments related to HIV/AIDs prevention in Alameda County. These pages included well wishes to CAL-PEP from various sponsors, such as Gilead Pharmaceuticals, the AIDS Healthcare Foundation, and the Magic Johnson Clinic, to name a few. Most notable among well-wishers, however, was Alameda County Supervisor Keith Carson, who congratulated "CAL-PEP for their 25

years of committed service to help educate individuals and families in preventing the spread of HIV/AIDS in our communities. I wish you continued success well into the future."

In many ways, this event offered high praise to public and political officials who often did not "come through" for CAL-PEP. The Center for Substance Abuse Treatment official and the county supervisor were praised and honored, for example, even though they did not provide CAL-PEP with the resources to continue the Day Treatment Program; however, holding a grudge would not serve CAL-PEP in the long run. As Judith Cohen explained to me, "Gloria knew that to sustain the organization she would need to build relationships and put her project at the forefront . . . [because] being a prostitute you learn how to ask for things and learn the importance of knowing what needs to be done—how to target money streams, how to make a plan to accomplish things, etc. She has outlived many political aspects and avoided blacklists—you have to succeed at this" (Interview, 7 July 2010). Taken together, this and the other examples of "permitted lobbying" play a key role in nonprofits' longevity. Through coalition formation, council memberships, or recognition events, social movement–borne nonprofits in particular may continue advancing the broader political struggles they emerged from and, in turn, influence and make policy makers aware of their constituents and their needs.

Public Awareness

Nonprofits also may engage in claims-making activities through public-awareness campaigns, which nonprofit law permits when these organizations do not advocate for a specific piece of legislation or political candidate. These campaigns may also allow activists to challenge public discourses about the communities they serve and to advance their oppositional political stances. A nonprofit's capacity to engage in discursive campaigns was evident in a press release from the SJI, which indicated the organization was launching "its first major media campaign featuring local sex workers to raise public awareness about sex workers' rights . . . [that] will appear on Muni [San Francisco Municipal Transit] buses throughout the month of October and will be featured in an art exhibit and launch party at Intersection for the Arts . . . on October 16, 2011" (Akers and Schreiber 2011: 1). Designed by SJI volunteer graphic designer Rachel Schreiber and photographer Barbara DeGen-

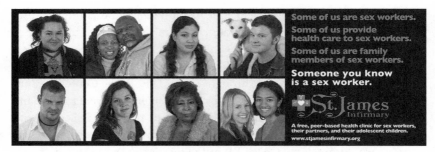

Figure 6. "Someone You Know is a Sex Worker," bus ad for the St. James Infirmary, 2011. Photo by Barbara DeGenevieve and Rachel Schreiber for the St. James Infirmary, 2011.

evieve, who interviewed and photographed twenty-seven adult sex workers, their family members, partners, and health- and social-service providers, the media campaign involved a series of individual and group photos (some of which are shown in Figures 6 through 9).

These ads made an important—and, arguably, political—claim that sex workers are not invisible but individuals who care for each other and their community. Therefore, the ads "promote [the] SJI's philosophy that social stigma contributes negatively to the health and wellness of sex workers. Our goals are to raise awareness of the important work of SJI, to increase financial support of our work, and to educate the community that sex workers are equal members of society" (Akers and Schreiber 2011: 2). These ads also have a broadly political purpose: they resist dominant discourses that sex workers are merely and always victims with no agency, or criminals, or vectors of disease, or a combination of these. As the SJI explained further in the press release, this campaign was and is necessary to counter the majority of media coverage of the sex industry, which mainly focuses on sex trafficking, while largely ignoring the wide range of issues pertinent to sex workers. Of course, the SJI clearly stated in its press release that it opposes human trafficking, but added that the "statistics quoted by anti-trafficking media campaigns are often highly inflated and under-researched" and this "biased research leads to harmful policies, and leads legislators to channel funding to law enforcement rather than housing and health care" (2).

But in the current issue context, this position is not popular, even in the "liberal" Bay Area. The SJI's public-awareness campaign was controversial from the outset. As a variety of media sources reported when the campaign began, the SJI actually had difficulty finding places for the ads (before it eventually se-

Figure 7. "Someone You Know Is a Sex Worker," bus ad on MUNI Bus, 2011.
Photo by Sister maeJoy B. With U, 2011.

cured an agreement with Titan 360, a transit-advertising company, to run them on the Muni). As an article in the *Bay Citizen* noted, the SJI decided to place its ads—unaltered—on Muni buses after two major advertising firms, CBS Outdoor and Clear Channel Outdoor, rejected the ads for billboard placement earlier this year: "'Sex workers' is 'not a family friendly term,' Barbara Haux, a CBS Outdoor senior account executive, wrote in a rejection e-mail to the clinic. The company said it would reconsider, but only if that phrase was not used. . . . In a statement to The *Bay Citizen*, a representative of Clear Channel Outdoor defended its choice not to run the ads, saying that local managers review all content to make sure it meets 'standards of the local community'" (Chong 2011). At the time of writing, it was too early to determine the ads' impact on the public and policy makers, but it was clear they generated public discussion and debate. The *Bay Citizen* article immediately generated a stream of comments ranging from outrage against the ads to support. As one commenter by the name of "Michael Smith" stated, "Prostitution, or 'sex work', is dehumanizing for the prostitute or 'sex worker,'" while commenter "Matthew Bakker" replied, "I for one think it's great that some people are stepping out, owning it, and showing that they are deserving of respect, whether you want to give it or not" (Chong 2011: see comments section).

By the time this book is in print, these ads will be replaced with myriad other images and advertisements for consumer goods that grace public-

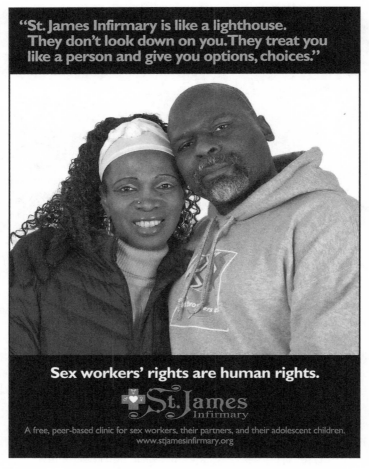

Figure 8. "Sex Workers' Rights Are Human Rights," poster for the St. James Infirmary, 2011. Photo by Barbara DeGenevieve and Rachel Schreiber for the St. James Infirmary, 2011

transit vehicles; however, even if the ads do not fully convince the public that sex workers are "just like us" (or lead to decriminalizing prostitution, for that matter), they indicate a potentially important nonprofit strategy for claims making. Through public-awareness campaigns, nonprofits may resist—and possibly change—understandings of their community and therefore continue advancing their social-movement goals.

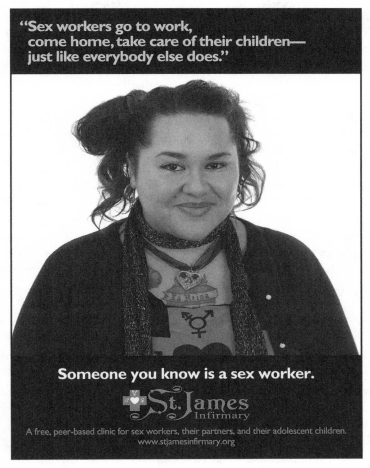

Figure 9. "Someone You Know Is a Sex Worker," poster for the St. James Infirmary, 2011. Photo by Barbara DeGenevieve and Rachel Schreiber for the St. James Infirmary, 2011

International Issue Advocacy

CAL-PEP and the SJI also illustrate that activists who form nonprofits are not limited to claims-making within national borders. Scholars have documented how much political activism and networking take place transnationally (Keck and Sikkink 1999), and many issues of activist concern are increasingly globalized. CAL-PEP and the SJI's advocacy efforts outside of

the United States thus indicates that the international health arena provides a major site of possibility for sex-worker rights activists' claims-making activities, especially since these activities do not count as lobbying or engaging in political campaigns under nonprofit law in the United States. In fact, internationally, CAL-PEP has been active at the International AIDS Conferences in Japan, Geneva, and Toronto, among other locations, where it has presented the results of many of its research projects.

Like CAL-PEP, the SJI has engaged in advocacy in the international health arena, and its work in that area indicates how social movement–borne nonprofits may use such venues to continue advancing the broader political struggles they emerged from. In October 2009, Naomi Akers was appointed to the UNAIDS Global Working Group on HIV and Sex Work Policy, which was founded by a network of sex workers around the globe in direct response to the growing presence of antiprostitution sentiments in international health-agency reports, namely, the 2007 UNAIDS Guidance Note on HIV and Sex Work (UNAIDS 2007). The guidance note reported that globally, despite twenty-five years of knowledge about HIV/AIDS prevention, HIV was still prevalent among sex workers. Although this statement was true, sex-worker rights and AIDS activists were concerned about the implications of the note because it "demonstrated a clear departure from human rights-based, evidence-informed approaches, to an emphasis on eliminating sex work altogether as an HIV prevention strategy" (St. James Infirmary 2010: 1).

Sex-worker rights advocates were concerned that the guidance note advised governments to pursue policies and programs that would "end demand" for prostitution. Although the note acknowledged a variety of factors that heightened sex workers' vulnerabilities to HIV/AIDS, such as drug use and poverty, it stressed that "male attitudes and behaviors, gendered-based violence, sexual exploitation, and stigma and discrimination against women and girls continue to be contributing factors to the HIV epidemic" (UNAIDS 2007: 3). Few experts in the field of HIV/AIDS prevention disagree that gender-based discrimination, exclusions, and violence increase sex workers' health risks.[4] But sex-worker rights advocates were concerned with the focus of the guidance note on addressing "Demand for Paid Sex" by "reduce[ing] the demand for sex work" among men (UNAIDS 2007: 4). To sex-worker rights advocates, this emphasis on ending demand signaled an alarming departure by the agency from principles of human rights–based and evidence-based programming and policy (SJI 2010), especially since there is little evidence that "end demand" programs, such as "john schools," actually end

demand for sex work, let alone reduce risk for HIV/AIDS transmission (Preston and Brown-Hart 2005; Wahab 2006).[5]

The SJI participated in efforts to reshape this UNAIDS document and, in so doing, indicated how nonprofits may advance broader political struggles through international issue advocacy. In 2009, the Global Working Group on HIV and Sex Work Policy met to develop and suggest changes to future guidance notes so that they would include specific recommendations "that addressed HIV interventions and access to HIV treatment for sex workers rather than trying to eliminate the world's oldest profession" (SJI 2010: 1). Akers, as a member of the North American Network of Sex Worker Projects, which "conducts a mix of proactive and re-active policy advocacy to support human rights and evidence based approaches to female, male and transgender sex workers and strengthening sex worker communities" (Network of Sex Workers Projects 2012: 1), represented the region at the Global Working Group in Geneva, Switzerland, in June 2010.

Akers presence was important because UNAIDS Guidance Notes often shape national and local HIV/AIDS prevention efforts in the global north (SJI 2010: 2). Therefore, she and other members engaged in policy education and advocacy at the June meeting, identifying how criminalizing sex work and repressive law-enforcement practices (particularly those that accompany many "end-demand-oriented" antitrafficking efforts) reduce access to health services. She and her fellow working group colleagues also identified and distinguished between reducing the demand for sex work generally and reducing the demand for unprotected sex, the latter of which is more effective for reducing HIV/AIDS transmission risks. As well, they spoke to issues of economic empowerment, and how health- and social-services programs that required individuals to exit the sex industry (as a condition of receiving services) were ultimately more harmful for sex workers than those that provided either support within the industry or optional employment opportunities. As a result of these efforts, UNAIDS agreed to postpone the publication and distribution of their next guidance note until the Global Working Group could draft complementary position papers "clarifying the position of UNAIDS in regards to the rights of sex workers and the harms of criminalization" (SJI 2010: 2).[6]

Conclusion

CAL-PEP and the SJI, like many nonprofits, are service organizations first, and like many of their counterparts in a range of fields, they need to maintain

their nonprofit status and grants to continue their work. As a result, they often carefully state that they are not "political" and that they "avoid political activities." But a closer examination of their activities confirms Jeffrey Barry and David Arons's (2003) finding that nonprofits must enter the political arena and maneuver politically in order to survive, whether they want to or not. Through what I term claims-making activities, which include knowledge production and policy advocacy, they prove the efficacy of their services and appraise funders about how valuable their work is.

However, these activities do more than simply sustain their organizations: CAL-PEP and the SJI serve a marginalized constituency that garners little public and political support (except when they are portrayed as victims), and so by engaging in claims making on the behalf of their constituency, these organizations also represent their constituents in the political and policy arena, broadly defined. Moreover, CAL-PEP and the SJI present an alternate social construction of their constituency and its needs through these activities. They are not seeking to end prostitution but to support persons engaged in this activity as workers. In so doing, CAL-PEP and the SJI show how activists may continue advancing their oppositional goals through their own nonprofit institutional structures. Although these methods are limited to varying extents, they are a step toward attaining the longer-term social, legal, and policy changes that will improve the conditions that their constituents live and work under.

CHAPTER 5

Lessons Learned: Social-Movement Evolution and the Nonprofit Sector

When I first began my research with CAL-PEP and the SJI, I was eager to observe and participate in their clinic nights and HIV/AIDS prevention outings for many reasons. I believed in their work, and I was curious to see how sex workers gathered in the spaces they created may carry on the movement for sex-worker rights. But as the previous chapters indicated, I observed something much more complicated. CAL-PEP's and the SJI's staff members and clients—like Tasha and Monica, introduced in Chapter 1—had multiple interests and concerns, many of which eclipsed the struggle for sex-worker rights. It quickly became clear to me that I, along with other scholars of social movements, civic engagement, and nonprofit institutions, have much to learn from CAL-PEP and the SJI.

Even as many scholars and observers may use such cases as CAL-PEP and the SJI to bolster claims that activists who "institutionalize" service provision necessarily deprioritize more contentious claims-making activities, a close examination of these organizations reveals their potential to do otherwise. Drawing from the insights of new institutional theories of the nonprofit sector, which holds broadly that nonprofits and government often have a reciprocal and dynamic (or, as Gronbjerg and Smith [2006] term it, "mutually synergistic") relationship, the preceding chapters illustrate and specify how activists may use the process of building and sustaining their own nonprofit institutions to continue advancing their political goals. Through a process I term "resistance maintenance"—where they employ oppositional implementation, community engagement, and claims-making—their founders and leaders minimize cooptation and continue pursuing broader social-change goals. The remainder of this book thus draws on CAL-PEP's and the SJI's experiences to consider the broader

lessons they provide about social-movement evolution and activists' transitions to the nonprofit sector.

Advancing Movement Goals: CAL-PEP, the SJI, and the Movement for Sex-Worker Rights

CAL-PEP's and the SJI's existence raises and challenges common assumptions about the evolution of social movements, namely, that as they formalize their operations (in nonprofit organizations, for example), they also diminish their resistance efforts and their prospects for compelling broader sociolegal changes from the (formal and informal) institutions they challenged. But at first glance, these assumptions about social movements seem true if one considers the sex-worker rights movement in the United States. With the ascendance of CAL-PEP and the SJI, prostitution remains illegal in the majority of the country. Furthermore, sex-worker rights perspectives are often overshadowed in public and political discussions by the dense network of advocates, policy makers, journalists, and scholars alike who support the abolitionist and antitrafficking perspective—a reality that I witnessed firsthand in November 2009, when I sat on a panel at Harvard Law School with a fellow scholar Elizabeth Wood, a professor at Nassau Community College; noted abolitionist Melissa Farley; and Vednita Carter, a former sex worker who now runs Breaking Free, a nonprofit that helps women leave prostitution and the sex industry.[1] Hosted by the campus chapter of the American Civil Liberties Union, the question before us was "what are the civil rights and liberties implications of legalizing or decriminalizing prostitution?" The panel was fiercely divided between me and Elizabeth Wood, who spoke in favor of removing prostitution from the purview of criminal laws, and Melissa Farley and Vednita Carter, who vehemently opposed this idea (Young 2009). Whenever Wood or I drew from research to state that prostitution occurs in many contexts and is experienced differently based on one's social location and the broader cultural, political, and economic context, the emphatic response from many audience members (composed of social workers, law students, and scholars) was "But how can you say that? Prostitution *is* violence against women!" And these sentiments are not exclusive to discussions in the ivory tower: here one only needs look at *New York Times* columnist Nicholas Kristof's extensive columns on sex trafficking to learn the story of "a teenage girl, Long Pross," who was brutally beaten by a brothel owner in

Cambodia (Kristof 2009) or the *New York Times Magazine*'s story of Lucilla, a Brooklyn teenager who worked for a pimp who took all of her money after every "trick" (Lustig 2007), for just a few examples of how the media has focused on emphasizing coercion and victimization in prostitution. And the U.S. State Department's 2010 *Trafficking in Persons Report* has an entire section entitled "Victims' Stories" that narrates individual experiences with coercive labor, often in prostitution (U.S. Department of State 2010), to further reinforce that sex work could never be a legitimate occupational choice.

I am not providing these examples to deny that violence occurs in the sex industry; instead, they indicate a context that evinces clear opposition to the sex-worker rights perspective. It is therefore understandable why many activists in the sex-worker rights movement formed and maintain nonprofits like CAL-PEP and the SJI to meet their community's health and safety needs more immediately and effectively. But many would also argue that in the long run nonprofit formation and social service provision is not the same as (or sufficient for) outwardly protesting and engaging in other direct efforts to change the laws, policies, and public discourses that define the conditions sex workers live and work under. The late Robyn Few explained this sentiment favoring protest over service to me one afternoon in Oakland. At the time, Few led the Bay Area chapter of the Sex Workers' Outreach Project (SWOP), "a national social justice network dedicated to the fundamental human rights of sex workers and their communities, focusing on ending violence and stigma through education and advocacy" (Sex Workers' Outreach Project 2007).[2] Few was a feisty blond woman who worked for many years as a sex worker, and she stated that while she thought the SJI and CAL-PEP provided excellent services for the community, she felt that in forming nonprofits, their founders and leadership surrendered their radicalism and commitment to securing better legal conditions for sex workers to secure the money necessary for organizational survival:

> The SJI has so much potential but has never reached it out of fear of losing money. . . . CAL-PEP is an organization that's run by a black woman who has the same views as I do [about decriminalizing prostitution], but has a staff that probably thinks she is an abolitionist because this is what you have to do to work the system. . . . [The SJI and CAL-PEP] shifted from activism to service provision because there was more money here, especially with AIDS. It's all about money! . . . In short, we need to organize for law reform: fuck this service goddamn bullshit! (Robyn Few, Interview, 20 October 2006)

Few's statement thus reflects a common belief among many scholars, observers, and activists alike that forming a nonprofit represents a form of institutionalization, a process that is often associated with activist demobilization. From this perspective, activists who form nonprofits (understandably) become preoccupied with seeking grants and contracts to sustain their existence as opposed to pursuing broader social and legal goals for change (Banaszak, Beckwith, and Rucht 2003).

While this understanding of social-movement change has merit, a closer look at CAL-PEP, the SJI, and the evolution of the sex-worker rights movement indicates that this understanding is also limited in two key ways. First, by reinforcing notions that oppositional politics are best advanced through the employment of noninstitutionalized, disruptive action (Sawer 2010), it valorizes groups capable of highly conflictual, demonstrative public protest over those who advance oppositional political claims by other, less visibly disruptive means—namely, those whose "arsenal of political activism" draws only fleetingly on demonstrative protest activities and, more rarely, on violent activism (Katzenstein 1998b: 196). For socially, sexually, and legally marginalized groups, such as women involved in the prostitutes' rights movement, their arsenal was limited not only by traditional gender role stereotypes but by their legal status, which made it difficult for COYOTE to raise funds and recruit large numbers of prostitutes, as many feared that being visible as activists would place them at risk for arrest (Weitzer 1991; West 2000). Therefore, labeling their (and other) activists' shift to nonprofit service as "cooptation" (or "depoliticization") serves only to minimize their efforts and place a premium on disruptive, publicly visible, state-centered repertoires of collective political action (Andrew 2010).

A second limitation of the conclusion that associates the institutionalization of activist goals with movement demobilization is that it precludes examining and specifying how activists continue their work once the movement reconfigures into new, often more formal institutions (Andrew 2010: 609). Even Frances Fox Piven and Richard Cloward—arguably the staunchest defenders of visible, protest-oriented politics—acknowledge that activists often reconfigure and formalize their strategies. Despite their famous declaration that "organizations endure by abandoning their oppositional politics" (Piven and Cloward 1977: xxi), they recognized that "often the resulting changes that are implemented may only be modest improvements to the existing system" (Schram 2002: 51). For prostitute-rights activists and many others, forming

nonprofits represents such a modest improvement, but this formalization does not necessarily signal the end of their resistance efforts.

Instead, by gathering and serving marginalized communities, and by engaging in the policy process, social movement–borne nonprofits like CAL-PEP and the SJI often continue advancing the movement's goals by doing—as Myra Marx Ferree and Patricia Yancey Martin label it—*"the work of the movement"* (1995: 3). Even though CAL-PEP and the SJI were formed as service organizations, the preceding chapters demonstrated how they carry out the work of the sex-worker rights movement by providing spaces that gather and potentially empower a stigmatized and marginalized community. Although many of the sex workers I interviewed at CAL-PEP and the SJI had varied opinions about decriminalizing prostitution (or felt they did not have the capacity for political action at this point in their life), many of them did claim that the SJI and CAL-PEP inspired them to get involved in civic life in the future. Staff members, such as Ashly and Grant, did participate in advocacy for sex workers (and other street-based populations) in some way, indicating that social movement–borne nonprofits may connect their staff and clients to broader oppositional political struggles.

Moreover, nonprofits' emergence from social movements does not preclude other activists from seeking broader social and legal changes by other means; in fact, these social change efforts may continue and expand in their wake. But in the case of the prostitutes' rights movement, these expanded efforts may not be immediately apparent. When activists began shifting in the 1980s from protest to service provision with CAL-PEP, such observers as Nancy Stoller concluded that "the child [CAL-PEP], as it were, swallowed the parent [COYOTE]" (1998: 89–90). Carol Leigh, a founding COYOTE member and sex-worker rights activist, maintains a Prostitute Education Network site, www.bayswan.org, which lists a phone number and post-office box address for COYOTE in San Francisco. However, this incarnation of COYOTE exists mainly in name and no longer publishes newsletters, meets regularly, or holds fundraising or membership drives. A COYOTE chapter in Los Angeles also has a website (http://www.coyotela.org/what_is.html), but it states that they no longer hold meetings as "previous support meetings were suspended when all the responsibility for meeting organization and member contacting fell on one individual and the other members did not contribute time or money to keep the meetings going."

However, even as COYOTE has faded, a wider network of advocacy and protest-oriented organizations has emerged in its wake to challenge formal

and informal state and societal institutions, demonstrating that protest politics need not be abandoned with the ascendance of nonprofit organizations. In the United States, SWOP is the most visible and active of the sex-worker rights movement's protest organizations, post-COYOTE. Formed by sex workers active in or sympathetic to COYOTE's work, SWOP's first major action was to organize the first annual International Day to End Violence Against Sex Workers in 2003, with a memorial for the victims of convicted prostitute murderer Gary Leon Ridgway (also known as the Green River Killer). In 2004, SWOP's most visible effort (which received coverage in the *New York Times*) was to spearhead a ballot initiative (Measure Q) to decriminalize prostitution in Berkeley, California, by making it a low enforcement priority for the police (Marshall 2004). Although Measure Q was defeated, in August 2008, SWOP was a key player in a coalition of activists who qualified to place Proposition K, a similar measure, on the San Francisco ballot in November 2008 (which also failed). And additionally, throughout the United States, the Red Umbrella Project, the Desiree Alliance, and the Network of Sex Work Projects also continue efforts to decriminalize and destigmatize sex work.[3] Outside of the United States, COYOTE and the prostitutes' rights movement more broadly has also inspired the creation of protest and advocacy-oriented organizations worldwide, including the Red Thread in the Netherlands, the Sex Professionals of Canada, the United Kingdom Network of Sex Worker Projects, the Australian Scarlett Alliance, the Sex Work Alliance of Nigeria, and the National Network of Sex Workers. In COYOTE's wake, these advocacy organizations employ a repertoire of actions, including public-awareness campaigns, demonstrations, and fundraising events (among other activities) aimed at reconstructing sociolegal understandings of prostitution as a legitimate work and civil-rights issue.

Institutional Impact: The Possibilities of Policy Coproduction

If we accept that nonprofit formation by activists does not necessarily preclude their movement's resistance efforts, what responses might these nonprofits compel from the institutions that they often engage with (and challenge)? Answering this question raises broader questions about the influence of social movements more generally, but scholars disagree about how to measure and determine these movements' outcomes, consequences, potential

impact, and success. As Marco Giugni (1999) notes, the study of social movements usually focuses on their emergence and mobilization, and so we know less about their consequences (or impact).[4] As a result, with the exception of studies that consider policy changes that result from protests, there is little information about the outcomes and impact of social movements. Even the field of new institutionalism—which considers the interactions between (political) actors and institutions—contains virtually no analysis of this subject (Banaszak and Weldon 2011).

It is not surprising, then, that scholarly discussions of social-movement outcomes also largely ignore nonprofits' potential institutional impact: one reason for this ignorance is that much of the social-movement scholarship has focused on the movements that flourished in the 1960s (and those more recent movements modeled on them), characterized by their visible protest activities against the state and dominant norms, and loosely organized structures (Andrew 2010). And so even as there has been an unprecedented amount and diversity of new organizational activity by social-movement actors since the 1970s (Minkoff 1997)—including activists' widespread adoption of the nonprofit form—social-movement scholarship has paid little attention to this nonprofit formation, if not dismissed it altogether (Cress 1997).

But if scholars are curious about determining the outcomes and impact of social movements on their institutional targets, examining social movement–borne nonprofits is potentially instructive. After all, if we accept the definition of social movements as sustained challenges to power holders by a disadvantaged population who live under their jurisdiction and influence (Tarrow 1996, 1998; Tilly 2004), then we should always be open to other means and venues through which activists continue these challenges (Meyer 2005), particularly as they direct them toward mainstream (government) institutions. Furthermore, if we accept the new institutional insight that mutual synergies may exist between government and nonprofits, it is possible that these institutions will also respond to and be influenced by nonprofits.

CAL-PEP's and the SJI's experiences indicate that—much like the rape crisis centers and needle exchanges described previously—activists may not only continue advancing social-movement goals through the nonprofit sector. As coproducers of government policy, they may also compel (favorable) responses from the (government) institutions that they originally challenged in at least two key ways. First, CAL-PEP and the SJI demonstrate how social movement–borne nonprofits may gain recognition from representatives of these institutions as experts and leaders (in this case regarding the provision

of occupational health and services to the sex-worker community). In my interviews with various government officials, they stressed repeatedly that CAL-PEP and the SJI provide much-needed services to hard-to-reach populations, and as a result, officials have learned a lot from the two organizations. At the San Francisco AIDS Office, which brings in funding from the CDC and the state and city government, among other sources, and distributes it to community organizations like the SJI, I met with two program managers who work specifically with the SJI to help them develop and implement services for sex workers (Interview, 27 February 2007). The managers recognized the SJI's efforts by stating that "the SJI is very good at employing a nonjudgmental harm-reduction approach [to sex worker health]." In explaining this statement, one of the managers added further that "the SJI is a place where you can totally be who you are and not be ashamed. The SJI takes cultural competency to another level—whatever level of sex work you do is okay, and they don't exclude anyone." And outside of San Francisco, international organizations have also recognized the SJI's work. In 2012, the Global Network of Sex Worker Projects nominated their public-awareness campaign (discussed in Chapter 4) for a consultancy to the World Health Organization.[5] As part of this consultation in Geneva in January 2012, a representative from the SJI presented the media campaign to the World Health Organization as part of their broader effort to "develop World Health Organization guidelines on HIV prevention, treatment, care and support services in lower and middle income countries for female, male and transgender sex workers and their clients. When published, the guidelines will include specific recommendations for health care providers as well as good practice in areas of community mobilization, human rights and violence against sex workers" (SJI 2012a).

Similarly, government institutions have also recognized CAL-PEP for its work providing essential services to marginalized communities. As Alameda County Supervisor Keith Carson explained to me, the county supports CAL-PEP, and because of the organization, "the county has not shied away from sex-work issues" (Interview, 11 January 2007). An official from the Alameda County AIDS Office, which funds CAL-PEP for HIV testing, described how its relationship with CAL-PEP has grown. Since she came to the Office of AIDS, she met with CAL-PEP's leadership over time to understand how they could connect people (particularly sex workers) with existing services. She told me that "nonprofits like CAL-PEP are the real experts," and they are also "strong, knowledgeable, compassionate, and understanding, and have a rapport with clients they serve." CAL-PEP, she added, is also one of the few agen-

cies that "researches their own work." As a result, she commended them for "going beyond looking at what they do and the results to ask and answer the bigger 'so what' questions" about their work (Interview, 29 November 2006). Added Ron Persons, another official with the Alameda County AIDS Office, CAL-PEP has "done a great job with the sex-worker community and hiring lots of peers to work in the off hours. They have been a major player in the AIDS epidemic and will continue to do so" (Interview, 29 November 2006).

In addition to being recognized by mainstream institutional actors for their work, CAL-PEP and the SJI also indicate a second potential response that social movement–borne nonprofits may compel from more mainstream institutions: they may change how various government agencies develop and deliver programs and services. In San Francisco, the fact that the SFDPH funds the SJI, the world's only occupational health and safety clinic for sex workers, represents a significant departure from business as usual for this government institution (especially if one recalls that it once confined all prostitutes to a district and subjected them to required medical exams, as described in Chapter 2). In addition to providing a new method of government service delivery to sex workers, the SJI has also expanded how this agency reaches and responds to this community. With the support of San Francisco Supervisor Jake McGoldrick and SWOP, the SFDPH implemented a sex-worker grievances hotline, where sex workers can anonymously file (via phone or e-mail) complaints about the police, public-health officials, or any other issues they might want to discuss (McGoldrick 2006). According to Dr. Klausner, beginning in April 2007, the SFDPH would review the information collected in order to determine what issues were most pressing to sex workers and how to best move forward. Klausner also noted, at the time of the interview, that the SFDPH had five calls and two e-mails, and they were working with SJI and SWOP to "get the word out" about the hotline since the least empowered sex workers—namely, street workers, who are most likely to be mistreated by the police and other public officials—are often the least likely to call and share such information (Interview, 31 October 2006).

Outside of San Francisco, CAL-PEP also indicates how social movement–borne nonprofits may influence and change how national government agencies like the CDC develop and deliver programs and services. As noted previously, COYOTE activists created CAL-PEP through a partnership with Project AWARE, which was part of the CDC program to study HIV/AIDS transmission risk and prevention among sex workers in the 1980s (Darrow 1990). CAL-PEP's participation helped the CDC understand that sex work-

ers did not constitute a major source of HIV transmission to the "general" population. Furthermore, it showed the agency that peer-based HIV prevention interventions were a more effective means of reaching sex workers (and other communities considered at higher risk for the virus). By 1988, as a result, the CDC was delivering the bulk of their HIV/AIDS prevention services through local peer and community-based nonprofit organizations like CAL-PEP, making them laboratories, in a sense, for the CDC to observe and learn about different HIV prevention interventions (Bailey 1991). From these partnerships with organizations like CAL-PEP, the CDC created a Community Demonstration Research Group to study these interventions in five cities to see how they might produce behavioral changes at the community level among female sex workers and other women who trade sex for money or drugs, but also injection drug users, female sex partners of male injection drug users, youth in high-risk situations, non–gay identified men who have sex with men, and residents of census tracts with high HIV rates. All sites used a common intervention protocol informed by earlier efforts like Project AWARE that involved community members to distribute and verbally reinforce safe-sex messages and materials among their peers; create small media materials featuring role-model stories with prevention messages; and increase availability of condoms and bleach kits. Overall, the study found that these interventions were effective and worth replicating, leading to the conclusion that "community level interventions can modify HIV risk behaviors" (CDC AIDS Community Demonstration Research Group 1999: 343).

Some Limitations
Government Power

Using CAL-PEP and the SJI as examples, this book has shown how social movement–borne nonprofits may continue the resistance efforts they emerged from and compel responses from the institutions they have challenged and worked with. Yet even as these results may demonstrate the mutual synergism (per Gronbjerg and Smith 2006) between government and nonprofits, this relationship has real limits that merit consideration. The first of these limits rests in the fundamental power imbalances between nonprofits and state agencies when they coproduce policy. As CAL-PEP's experience with the CDC's Diffusion of Effective Behavioral Interventions (DEBI) program indicates, nonprofits—no matter how radical or oppositional their

origins—often have less power and autonomy in these relationships to represent and serve their constituents than they desire.

The CDC began the DEBI program in 2002 as the largest centralized effort to diffuse evidence-based prevention science to fight HIV/AIDS in the United States. Essentially, the program's goal was to bridge the gap between researchers primarily associated with academic institutions, who were developing and empirically evaluating behavior-based HIV prevention strategies based on established theories of psychology and behavior change, and community-based service providers, who have historically provided the "homegrown" programs that they developed in direct response to needs they saw within their constituent populations (often without rigorous scientific evaluation, even though they filled important service gaps) (Owczarzak and Dickson-Gomez 2011). Thus far, the CDC has identified and tested twenty-six interventions with sufficient empirical evidence of their effectiveness to broadly disseminate (many of these were originally created by community-based organizations and tested through the CDC's Demonstration Project, described above) (Owczarzak and Dickson-Gomez 2011: 106). Although the list of DEBIs is currently extensive, and these interventions reach a range of populations, two DEBIs reflect the early efforts of sex workers, through Project AWARE, to conduct peer outreach to women: SISTA (Sisters Informing Sisters About Topics on AIDS), which targets African American women at higher risk for HIV (such as street-based sex workers) and uses small-group interventions to prevent HIV risk behavior through culturally relevant activities, including group discussions, videos, and role playing; and RAPP (Real AIDS Prevention Project), which targets women at risk, with activities including using peer networks for community outreach and engaging individuals in safer-sex discussions (Wolitski et al. 2006).[6]

In many ways, the DEBI programs exemplify the reciprocal, mutually synergistic, and influential relationship that can exist (in the process of co-producing policy) between nonprofit service providers (social movement–borne or not) and mainstream, governmental institutions. As Shari Dworkin and colleagues (2008) write, the DEBI program brings these science-based, community- and group-level HIV prevention interventions to community-based service providers and state and local health departments to reach specific target populations considered at high risk for HIV at the individual, group, and community levels. To prepare for implementing their particular DEBI program, funded organizations receive training from the CDC about the specific intervention of interest. They are provided with guidelines for

adapting interventions that include the requirement of adherence to "core elements"—those elements of an intervention that lead to the desired behavioral outcomes and must be implemented locally (Dworkin et al. 2008). Between 1999 and 2008, the CDC's DEBI program trained over ten thousand service-provider participants from more than five thousand agencies (Owczarzak and Dickson-Gomez 2011: 106).

But on closer examination, the DEBI program also indicates the "inequitable distributions of power and control among funding agencies, health departments, and service organizations" (Dworkin et al. 2008: 54). In CAL-PEP's case, after a particularly lean period following the economic collapse of 2008, they received a $400,000 grant in 2010 from the CDC, which came as a relief. But reflecting the CDC's focus on planned interventions like DEBIs, Dillard Smith explained to me that CAL-PEP would not have free rein with this grant to develop new, nonjudgmental interventions that reflected their commitment to sex-worker rights and meeting the needs of the street-based populations they serve. Instead, she said that they would be "doing many planned interventions (DEBIs) with this grant." Dillard Smith explained further that this was because "the CDC wants very 'outcome-y' stuff" and so DEBIs—with their clear structures, goals, guidelines, and targeted outcomes—are what the CDC will fund nonprofits to do." In short, as Dillard Smith understood it, this was because "we are now in a trend where the government wants to support what we do [help poor people, etc.] as long as we do their damned DEBIs" (Interview, 6 July 2010).

CAL-PEP was and is experienced with DEBIs: it had run the SISTA program for many years; however, CAL-PEP's reflections on the prospect of doing more DEBIs indicates the power imbalance in this government-nonprofit relationship. For CAL-PEP, as Dillard Smith explained further, while committing to DEBIs provides them with funding and programming opportunities, it also left them with less room for innovation, all of which often made CAL-PEP's program delivery seem rigid and nonresponsive (Interview, 6 July 2010). This sentiment was and is not unique to CAL-PEP: research shows that community-based organizations that deliver these DEBIs must adapt the program's components to fit the local needs and populations while still maintaining the internal logic that contributed to the intervention's effectiveness (Collins et al. 2006). Therefore, they have to do formative assessments of their communities but then accept and implement the DEBI program accordingly, leaving little room for nuancing and adapting it to local conditions (Vega 2009).

To illustrate this challenge, Dillard Smith explained that before imple-

menting a DEBI, the CDC required CAL-PEP to conduct an epidemiological analysis of the rates of HIV infection in the area the program would serve (which meant having staff map out the regions in their area with the highest rates of infection). However, said Dillard Smith, once they received the grant for the DEBI, they could only implement it in the mapped areas. But by that time, she explained, HIV rates had begun increasing in other (unmapped) areas where they could not go because these areas did not fit into the plan. As she explained to me, it was not surprising that the marginalized people they serve were experiencing higher rates of infection because, under the constraints of their grants, organizations like CAL-PEP were less able to respond to their needs in more nuanced, flexible ways (Interview, 6 July 2010).

These power imbalances are evident further when it comes to data collection. Evaluating DEBIs requires implementing organizations to collect data and evaluate their outcomes and effectiveness. As the previous chapters indicated, data collection is useful to these organizations in many ways; however, many nonprofits and other community-based organizations that implement DEBI programs often lack the resources to complete the required program evaluations (Collins et al. 2006; Vega 2009), which was the case for CAL-PEP. As Dillard Smith explained to me about the upcoming DEBI implementation, while the grant would pay for the DEBI's delivery, "[CAL-PEP] can't [afford to] pay for the administrative support [with the grant] to collect the data for the outcomes." Dillard Smith added that "CAL-PEP is plugging away and trying to do something and be on the ground . . . [but then] the government keeps taking away the infrastructure that supports organizations like us" (Interview, 6 July 2010).

The Status Quo

In addition to these power imbalances, a second limitation of the government-nonprofit relationship is that government institutions are more likely to work with and be influenced by nonprofits that adhere to the status quo (if not more conservative values), as indicated by the increased state support for religious (or "faith-based") nonprofit service providers in the past decade. As Gwendolyn Mink writes, after President George W. Bush's election victory in 2000, he summoned "armies of compassion" to fulfill government's social-policy obligations by delegating the delivery of social services from government agencies to (nonprofit) proponents of faith. Through a statutory inno-

vation termed "charitable choice," government would inadvertently "spread the gospel of faith to single mothers, unwed fathers, substance abusers, the homeless, and the imprisoned" (2001: 5).[7] Although many of these organizations provide important services to help the homeless, the unemployed, and the poor, to name just some groups (Cadge and Wuthnow 2006), many also promote traditional religious—if not very conservative—social goals, thereby illustrating the power of government institutions to support nonprofit efforts that reinforce the status quo.[8]

Regarding sex workers, we see that while government institutions will work with more radical nonprofits like CAL-PEP and the SJI to reach this population, they will often work more closely with COYOTE's nonprofit organizational descendants that reject its goals and ideals and subscribe to the status quo notion that sex work (and prostitution in particular) is not a legitimate occupational choice. In the Bay Area, Standing Against Global Exploitation (SAGE), which was founded in 1992 by the late Norma Hotaling (a formerly homeless heroin addict and street prostitute), is the most prominent of these organizations.[9] Hotaling stated that she was once active with COYOTE—"toeing the line that prostitution was good for my self-esteem, and that I was pro decriminalization"—but after working with a therapist who linked her experience in prostitution to issues of depression, post-traumatic stress, suicidality, and drug use, she left COYOTE and founded SAGE (Interview, 26 May 2006).

SAGE is devoted to helping women, men, and transgender individuals leave the commercial sex industry, and it provides trauma recovery services, substance-abuse treatment, vocational training, housing assistance, and legal advocacy to persons in the sex industry. In addition to providing services, SAGE is also a countermovement to the COYOTE-oriented prostitutes' rights movement: it is strongly informed by abolitionist feminism and thus largely rejects the distinction between voluntary and involuntary prostitution, as indicated by their "one primary aim: bringing an end to human trafficking and the commercial sexual exploitation of children and adults."[10] SAGE thus believes that "most women and girls are coerced, defrauded, or forced into commercial sex, and are exploited for the commercial gain of others" (Shively et al. 2008: 48) Therefore, while SAGE is client centered in that it provides services to anyone in the sex industry regardless of whether they plan to leave it, SAGE does not support prostitution as a legitimate occupational choice (Hotaling, Interview, 26 May 2006).

Because its position on prostitution is politically popular with various lo-

cal, state, and federal administrations, SAGE has gained extensive recognition for its efforts and has shaped how government agencies—particularly in the criminal-justice sector—respond to prostitution. The recognition that SAGE has gained is apparent in the extensive financial support that it has received for its efforts. According to a SAGE representative (Interview, 18 May 2006), the organization's budget for 2007 was \$2.1 million, 86 percent of which is from government sources, such as the local health department and the federal Department of Justice. And in conversations with various government officials, particularly at the city level, this recognition extends further. According to Lane Kasselmann, a representative from the then Mayor Gavin Newsom's office and point person on sex-work policy issues, the mayor's office meets with sex-worker activists regularly, including representatives from sex-worker rights organizations like SWOP; his office "deals with them like they do any other interest group" and "will sit down and work with and listen to them." However, he added, "they work with SAGE on everything, and Norma Hotaling [was] a good friend of the mayor's." In the eyes of his office, "SAGE does 'God's work' and is setting the bar internationally and across the country" (Interview, 22 November 2007).

SAGE has also played a key role in shaping how government institutions (especially in the criminal-justice system) respond to prostitution in the city. In the 1990s, when San Francisco residents were increasingly concerned with the presence of street-based sex workers in neighborhoods, the San Francisco Police Department, the district attorney's office, and SAGE began "collaborating to identify new approaches to reduce the volume and impact of commercial sex within San Francisco." They decided to work together because they were all "in agreement that the most promising direction for the program would be a focus on reducing the demand for commercial sex, and that the best way to accomplish demand reduction was education rather than trying to punish the problem away" (Shively et al. 2008: 11). Together they established the First Offender Prostitution Program in 1995.

In part of this program, prostitutes (mostly female) arrested for prostitution have the option to work with SAGE, where they are first given (in lieu of jail) in-custody and out-of-custody assessments, referrals, peer support, rehabilitation, vocational training, and case management. However, the program also targets "johns" (men who solicit prostitutes) who are arrested by giving them the option to pay a sliding-scale fine of up to \$1,000 and complete a first-offender class (in lieu of prosecution), where they learn about the legal, social, and economic implications of their actions (and prostitution more generally). According to

the representative from the San Francisco district attorney's office, all of these programs represent a way to "start thinking outside of the box with prostitution" by "improving the lives of those arrested because of their contact with the criminal-justice system." He added that instead of simply punishing johns by sending them to jail, the First Offender program can "break the cycle of prostitution by making people stop and think about what they are doing" (Interview, 25 October 2006). Indeed, sex-worker rights advocates would disagree with this sentiment, but it indicates the influence that nonprofits may have on government institutions if they are willing to adhere to and support the status quo.

Resistance Maintenance Going Forward

Despite the very real challenges and limitations that activists face when they enter the nonprofit sector, CAL-PEP and the SJI indicate how social movement–borne nonprofits may negotiate institutional constraints and continue resisting the broader sociolegal order that affects their constituents. Although small case studies like these can never firmly establish general theoretical propositions, they can play an important role in building knowledge and highlighting important dynamics and processes that scholars may test for and further define in other settings, and they expand our understandings of broader phenomenon (Gerring 2004).

Therefore, even though they may be small and regionally specific organizations, CAL-PEP and the SJI engage with a dilemma that has bedeviled a wide range of activists in the United States for decades: balancing service delivery with advocacy work while receiving funds from governmental sources. As a result, they are much like a range of other nonprofits nationwide, such as Helping Individual Prostitutes Survive (HIPS) in Washington, D.C., which offers harm-reduction services to men, women, and transgender individuals engaged in sex work, to help them protect their health and safety. In New Orleans, Women with a Vision engages in advocacy, health education, supportive services, and community-based participatory research to improve the lives of marginalized women, particularly those engaged in the sex industry. And Project Safe, in Philadelphia, "is an organization dedicated to ensuring the health, safety and survival of women on the street by providing advocacy, education and support using a harm reduction model" in an effort to reduce the transmission of HIV, hepatitis C, and other infections among working women.[11] And beyond organizations gathering and serving members of the

sex-worker community, various nonprofits exist that are involved in a myriad of social-welfare issues and serve a range of groups. CitiWide Harm Reduction in the Bronx, New York, for example, was founded by a drug user and offers services to other drug users, while also advocating for policies that protect the rights of drug users, the homeless, and people living with HIV. The Empowerment Program in Denver advocates for and works to decrease the poverty of women involved in the criminal-justice system by providing street outreach, onsite education, employment training, counseling, and supportive services. And Bread and Jams in Boston seeks to promote empowerment, self-advocacy, and a sense of community among homeless individuals through their drop-in program (that provides for basic needs, such as showers) and connections to services, while also maintaining a broader commitment to the eradication of homelessness.[12]

Clearly this list is not exhaustive, but it demonstrates the range of organizations nationally that gather and serve members of marginalized communities while potentially maintaining a commitment to advocating for their rights (Isaac 2003; Sirianni and Friedland 2001). And they are doing this at a time when nonprofits of all types are a large and growing part of the civic and political universe, due in large part to the broader devolution of welfare responsibility onto these organizations (Banaszak, Beckwith, and Rucht 2003). Furthermore, they are also active at a time when political participation is increasingly the domain of the educated, affluent, and politically interested (Galston 2001, 2007; Verba, Scholzman, and Brady 1993; Dalton 2008).

In this context, the reality is that nonprofits are often the only link between government institutions (and the broader political process), and some of the most marginalized members of society (Berry 2005). The remainder of this chapter thus considers how governmental and societal actors may support organizations like CAL-PEP and the SJI so they may empower and serve their communities and gain a larger voice in the polity.

Nonprofit Law

One way to empower nonprofits is to educate them about how they may employ various political-advocacy strategies without compromising their tax-exempt status or data-collection duties. The H-election is an inexpensive, simple way to facilitate this empowerment because it allows nonprofits to devote a specified portion of their resources to political activities like

lobbying without risking their tax-exempt status. By signing IRS form 5768 (which is free), nonprofits register themselves with the IRS and are subject to an expenditure test, under which they may devote a percentage of their tax-exempt purpose budget to directly lobbying legislators. According to the IRS, H-electors may devote up to 20 percent of the first $500,000 of their exempt-purpose budget to lobbying. However, such measures require most nonprofits to overcome significant knowledge and resource constraints. In line with Berry and Arons's findings, the SJI and CAL-PEP are among the 97.5 percent that have not made the H-election (Berry and Arons 2003). Even if many nonprofits like CAL-PEP and the SJI do not have money in their budgets for political activities, making the H-election would at least ease any insecurity about the lobbying they may do, even if it costs little to nothing. Such activities may include, for example, sending e-mails to legislators or taking a group to City Hall to testify in hearings about the passage of by-laws that relate to their community.

Nonprofits also have the option to create separate advocacy organizations under section 501c4 of the IRC. According to the IRC, "An organization is operated exclusively for the promotion of social welfare if it is primarily engaged in promoting in some way the common good and general welfare of the people of the community" (2013: Section 501c4). Although this type of organization is explicitly prohibited from directly participating in or supporting candidates in political campaigns for public office, it does allow these organizations to work in the interests of their constituencies. Specifically, 501c4 organizations may do this in ways that "primarily promote the common good and general welfare of the people of the community as a whole" (Reilly, Hull, and Briag-Allen 2003: I-3). To create a 501c4 organization, one must complete IRS Form 1024 and submit it to the IRS with either a $400 or $850 filing fee.[13]

For example, Planned Parenthood clinics (or "affiliate organizations") are registered under section 501c3 (with its attendant restrictions on political activity), and their focus is on offering reproductive health services. However, the Planned Parenthood Action Fund is registered under section 501c4, which allows it to "engage in educational and electoral activity including public education campaigns, grassroots organizing and legislative activity" (www.ppaction.org). While it may be costly for a nonprofit with a smaller and less affluent donor constituency (than Planned Parenthood, for example) to spend the time completing the required paperwork and paying the required fee to do so (to say nothing of paying staff to do the work "promoting the common good"), it may well be worth the expenditure, as it allows a non-

profit organization even more leeway for conducting advocacy and lobbying activities.

Permitted "Lobbying"

Even if nonprofits do not make the H-election or create 501c4 organizations, there are many other ways that they may interact with mainstream institutions to influence policy with and on behalf of their constituents. One way is to engage in the "nuts and bolts" of the policy-making process by effectively "lobbying" in ways permitted by nonprofit law: these activities include advising government agencies and testifying at legislative hearings, to name just two examples. In the HIV/AIDS prevention field, such lobbying has brought previously excluded groups into the realm of AIDS service politics and policy development, and it has helped marginalized and underserved groups, such as gay men and women, sex workers, and intravenous drug users, advocate for and help government agencies develop policies and programs that better meet their needs. For gay men and sex workers, forming nonprofits concerned with HIV/AIDS prevention brought them into synergistic relationships with such mainstream institutions and helped previously excluded and stigmatized groups become players in the realm of health-service provision and policy development.

While grants are often scarce, and data-collection and other accountability requirements are onerous, nonprofits like CAL-PEP and the SJI continue engaging in the policy process in a variety of ways to help government agencies deliver services more effectively to underserved communities. As a nonprofit with a long history in policy coproduction, CAL-PEP's experience indicates that these activities keep nonprofits on the "radar" of their funding agencies; however, it also indicates their potential for policy influence. Gloria Lockett told me that the Substance Abuse and Mental Health Services Administration (SAMHSA) recently asked her to be part of a review panel that was considering twenty different applications for HIV/AIDS prevention grants. I asked her if she was going to do it, and despite having a full plate (CAL-PEP had just moved again to another office space and was in the process of opening a clinic), she answered, "Of course, I said yes—they give out million-dollar grants!" (Interview, 12 February 2012). While no one can say for certain whether SAMHSA may thank Lockett for her service one day with a million-dollar grant for CAL-PEP, in the meantime, her work here as an

HIV/AIDS prevention expert can inform grantee selection and how policies and programs are developed for and delivered to other marginalized communities nationwide. This is but one example of how nonprofits—and social movement–borne nonprofits that represent underserved and underrepresented communities, in particular—can and do seek influence in the policy-making process.

Connections to Broader Movements

Although working within mainstream institutional structures may help social movement–borne (and other) nonprofits represent their constituents in the broader political process, it is important for them to maintain connections with broader movements for social change. One major criticism of the "nonprofitization" of protest is that it places community-based organizations into competition with each other for grants and therefore deters them from working together to advocate for broader changes to help their community, such as universal health care and a more just and equitable distribution of resources overall. Certainly we see organizations like CAL-PEP and the SJI in this situation. In fact, when I began my research with CAL-PEP in 2006, they shared their office space with AIDS Project East Bay, another nonprofit organization that offered HIV/AIDS prevention, education, and testing services in the Oakland area, and as a result, they were often competing for the same grants. While they occasionally shared grants and work—sometimes, for example, the CAL-PEP mobile van would do testing events with AIDS Project East Bay—both organizations were understandably more focused on their own organizational survival than working together for broader social change.

At the same time, CAL-PEP and the SJI indicate there is room for social movement–borne nonprofits to build alliance formation into their own institutional practices. CAL-PEP's long-standing participation in the San Francisco AIDS Walk, for example, is one way they link their particular community's interests with the broader struggle for HIV/AIDS awareness. The SJI has also connected with groups fighting for reproductive justice. When we met in July 2010, Ashly (Interview, 30 July 2010) told me that the SJI had joined the Reproductive Justice Network. Funded and created by the Third Wave Foundation in 2003 "to help build solidarity and movement between young people, particularly young women of color and transgender youth, who have been

overlooked, unheard, or tokenized within the larger movement," the Network works "to examine the impacts of race, sexuality, class, economic status, educational status and ability on an individual's capacity to live autonomously and engage fully in civil society. With our support, grassroots organizations have solidified bases of social justice movements, defeated harmful legislation, increased access to reproductive and sexual health education and care, and shifted the terms and framework of national debates on gentrification, gender, and reproductive health" (Third Wave Foundation 2012).[14] In the SJI's case, working with the Network helped them link the struggle for sex-worker rights to broader issues of reproductive health and choice. As Ashly explained to me, "People [in the Network] really get that we need to link [the issue of] mothers being handcuffed in prison while giving birth to issues of sex-worker rights. We need to see reproductive justice issues go beyond choice" (Interview, 30 July 2012). In essence, the SJI indicates how social movement–borne nonprofits can focus on organizational survival while also connecting their community to others facing similar injustices.

Nonprofits like CAL-PEP and the SJI gather, serve, and represent some of the most marginalized Americans. Going forward, governments will increasingly rely on such nonprofits to do more with less as the economy slowly recovers and dollars for social programming remain increasingly scarce (in both the nonprofit and public sectors). Recognizing and encouraging political engagement by nonprofits like CAL-PEP and the SJI is therefore a worthy goal if we are concerned with their well-being and that of the marginalized, underrepresented communities they serve. Sex workers like Tasha and Monica certainly—but also drug users, prisoners, women on welfare, and undocumented persons—have the most to lose when the nonprofits that gather, serve, and represent them are silenced in the political process. We therefore must continue searching for, supporting, and invigorating organizations like CAL-PEP and the SJI so they can make demands for recognition and claim their fair share of resources, which will benefit their constituents. Our democracy demands it.

A Note on Methods

The so-called Perestroika movement within the American Political Science Association raised concerns that "the enterprise of political science is becoming identified too exclusively with heavily mathematical work" (Chronicle of Higher Education 2002: B10; Isaac 2010; Kasza 2010; McGovern 2010; Yanow and Schwartz-Shea 2010). But even as a growing number of scholars in the discipline have since argued that qualitative and quantitative research share similar scientific concerns with concept formation, the relationship between empirical evidence and conceptual confirmation and development, and causal complexity, to name just a few (Thomas 2005), qualitative research is still infrequently featured in many (mainstream) political-science publications.

But political scientists have not shied away from qualitative research: this book is but one example, and the following pages explain the methods I used to complete this work. Before embarking on an explanation, however, I also highlight the potential of qualitative methods for illumination and reciprocation. In so doing, I am not trying to rehash the Perestroika debates. Instead, I use this discussion to indicate how these methods may help political scientists collect data to solve research puzzles and, more important, highlight the voices and experiences of marginalized and understudied communities.

Illumination

My research indicates how qualitative methods can serve illuminating purposes; that is, they may be used to draw attention to the political struggles of populations not traditionally studied in the discipline, such as sex workers. Despite the political questions and controversies their work raises, little

scholarly analysis of sex workers exists in political science, especially regarding how they participate in political life (for recent exceptions, see Schotten 2005; Showden 2011; Majic 2011). At first glance, this lack is somewhat understandable: criminal status and related societal stigmas render sex workers a largely "hidden" population that is difficult to access via traditional social-science research methods (Lee and Renzetti 1990). As a result, there is no available data about sex workers that provides an accurate demographic snapshot of their community and, hence, the issues they face. Instead, most of this data (including that from the Bureau of Justice Statistics) is unrepresentative, often based on information given by arrested or jailed prostitutes (Norton-Hawk 2001; Weitzer 2005, 2010a).

Yet despite these challenges, good reasons abound for scholars concerned with the political struggles of marginalized people to study sex workers. First, the American sex industry is vast, even by the most conservative estimates. As Ronald Weitzer (2011: 1) documents, in 2006 alone, Americans spent $13.3 billion on X-rated magazines, videos, and DVDs; live sex shows; strip clubs; adult cable shows; computer pornography; and commercial telephone sex. In addition to these legal forms, an unknown amount is spent on prostitution, which is almost universally criminalized in the United States. Second, while there is no reliable demographic profile or population count of persons who work or have worked in the sex industry (despite its size), existing research indicates that they face multiple and intersecting stigmas and, by extension, barriers to participation. Although abolitionists (described previously) argue that sex work—and prostitution specifically—is inherently violent and exploitative to all who engage in it, in fact sex workers' marginalization results from a variety of socioeconomic and legal factors. Studying sex workers' engagement in the polity, then, illuminates critical questions that often do not arise from the lives of those in dominant positions by allowing researchers and policy makers to "see from below" (Haraway 1990: 181). Given sex workers' barriers to participation, CAL-PEP's and the SJI's emergence and growth from the sex-worker rights movement raises a set of puzzles and questions— and, hence, potential insights "from below"—that are worth examining.

Reciprocation

To begin such a research project with sex workers (or other similarly situated communities), researchers require access to the community (and, in

this case, the nonprofits that gather and represent them); since access is not always guaranteed, it is difficult to replicate such studies. However, the process of accessing and establishing relationships with these organizations thus illustrates a second potential benefit of qualitative research: reciprocation—namely, the mutually beneficial relationship that may develop between the researcher and the community studied.

In my case, to work with CAL-PEP and the SJI, I had to introduce myself and develop relationships with their leadership, staff, and constituents. These tasks were a particular challenge for me because when I began the project I was merely a graduate student with a lot of coursework, little research experience, and no significant publication record behind me. And as a white woman from a middle-class background who had never been a sex worker and was then pursuing a doctoral degree at an elite institution, I was also positioned differently from many of the staff members and clients at CAL-PEP and the SJI (who were often persons of color, members of sexual minority groups, and members of street-based populations, including sex workers, substance users, and persons recently released from prison). Furthermore, like many nonprofits, CAL-PEP and the SJI had (and have) limited physical spaces and scarce resources, but unlike many nonprofits, they also operate from a politically unpopular standpoint and work with extremely marginalized, stigmatized individuals. Therefore, they did not want to share scarce resources with someone who could potentially harm their reputation or their clients.

As a result, I had to show them I was not just coming in to "take what I needed and leave," as Gloria Lockett, CAL-PEP's executive director, once remarked about an early experience she had with researchers (Interview, 18 July 2007). And so at both organizations, I agreed that in exchange for access to their staffs, clients, documents, and activities, I would assist with their operations in any way I could. This reciprocal agreement proved invaluable not only for gaining access to the organizations but also for learning firsthand about how these organizations operate and maintain their oppositional political commitments. Put simply, CAL-PEP and the SJI, like so many other community-based organizations, have a lot of work to do; to learn how these organizations operate, you have to help them do their work.

For many of us who have spent years in the academy, we may wonder if we have any skills that can help the organizations we want to study; after all, many of them do work that may be unfamiliar to us or that may not align

with our area of study. In my case, I was not certified to administer HIV tests or conduct harm-reduction counseling; however, I could take directions, and I could write. Therefore, as I explain below, I became involved in a range of activities, from washing dishes to filling bags for the food bank. Additionally, I wrote grants. Although one may initially look at this as time consuming and peripheral to "actual" data-collection activities like interviewing, it was an invaluable experience. Grant writing in particular is a major component of nonprofits' operations, and the process provided me with great insights into the organizations' operations, challenges, and strengths. Moreover, it also helped the organizations: some of the grant applications I assisted with were funded (and of course, many were not).

Document Research

I spent long periods with CAL-PEP and the SJI, first from October 2006 through March 2007 and then during July 2007, March 2008, and January and July 2010. As I describe in the pages below, during these visits I engaged in document-based, participant-observation, and interview research; in return, these organizations received assistance from me with grant writing and other projects as the need arose.

To understand the context that CAL-PEP and the SJI emerged from and worked in, I collected and reviewed a variety of documents, many of which are cited throughout this book. These included news articles from a variety of outlets, including the *San Francisco Chronicle,* the *San Francisco Examiner,* and the *San Francisco Bay Guardian*, and any scholarly articles and books produced by or about these organizations. I was also fortunate to obtain documents produced by each organization from their websites and in-house collections.[1] At the SJI, I completed an archiving project that involved organizing and sorting many of the SJI's books, forms, and documents; from this task, I was able to make copies of many of their intake forms, *Occupational Health and Safety Handbooks*, and annual reports. I also conducted similar work at CAL-PEP, collecting from them copies of their newsletters, intake forms, and *Street Outreach Training Manual*. Additionally, I visited the San Francisco and Oakland city archives to collect relevant documents, such as city government reports related to prostitution and sex-worker rights activism more broadly (for example, the Final Report of the San Francisco Taskforce on Prostitution). The Special Request Unit at the State of California's

Criminal Justice Statistics Center also provided me with state and local prostitution arrest statistics.

Participant Observation

At each organization I engaged in participant-observation research. At CAL-PEP, since the majority of its work is done in the community through street outreach, I was fortunate to accompany staff and participate in and observe various HIV/AIDS prevention outings (many of which are described in the preceding chapters). Over the course of these visits, I also helped the CAL-PEP staff complete grant applications for the Substance Abuse and Mental Health Services Administration, Pfizer Pharmaceuticals, and Gilead Sciences. (We received $100,000 from Pfizer.)

At the SJI, my participant-observation activities were slightly different. Since the clinic is only open for limited hours during the week, I mainly attended the transgender clinic on Tuesdays and the open clinic nights on Wednesdays. I participated in any way possible, whether it meant setting up the food and clothing bank, stocking condom baskets, or doing dishes. I also observed a group session for HIV-positive transgender sex workers, helped the SJI develop guidelines for when other researchers visit the clinic, and wrote a grant that helped them secure a new computer from the National Minority AIDS Coalition.[2]

Interviews

I conducted 140 interviews that included CAL-PEP and the SJI's leadership, staff members, and the sex workers using their services; police officers and public-health officials in Oakland and San Francisco; and activists supporting (and opposing) sex-worker rights. My interviewee recruitment took many forms. For SJI and CAL-PEP staff, public officials, and activists, I mainly requested interviews in person or through the phone or e-mail. In these cases, I also employed "snowball sampling," where I determined the point of saturation when the references interviewees provided began repeating themselves. I also triangulated and supplemented the interview information with scholarly, media, and historical-archival documents.

Given the limited information available about sex workers' engagement in the polity—and in an effort to encourage more research with this community

in the future—I provide more detail below about how I recruited sex workers who use CAL-PEP's and the SJI's services. In essence, I took the organizational leaders' advice. At the SJI, I posted a flier soliciting interviewees that gave my phone number and e-mail address; twenty sex workers contacted me to arrange an interview time. At CAL-PEP, I recruited fifteen sex workers through the organization's case managers and outreach workers, and five by attending an outing with their Mobile Outreach for Ex-Offenders project. Staff at both organizations recommended that I compensate the sex workers I interviewed for their time, and so I offered CAL-PEP clients $20 in cash and SJI clients a $20 gift card from Walgreens drugstore. Based on my (limited) research budget, I was able to recruit forty adult sex workers, all of whom were eighteen years of age or older, had exchanged sexual services for cash or other trade, and used the services at either CAL-PEP or the SJI. Table 3 provides a demographic overview. The sex workers in my sample probably do not represent the American sex-worker community writ large. While the lack of reliable demographic data about this community makes it difficult to find such a sample, the sex workers I recruited were drawn from two very particular organizations that offer health and social services in a specific geographic location. Had I been studying organizations that focused only on prostitutes' rights activism, for example, the sample would likely have been much more advantaged.[3]

Despite these limitations, however, the sex workers I did interview represented CAL-PEP and the SJI's constituencies to a fair extent. While the SJI serves a fairly socioeconomically diverse range of sex workers, my monetary incentive attracted more disadvantaged sex workers: over one-half were transgender, which is not entirely representative of all sex workers or the SJI's clientele, but it is the fastest-growing portion of the SJI's clientele due to the extreme poverty and lack of access to hormone and health-care services they often face (SJI 2009c: 7). At CAL-PEP, the sex workers I recruited were extremely disadvantaged African Americans, which is CAL-PEP's target population. Most interviews with sex workers took place in a private room at the SJI, while others took place in conference rooms at the public library or in coffee shops.

To ensure sex workers' confidentiality—whether they were peer staff, clients, or both at CAL-PEP and the SJI—I did not ask for their names, addresses, or dates of birth. In the preceding pages, I removed any details that in combination could identify these sex workers specifically, and I also used pseudonyms for them (with the exception of CAL-PEP's and the SJI's executive directors). These measures were essential because many of these interviewees had been (or were currently) involved in illegal activities, and

Table 3. Basic Demographics for Sex Worker Interviewees Who Used Services at CAL-PEP and the SJI

Characteristics	CAL-PEP	SJI	TOTAL
Age (average, in years)	44.8	40.2	42.5 (average)
Gender			
Male	7	3	10
Female	13	6	19
Transgender	0	11	11
Race/ethnicity			
African American	20	6	26
Hispanic	0	2	2
Caucasian	0	8	8
Native American	0	2	2
Multiracial	0	2	2
Education			
Graduate degree	0	1	1
College degree	1	4	5
Some college	2	2	4
High school diploma	9	4	13
Less than high school (including those who spent some time in high school but did not graduate)	7	8	15
GED	1	1	2
Receiving government services			
Government Assistance	18	14	32
Supplemental Security Income	12	13	25
MediCal	13	15	28
Food stamps	9	13	22
Temporary Assistance for Needy Families	4	0	4

some also received various government benefits that I did not want to compromise.

With all (sex worker and non–sex worker) interviewees, I used semi-structured, open-ended interview (SOEI) techniques. According to Sh-ulamit Reinharz (1992), SOEIs use loosely structured questions that permit more than "yes-no" answers, which allows for an exploration of people's views of reality while permitting the researcher to maximize discovery and description through the production of nonstandardized information. SOEIs suited my project for a number of reasons. First, without a rigid, formal structure, I was able to engage in a more dialogic interview where interviewees were also encouraged to question me and refuse to answer certain questions at any point. These factors helped diminish power dif-ferentials with the interviewees, while also clarifying my motives for re-search. Second, SOEIs allowed me to foster relationships with the subjects. Although SOIEs do not generally require long-term involvement in the re-search subjects' lives, in my cases, they were typically one or two hours in length, which was often enough time to develop a trusting relationship that allowed me to revisit them if needed. This rapport was especially useful as I developed and clarified concepts in the project's analytic phase. To il-lustrate this briefly, I engaged with the concept of "civic engagement" later in the project after I completed the initial draft. Since I had a relationship with CAL-PEP's and the SJI's leadership, I could return and ask them spe-cific, targeted questions about their own civic engagement, which would not have been possible in a standard "one-shot" survey.

Therefore, to gain a broad contextual understanding of CAL-PEP's and the SJI's origins, operations, and current activities, I asked all of my interviewees (staff, activists, and public officials) about how they support and understand CAL-PEP's and the SJI's work as service providers and sites of community engagement, and about their perceptions of these organizations' roles in the broader political and policy-making arenas. I also asked CAL-PEP's and the SJI's clients about how they became involved with the organization and how these organizations contributed to their own civic and political development, as well as the organization's role in the broader political arena, including the politics of prostitutes' rights. I also asked them about their own background as sex workers, and about CAL-PEP's and the SJI's role in their social and political lives. I supplemented these SOEIs with sex workers' demographic information, including their age, length of time in the sex industry, racial-ethnic identification, and so forth.

Together, this multimethod qualitative research allowed me to conduct "an in-depth study of a single unit (a relatively bounded phenomenon) . . . to elucidate features of a larger class of similar phenomena" (Gerring 2004: 342). CAL-PEP and the SJI represent this unit, and scholars may learn from and apply the insights and concepts they generated in further studies of similarly situated social movement–borne nonprofit organizations. Continuing this research will also—I hope—amplify and illuminate the voices and experiences of marginalized and under-studied communities.

NOTES

Chapter 1. Institutional Negotiation

1. I will use the term *prostitute/prostitution* interchangeably with the broader term *sex work*. The latter term refers to the exchange of commercial sexual services for material compensation and covers a wide range of activities—some of which are legal in the United States—such as dancing, pornography, and phone sex. While these legal forms of sex work are certainly of interest to me, this book is mainly concerned with organizational efforts around prostitution, which is illegal in most of the United States.

2. I use David Meyer and Debra Minkoff's definition of political opportunity as the "exogenous factors [that] enhance or inhibit prospects for mobilization, for particular sorts of claims to be advanced rather than others, for particular strategies of influence to be exercised, and for movements to affect mainstream institutional politics and policy" (2004: 1457).

3. Universities and local health departments applied, and the selected grantees were from Miami; Los Angeles and San Francisco; Newark, Jersey City, and Paterson, New Jersey; Atlanta; Colorado Springs; and Las Vegas (CDC 1987), and data collection commenced in May 1986.

4. According to Stephen Block (2000), these were the first documented organized responses to the plight of the poor by Parliament that sought to stop begging by the indigent and able-bodied poor. The Poor Laws assumed individuals should work and take care of their families' needs, but where this was not possible, the community was obliged to respond by developing their own organizations that provided at least the minimum resources (funded by property taxes) for the poor to survive.

5. The theory underlying CAPs was that by strengthening and developing community organizations in poor neighborhoods, individuals could gain skills, education, and resources to move out of poverty, improve the quality of life for all in these neighborhoods, develop a broader sense of connection to the wider social world, and improve access to resources outside the community (Naples 1998).

6. Kennard Wing, Katie Roeger, and Thomas Pollak's figure does not include hospitals and other primary-care facilities, which constitute 2.1 percent of all public charities in the health field.

7. This is specified in the Office of Management and Budget's Circular A-122, which states federal government agencies will not reimburse direct lobbying expenses, and

nonprofits may not spend any share of their overhead cost pool on lobbying activities, including advocacy for renewal of a federal grant. According to Nonprofit Action (2005), a leading nonprofit advocacy group, Circular A-122 does not restrict lobbying at the local level, but this lobbying must be consistent with the purposes of the grant. Some communications with legislators may be paid for with federal grant funds, such as responding to requests for information.

8. IRS Form 5768 is titled Election/Revocation of Election by an Eligible Section 501c3 Organization to Make Expenditures to Influence Legislation.

9. For more information, see the complete text of IRC 4911, which is available through the Cornell University Law School's Legal Information Institute at http://www.law.cornell.edu/uscode/text/26/4911.

10. According to an official from the CDC's Program Evaluation and Research Branch (PERB), evaluation requirements for local HIV/AIDS prevention programs have generally varied by the grant and contract agreement (Telephone interview, PERB official, 12 December 2007).

11. The SJI's remaining funds have come from the California State Office of AIDS for needle exchanges, various foundations, harm reduction organizations, individual donations, and fundraising events.

12. For examples of sex radical theory applied to prostitution, which holds that prostitution may not only be financially remunerative but sexually fulfilling, see, for example, work by Gail Pheterson (1989) and Carol Queen (2000).

13. The now-plentiful review essays (Bendor, Moe, and Shotts 2001; Gil-Swedberg 1993; Hall and Taylor 1996; Immergut 1998; Mackay et al. 2010; March and Olsen 2006a, 2006b; Schmidt 2006) generally identify four particular schools of new institutionalism, which are united by their attention to both formal and informal institutions (Mackay et al. 2010). Rational-choice institutionalism focuses mainly on the micro level, analyzing the strategic actions of actors, where institutions are largely understood (somewhat uncritically) as rules that structure the contexts in which actors make decisions (Weingast 2002). In contrast, historical institutionalists (Pierson and Skocpol 2002), focus on the macro level by considering the ramifications of largely contingent events. For this school, institutions are formal and informal procedures, routines, and so forth that are embedded in the organization of politics, society, and the economy. Here the concern is not only how these institutions exacerbate asymmetrical power relations but on how path dependence may also have unintended consequences. Between these two positions, then, rests sociological (or organizational) institutionalism (Powell and DiMaggio 1991). Sociological institutionalism sees institutions as not just rules and procedures but also symbols, morals, and cognitive scripts that provide "frames of meaning" to guide human behavior (March and Olsen 1984); this school focuses on how relationships between institutions and individual actors mutually constitute each other. And most recently, discursive institutionalism (Schmidt 2008) engages on multiple levels of micro- and macro-level analysis, defining institutions broadly and placing a greater emphasis on the role of how the ideational foundations, broadly defined, on which institutions

are built influence institutional design and actors' interests, preferences, and behaviors.

14. William Gamson's *The Strategy of Social Protest* (1990) was one of the first works to consider the impact and effectiveness of social movements. He compared the careers of fifty-three American challenging groups active between 1800 and 1945 and found that a number of factors influence a movement's success, including having single issue demands, using selective incentives and more violent or disruptive tactics, and having more bureaucratized groups.

15. In just some examples, feminist institutional scholars have shown here how parliamentary cultures constrain the ability of female legislators to represent women (Carroll 1984) and how powerful institutional norms prescribe and proscribe acceptable values of masculine and feminine forms of behavior for men and women within institutions (Chappell 2011; Franceschet 2011).

16. IRS Form 5768: Election/Revocation of Election by an Eligible Section 501c3 Organizations to Make Expenditures to Influence Legislation.

17. According to the IRS, H-electors may devote up to 20 percent of the first $500,000 of their exempt purpose budget to lobbying.

18. As David Whiteis documents, patterns of inequality have become especially evident in major cities. Between 1970 and 1990, the unevenness of the distribution of the poor throughout a metropolitan area increased by 11 percent, and from 1980 to 1990, in the hundred largest cities in the United States, the percentage of census tracts characterized as extreme poverty tracts (at least 40 percent of all residents living below the federal poverty level) increased from 9.7 percent to 13.7 percent (Whiteis 2000: 258).

19. Examples like the Ku Klux Klan indicate that not all civic organizations develop social capital and promote civic and political engagement in positive, prodemocratic ways (Fiorina 1999; Theiss-Morse and Hibbing 2005; Tamir 1998).

20. Examples of these activities include providing testimony on an issue in response to a request from a legislative body; contacting executive, judicial, and administrative bodies on matters not related to legislation; conducting, publishing, and disseminating nonpartisan issue research and analysis; discussing broad social issues as long as specific legislation is not discussed; and contacting legislative bodies about legislation relating to the organization's existence.

21. The concept of "policy feedback" is based on research that shows how citizens' direct connections to government, through policies and programs, may shape their participatory inclinations (which is an important first step toward more complex engagements). As Suzanne Mettler's (1998, 2005) work demonstrates, large, nationalized, and smoothly administered programs and policies, such as the G.I. Bill and various New Deal policies, helped constitute politically efficacious citizens who were more active in political and civic life than those connected to government through particularistic, variable, state-level policies. Additionally, as Joe Soss's work comparing Aid to Families with Dependent Children (AFDC) recipients with those receiving Supplemental Security Disability Income (SSDI) shows, AFDC recipients felt more negative toward government and, hence, less civically efficacious than those in the universal SSDI program (Schram and Soss 1998; Soss

1999, 2000). Similar relationships are apparent in the realm of criminal-justice policy and programming (which, consequently, many persons engaged in prostitution encounter), where research indicates citizens encountering and interacting with prisons and other elements of the "carceral state" are less likely to participate in politics and carry out other responsibilities of citizenship (Lerman and Weaver 2010).

22. These cases included a neighborhood representation and empowerment program in Seattle, a citywide system for youth civic engagement in Hampton, Virginia, and the Community Action for a Renewed Environment program, a federally administered plan that promoted community-based environmental protection.

Chapter 2. Oppositional Implementation

1. Section 647(b) also states that "a person agrees to engage in an act of prostitution when, with specific intent to so engage, he or she manifests an acceptance of an offer or solicitation to so engage, regardless of whether the offer or solicitation was made by a person who also possessed the specific intent to engage in prostitution. No agreement to engage in an act of prostitution shall constitute a violation of this subdivision unless some act, in addition to the agreement, is done within this state in furtherance of the commission of an act of prostitution by the person agreeing to engage in that act. As used in this subdivision, 'prostitution' includes any lewd act between persons for money or other consideration."

2. The one exception to this enforcement occurred in 1977, when the San Francisco Police Department (SFPD) tried a policy of nonenforcement, which the San Francisco Crime Commission report suggested in 1971 so officers could devote time to more serious crimes (Hathaway 2004). However, this policy was short-lived. According to a longtime vice officer with the SFPD (Interview, 20 July 2006), it resulted in the streets (especially in the Union Square and Tenderloin areas, where many of the hotels and tourists congregated) becoming "packed" with prostitutes. Consequently, the practice of arresting prostitutes continued. Similarly, in Oakland, policing street prostitution also increased in the late 1970s when news coverage of the issue focused on how citizens in East and West Oakland were beginning to patrol the neighborhoods themselves to remove prostitutes from the area, claiming the police would not let prostitutes loiter in the wealthier (and whiter) areas like Lake Merritt. These complaints led to a police crackdown on prostitution in these areas of Oakland (Leigh 1996).

3. One of the most highly publicized examples here was the "broken windows" strategy, employed under the Giuliani administration in New York City. Based on the argument that neighborhoods that fail to fix broken windows display a lack of informal social control and invite criminals into their midst, the policy was used to justify aggressive policing in New York City in the 1990s, particularly in Times Square and among poor communities of color.

4. The Alameda County Public Health Department is headquartered in Oakland and has twenty-five satellite offices across the county, covering 1.4 million residents. Their six-hundred-plus staff includes public-health nurses, doctors, epidemiologists, dentists, medical social workers, physical and occupational therapists, dietitians, outreach workers,

health educators, and program managers, among others, working in six divisions: Community Health Services, the Division of Communicable Diseases Control and Prevention, Family Health Services, Emergency, Medical Services, and Administrative Services.

5. The district attorney's office and the police responded with a "mapping" plan that would attempt to ban prostitutes from loitering in areas where arrests were regularly made between 9:00 P.M. and 3:00 A.M. But this plan was not instituted without protest from activist sex workers who gathered at City Hall, claiming this would be an unconstitutional restriction on mobility rights that would not solve the problems related to street prostitution and simply push it to other areas (Herbert and Brown 2006).

6. Six members of the taskforce representing various neighborhood associations also expressed concerns, eventually leaving the taskforce claiming that they believed the deck was "stacked" in favor of legalizing prostitution (Hoover 1992; Ganahl 1992).

7. Since beginning my research with CAL-PEP in 2006, the organization moved to the Franklin Avenue location from its previous office in the former Alameda County Public Health Department building, and then from there to their current location on Adeline Street in Oakland.

8. According to "Good Jobs NOW!" (Strupp 1994b, 1995), a snapshot of the economic health of transgender persons in San Francisco, of those surveyed, 60 percent of respondents earned under $15,300 per year, and only 8 percent earned over $45,900, while over 57 percent have experienced employment discrimination. The report illustrates further that low income and transgender status has also contributed to instability in living situations for many: 27 percent have experienced housing discrimination, and less than 5 percent own their own residence. Regarding street-based sex workers, according to Cohan and colleagues (2006), at the SJI, those doing street-based work were less likely to have a community or contact with other sex workers, and were also the most likely to be arrested and convicted of sex work–related charges and to have experienced sex work–related violence.

Chapter 3. Community Engagement

1. The Hull House Settlement in Chicago was one of the most notable settlement houses. As Laura Abrams documents, settlement houses were run by women who were public figures and national-policy advocates (Jane Addams, of Hull House, was the first American woman to win a Nobel Peace Prize). These women saw the crowded quarters of most immigrant communities as a threat to young women's health and moral development, and they sought to uphold the value of domesticity for working-class and immigrant young women by taking them away from their (allegedly) incompetent parents. Young women sentenced in juvenile courts for supposed sexual-moral "offenses" were sent to places like Hull House, which "sought to rehabilitate female delinquents through re-socialization in traditional female codes of conduct and often detained girls until they were of a marriageable age of 21 or older" (2000: 444).

2. A felony conviction would mean they would have to serve time in prison, as opposed to simply paying a fine or completing probation, which a basic prostitution charge (a misdemeanor) usually incurs.

3. Students can also seek certification through such national organizations as the American Society of Clinical Pathologists, the National Health Career Association, and the National Phlebotomy Association.

4. See List of Abbreviations for the names of the various programs.

5. The reports Akers is referring to are the biannual reports documenting and evaluating their programs and organizational activities, which are a major requirement of their grant agreement with the SFDPH.

6. The following excerpt illustrates the level of detail required in these reports:

1. You must provide CDC with an original, plus two copies of the following reports:

(a) Your interim progress report, no later than February 15 of each year. The progress report will serve as your non-competing continuation application, and must contain the following elements: (1) Current budget period activities objectives. (2) Current budget period financial progress. (3) New budget period proposed program activity objectives. (4) Detailed line-item budget and justification. (5) Baselines and target levels of performance for core and optional indicators. (6) New budget period proposed program activities. (7) Additional requested information.

(b) The second semi-annual report will be due August 30 of each year. Additional guidance on what to include in this report may be provided approximately three months before the due date. It should include: (1) Baseline and actual level of performance on core and optional indicators. (2) Current budget period financial progress. (3) Additional requested information.

(c) Financial status report, no more than 90 days after the end of the budget period.

(d) Final financial and performance reports, no more than 90 days after the end of the project period.

(e) Data reports of agency, financial, and HIV interventions including, but not limited to, HIV individual and group level; PCM; outreach; CTR; and/ or partner CTR services are required 45 days after the end of each quarter or as specified in the most recent evaluation guidance. Project areas may request technical assistance. Submit data to the Program Evaluation Research Branch electronically, and then send an electronic notification of your data submission to the Grants Management Specialist listed in the 'Agency Contacts' section of this announcement.

2. Submit any newly developed public information resources and materials to the CDC National Prevention Information Network (formerly the AIDS Information Clearinghouse) so that they can be incorporated into the current database for access by other organizations and agencies.

3. HIV Content Review Guidelines

(a) Submit the completed Assurance of Compliance with the Requirements

for Contents of AIDS-Related Written Materials Form (CDC form 0.1113) with your application as Appendix D. This form lists the members of your program review panel. The form is included in your application kit. The current Guidelines and the form may be downloaded from the CDC website: www.cdc.gov/od/pgo /forminfo.htm. Please include this completed form with your application. This form must be signed by the Project Director and authorized business officer.

(b) You must also include approval by the relevant review panel of any CDC-funded HIV educational materials that you are currently using by the relevant review panel. Use the enclosed form, 'Report of Approval.' If you have nothing to submit, you must complete the enclosed form 'No Report Necessary.' You must include either the 'Report of Approval' or 'No Report Necessary' with all progress reports and continuation requests.

(c) Use a Web page notice if your Web site contains HIV/AIDS educational information subject to the CDC content review guidelines.

4. Adhere to CDC policies for securing approval for CDC-sponsored conferences. If you plan to hold a conference, you must send a copy of the agenda to CDC's Grants Management Office.

5. If you plan to use materials using the CDC's name, send a copy of the proposed material to the CDC's Grants Management Office for approval (CDC 2004).

7. This staff member requested that I not tape our conversation, and so I cannot provide a more extensive direct quotation to describe this incident.

Chapter 4. Claims-Making Activities

1. For a recent example, see the debate in the journal *Violence Against Women* between Ronald Weitzer (a criminologist at George Washington University) and Melissa Farley (Weitzer 2005; Farley 2005).

2. For this evaluation CAL-PEP used the Government Performance and Results Act (GPRA) survey. According to the Department of the Interior, "GPRA seeks to make the federal government more accountable to the American people for the tax dollars it spends and the results it achieves. The Department of the Interior is complying with GPRA through its performance management system that provides useful information to managers and promotes accountability for results. In addition to a strategic plan, GPRA requires agencies to prepare related annual performance plans and annual performance reports. The legal requirements for an annual performance plan are met by a performance budget. The annual performance report requirement will be fulfilled by both the performance budget and the performance and accountability report" (Department of the Interior 2012). In each Day Treatment Program cohort, then, over the course of the year (at intake, and roughly six and twelve months into the program), clients completed interviews for the GPRA, and following the twelve-month questionnaire, they were welcome to return to the Day Treatment Program informally.

3. Ben Bowser, Lisa Ryan, Carla Dillard Smith, and Gloria Lockett drafted this working paper in 2007, titled "Outreach-Based Drug Treatment for Minority Women: The Cal-Pep Risk-Reduction Demonstration Project." It is available from Ben Bowser (benjamin.bowser@csueastbay.edu). See Bowser et al. (2008) for the published version.

4. For an excellent discussion of this, see Roth and Hogan (1998).

5. "John schools," where men arrested for soliciting prostitution pay a fine and complete a class about the consequences of their actions, constitute an increasingly popular "end demand" initiative, particularly in the United States. The nation's flagship john school program, the First Offender Prostitution Program, which was established in 1995 in San Francisco, has been replicated in cities in nine other U.S. states. See Chapter 5 for more information about the program's history.

6. At the time of writing, UNAIDS had not yet released its new guidance note, but Akers continues to work with the Global Working Group "to identify and secure the financial resources required to support sex workers rights in regional and global networks; ensure meaningful participation of sex worker organizations in regional and national consultations and trainings; and identify five or six countries and the process for following the roll-out of programs on HIV and sex work, including the possibility of country visits for documenting and sharing good practices" (SJI 2010: 2).

Chapter 5. Lessons Learned

1. For more information about this organization, visit their website: http://www .breakingfree.net/.

2. Robyn Few passed away on 13 September 2012 after a long struggle with cancer.

3. For more information about these organizations, visit the following websites: www.swopusa.org (Sex Workers Outreach Project); www.desireealliance.org (Desiree Alliance); www.nwsp.org (Network of Sex Work Projects); and www.redumbrella project.org (The Red Umbrella Project).

4. Giugni explains further that the scholarship that does exist about the impacts of social movements largely considers whether disruptive or moderating actions are more effective in the end or whether certain social movement–controlled variables (for example, tactics) or aspects of a movement's environment better account for its success.

5. According to their website, the Global Network of Sex Worker Projects is "a membership organisation and is committed to facilitating the voices of sex workers from both the Global North and South" that "conducts a mix of pro-active and re-active policy advocacy to support human rights and evidence based approaches to female, male and transgender sex workers and strengthening sex worker communities." For more information, visit http://nswp.org.

6. For a complete list of DEBIs, visit the CDC's "Effective Interventions" site at http://www.effectiveinterventions.org/en/HighImpactPrevention/Interventions.aspx.

7. Mink adds that "federal support for the work of religious organizations is not new: Catholic Charities and Lutheran Social Services, for example, have long relied on federal assistance to operate homeless shelters and soup kitchens. Before 1996, however, religious groups had to set up separate, secular agencies to receive federal money" (2001: 6).

8. For example, a growing number of faith-based organizations have accessed funding to promote (heterosexual) marriage among poor women in an effort to "solve" their poverty (Heath 2009). In another example, researchers found that faith-based homeless service organizations were more likely than their secular counterparts to deliver a variety of religious services as part and parcel of their social service–delivery agendas. They were also more likely to have organizational cultures that were thoroughly imbued with religious values in terms of staff interactions with clients (Ebaugh et al. 2003: 423).

9. I interviewed Norma Hotaling on 29 May 2006, and she passed away in December 2008 from pancreatic cancer.

10. For more information about the organization, please visit SAGE's website: http://www.sagesf.org.

11. For more information about these organizations serving sex workers, please see the following websites: http://hips.org (HIPS), http://wwav-no.org/ (Women with a Vision), and http://safephila.org/ (Project Safe).

12. For more information about these organizations, please see their websites: http://citiwidehr.org/ (CitiWide Harm Reduction), http://empowermentprogram.org (the Empowerment Program), and http://breadandjams.org (Bread and Jams).

13. This form is much more extensive than IRS Form 5768, which is required for the H-election, and subjects the organizations to various questions about their past political activities and so forth. For a copy of this form, visit http://www.irs.gov/pub/irs-pdf/f1024.pdf. Organizations with annual gross receipts of $10,000 or less pay a $400 fee, and those with annual gross receipts of more than $10,000 pay $850. For a complete list of filing fees, visit the IRS's list of "Exempt Organizations User Fees" at http://www.irs.gov/charities/article/0,,id=232771,00.html.

14. The Third Wave Foundation was created in 1992 and is a "feminist, activist foundation that works nationally to support young women and transgender youth ages 15 to 30. Through strategic grantmaking, leadership development, and philanthropic advocacy, we support groups and individuals working towards gender, racial, economic, and social justice" (Third Wave Foundation 2012: see "Mission").

Appendix

1. For the St. James Infirmary, see http://stjamesinformary.org; for CAL-PEP, visit http://www.calpep.org.

2. To see a copy of these guidelines for researchers, visit their link to Community Guidelines for Conducting Research and Student Internships at http://stjamesinfirmary.org/wordpress/wp-content/uploads/2008/05/SJI-Student-Internship_Research-Application-2012.pdf.

3. As Elizabeth Bernstein (2007: chap. 4) demonstrates through her ethnographic research with sex-worker rights activists in the Bay Area, these individuals were more often white, educated women who worked independently, in the indoor sectors of the sex industry that are less susceptible to police investigation.

BIBLIOGRAPHY

Abramovitz, Mimi. 2000. *Under Attack, Fighting Back: Women and Welfare in the United States.* New York: Monthly Review Press.

Abrams, Kathryn. 1995. "Sex Wars Redux: Agency and Coercion in Feminist Legal Theory." *Columbia Law Review* 95 (2): 304–76.

Abrams, Laura. 2000. "Guardians of Virtue: The Social Reformers and the 'Girl Problem.'" *Social Service Review* 74 (3): 436–52.

Abramson, Paul, Steven Pinkerton, and Mark Huppin. 2003. *Sexual Rights in America.* New York: New York University Press.

ACT-UP. 2003. "Global Gag Rule." New York: AIDS Coalition to Unleash Power.

Akers, Naomi. 2005. "A Pilot Health Assessment of Exotic Dancers in San Francisco." San Francisco: Masters in Public Health Program, San Francisco State University.

Akers, Naomi, and Rachel Schreiber. 2011. "Sex Workers' Rights Are Human Rights." Media campaign sponsored by the St. James Infirmary. San Francisco: SJI.

Alameda County. 2003. "State of Emergency: African American Taskforce." Oakland, Calif.

Alameda County Public Health Department. 2009. "Comprehensive HIV Services Plan 2009–2011." Oakland, Calif.

Alderson, Arthur. 1999. "Explaining Deindustrialization: Globalization, Failure or Success." *American Sociological Review* 64 (5): 701–21.

Alexander, Priscilla. 1995a. "Prostitution Is Sex Work: Occupational Safety and Health." Washington, D.C.: North American Taskforce on Prostitution.

———. 1995b. "The St. James Infirmary: A Sex Workers' Occupational Health and Safety Clinic." San Francisco: North American Task Force on Prostitution.

———. 1998. "Sex Work and Health: A Question of Safety in the Workplace." *Journal of American Medical Women's Association* 53 (2): 77–82.

Altman, Dennis. 1993. "Expertise, Legitimacy and the Centrality of Community." In *AIDS: Facing the Second Decade*, edited by Peter Aggleton, Peter Davies, and Graham Hart, 1–12. London: Falmer.

Alvarez, Sonia. 1999. "Advocating Feminism: The Latin American Feminist NGO 'Boom.'" *International Feminist Journal of Politics* 1 (2): 181–209.

Amenta, Edwin, and Neal Caren. 2004. "The Legislative, Organizational, and Beneficiary Consequences of State-Oriented Challengers." In *The Blackwell Companion*

to *Social Movements*, edited by Sarah Soule, David Snow, and Hanspeter Kriesi, 461–83. Malden, Mass.: Blackwell.

Andrew, Merrindahl. 2010. "Women's Movement Institutionalization: The Need for New Approaches." *Politics and Gender* 6 (4): 609–16.

Armstrong, Elizabeth. 2002. *Forging Gay Identities: Organizing Sexuality in San Francisco, 1950–1994*. Chicago: University of Chicago Press.

Arno, Peter. 1986. "The Nonprofit Sector's Response to the AIDS Epidemic: Community Based Services in San Francisco." *American Journal of Public Health* 76 (11): 1325–30.

Bailey, Marvin. 1991. "Community-Based Organizations and CDC as Partners in HIV Education and Prevention." *Public Health Reports* 106 (6): 702–8.

Banaszak, Lee Ann, Karen Beckwith, and Dieter Rucht. 2003. *Women's Movements Facing the Reconfigured State*. Cambridge: Cambridge University Press.

Banaszak, Lee Ann, and Laurel Weldon. 2011. "Informal Institutions, Protest, and Change in Gendered Federal Systems." *Politics and Gender* 7 (2): 262–72.

Banks, Manley, Nelson Wikstrom, Michon Moon, and Joseph Andrews. 1996. "Transformative Leadership in the Post-Civil Rights Era: The 'War on Poverty' and the Emergence of African-American Municipal Political Leadership." *Western Journal of Black Studies* 20 (4): 173–87.

Barry, Kathleen. 1984. *Female Sexual Slavery*. New York: New York University Press.

Bendor, Jonathan, Terry M. Moe, and Kenneth W. Shotts. 2001. "Recycling the Garbage Can: An Assessment of the Research Program." *American Political Science Review* 95 (1): 169–90.

Berger, Ben. 2009. "Political Theory, Political Science and the End of Civic Engagement." *Perspectives on Politics* 7 (2): 335–50.

Berman, Jacqueline. 2006. "The Left, the Right and the Prostitute: The Making of a U.S. Antitrafficking in Persons Policy." *Tulane Journal of International and Comparative Law* 14 (2): 269–95.

Bernard, Edwin. 2006. "U.S. Anti-Prostitution Gag for HIV Work Unconstitutional, Rules U.S. Judge." N.A.M. aidsmap. Available at http://www.aidsmap.com/en/news/D03B0C8F-CCA5-4FF0-B976-8D920F4E6B80.asp.

Bernstein, Elizabeth. 2007. *Temporarily Yours: Intimacy, Authenticity, and the Commerce of Sex*. Chicago: University of Chicago Press.

———. 2010. "Militarized Humanitarianism Meets Carceral Feminism: The Politics of Sex, Rights, and Freedom in Contemporary Antitrafficking Campaigns." *Signs* 36 (11): 45–71.

Berry, Jeffrey. 2005. "Nonprofits and Civic Engagement." *Public Administration Review* 65 (5): 568–78.

Berry, Jeffrey, and David Arons. 2003. *A Voice for Nonprofits*. Washington, D.C.: Brookings Institution.

Block, Stephen. 2000. "Nonprofit Organizations (1998)." In *The Nature of the Nonprofit Sector*, edited by Steven Ott, 152–61. Boulder, Colo.: Westview.

Blumenthal, Ricky. 1998. "Syringe Exchange as a Social Movement: A Case Study of Harm Reduction." *Substance Use and Misuse* 33 (5): 1147–71.

Boone, David, Elaine Bautista, and Barbara Green-Ajufo. 2005. "AIDS Epidemiology Report, Alameda County, California: 1980–2004." Oakland: Alameda County Health Services Agency, Public Health Department.

Boris, Elizabeth. 2006. "Nonprofit Organizations in a Democracy: Varied Roles and Responsibilities." In *Nonprofits and Government: Collaboration and Conflict*, edited by Elizabeth Boris and Eugene Steuerle, 1–36. Washington, D.C.: Urban Institute.

Bowser, Ben, Lisa Ryan, Carla Dillard Smith, and Gloria Lockett. 2007. "Outreach-Based Drug Treatment for Minority Women: The CAL-PEP Risk Reduction Demonstration Project." Working paper. Received through personal correspondence (6 January 2013) with Ben Bowser at benjamin.bowser@csueastbay.edu.

Bowser, Ben, Lisa Ryan, Carla Dillard Smith, and Gloria Lockett. 2008. "Outreach-Based Drug Treatment for Minority Women: The CAL-PEP Risk Reduction Demonstration Project." *International Journal of Drug Policy* 19 (6): 492–95.

Bowser, Ben, Deborah Whittle, and David Rosenbloom. 2001. "Fighting Drug and Alcohol Abuse in Communities and Improving Race Relations: Theoretical Lessons Learned." *Research in Social Problems and Public Policy* 8: 167–94.

Bowser, Ben, Carla Word, Gloria Lockett, and Carla Dillard Smith. 2001. "How Drug Abusers Organize Their Participation in HIV/AIDS Studies: Their Time, Their Place." *Journal of Drug Issues* 31 (4): 941–56.

Bowser, Ben, Tazima Jankins-Barnes, Carla Dillard-Smith, and Gloria Lockett. 2010. "Harm Reduction for Drug Abusing Ex-Offenders: Outcome of the California Prevention and Education Project MORE Project." *Journal of Evidence-Based Social Work* 7 (1-2): 15-29.

Brenner, Neil, and Nik Theodore. 2002a. "Cities and Geographies of 'Actually Existing Neoliberalism.'" *Antipode* 34 (3): 349–79.

———. 2002b. "Preface: From the 'New Localism' to the 'Spaces of Neoliberalism.'" *Antipode* 34 (3): 341–47.

Brookings Institution. 2003. "Oakland in Focus: A Profile from Census 2000." Washington, D.C.: Brookings Institution.

Cadge, Wendy, and Robert Wuthnow. 2006. "Religion and the Nonprofit Sector." In *The Nonprofit Sector: A Research Handbook*, edited by Walter Powell and Richard Steinberg, 485–505. New Haven, Conn.: Yale University Press.

CAL-PEP. 1989. *PEP-TALK: The Newsletter of the Sex Industry's AIDS and Drug Use Education Outreach Project*. San Francisco: CAL-PEP.

———. 1992. "CAL-PEP Update." Oakland, Calif.: CAL-PEP.

———. 1999/2000. "Health Education Express." Oakland, Calif.: CAL-PEP.

———. 2001. "Health Talk." Oakland, Calif.: CAL-PEP.

———. 2004. *Street Outreach Training Manual*. Oakland, Calif.: CAL-PEP.

———. 2008. *CAL-PEP: Annual Data Report*. Oakland, Calif.: CAL-PEP.

———. 2009. "25th Anniversary Celebration and Community Recognition Awards Dinner." Oakland, Calif.: CAL-PEP.

Campbell, Rebecca, Charlene Baker, and Terri Mazurek. 1998. "Remaining Radical? Organizational Predictors of Rape Crisis Centers' Social Change Initiatives." *American Journal of Community Psychology* 26 (3): 457–83.

Carroll, Susan. 1984. "Women Candidates and Support for Feminist Concerns: The Closet Feminist Syndrome." *Western Political Quarterly* 37 (2): 307–23.

Cazenave, Noel A. 2007. *Impossible Democracy: The Unlikely Success of the War on Poverty Community Action Programs.* Albany: State University of New York Press.

Centers for Disease Control and Prevention. 1987. "Antibody to HIV in Female Prostitutes." *Morbidity and Mortality Weekly Report* 36 (11): 157–61.

———. 2004. "Cooperative Agreement U65/CCU923903-02: Centers for Disease Control and Prevention Human Immunodeficiency Virus (HIV) Prevention Projects for Community-Based Organizations" (edited by Department of Health and Human Services). Atlanta: Centers for Disease Control and Prevention.

———. 2007. *CDC's HIV/AIDS Prevention Activities.* (accessed 1 December 2007). http://www.cdc.gov/hiv/resources/factsheets/cdcprev.htm.

———. 2011. "HIV Counseling with Rapid Tests." http://www.cdc.gov/hiv/topics/testing/resources/factsheets/rt_counseling.htm.

Centers for Disease Control and Prevention AIDS Community Demonstration Research Group. 1999. "Community-Level HIV Intervention in 5 Cities: Final Outcome Data from CDC AIDS Community Demonstration Projects." *American Journal of Public Health* 89 (3): 336–45.

Chambré, Susan Maizel. 2006. *Fighting for Our Lives: New York's AIDS Community and the Politics of Disease.* New Brunswick, N.J.: Rutgers University Press.

Chapkis, Wendy. 2000. "Power and Control in the Commercial Sex Trade." In *Sex for Sale: Prostitution, Pornography and the Sex Industry,* edited by Ronald Weitzer, 181–202. London: Routledge.

———. 2005. "Soft Glove, Punishing Fist: The Trafficking Victims Protection Act of 2000." In *Regulating Sex: The Politics of Intimacy and Identity,* edited by Elizabeth Bernstein and Laurie Shaffner, 51–67. New York: Routledge.

Chappell, Louise. 2011. "Nested Newness and Institutional Innovation: Expanding Gender Justice in the International Criminal Court." In *Gender, Politics and Institutions: Towards a Feminist Institutionalism,* edited by Mona Lena Krook and Fiona Mackay, 163–180. Basingstoke: Palgrave Macmillan.

Chaves, Mark, Joseph Galaskiewicz, and Laura Stephens. 2004. "Does Government Funding Suppress Nonprofits' Political Activity?" *American Sociological Review* 69 (2): 292–316.

Chong, Stephanie. 2011. "Rejected as Billboards, Sex Worker Ads to Run on Muni." *Bay Citizen,* October 22.

Chronicle of Higher Education. 2002. "Putting Substance Back in Political Science." *Chronicle of Higher Education* 48 (30): B10–B12.

Clarke, Susan. 2001. "The Prospects for Local Democratic Governance: The Governance Roles of Nonprofit Organizations." *Policy Studies Review* 18 (4): 129–45.

Clemens, Elisabeth, and James Cook. 1999. "Politics and Institutionalism: Explaining Durability and Change." *Annual Review of Sociology* 25: 441–66.

Cohan, Deb, Antje Herlyn, Johanna Breyer, Cynthia Cobaugh, Tomi Knutson, Alexandra Lutnick, Daniel Wilson, and Charles Cloniger. 2004. "Social Context and the Health of Sex Workers in San Francisco." Presented at the International Conference on AIDS, Bangkok, Thailand, 11–16 July.

Cohan, Deb, Alexandra Lutnick, Peter Davidson, Charles Cloniger, Antje Herlyn, Johanna Breyer, Cynthia Cobaugh, Daniel Wilson, and Jeffrey Klausner. 2006. "Sex Worker Health: San Francisco Style." *Sexually Transmitted Infections* 82 (5): 418–22.

Cohen, Cathy J. 1999. *The Boundaries of Blackness: AIDS and the Breakdown of Black Politics.* Chicago: University of Chicago Press.

Cohen, Ira, and Ann Elder. 1989. "Major Cities and Disease Crises: A Comparative Perspective." *Social Science History* 13 (1): 25–63.

Cohen, Jean. 1985. "Strategy or Identity." *Social Research* 52 (4): 663–716.

Cohen, Judith, and Priscilla Alexander. 1995. "Female Sex Workers: Scapegoats in the AIDS Epidemic." In *Women at Risk: Issues in the Primary Prevention of AIDS,* edited by Ann O'Leary and Loretta Sweet-Johnson, 195–220. New York: Plenum.

Cohen, Judith, Pamela Derish, and Lori Dorfman. 1994. "AWARE: A Community Based Research and Peer Intervention Program for Women." In *AIDS Prevention and Services,* edited by Johannes VanVugt, 109–28. Westport, Conn.: Bergin and Garvey.

Coles, Romand. 2010. "Collaborative Governance and Civic Empowerment: A Discussion of Investing in Democracy—Engaging Citizens in Collaborative Governance." *Perspectives on Politics* 8 (2): 601–4.

Collins, Charles, Camilla Harshbarger, Richard Sawyer, and Myriam Hamdallah. 2006. "The Diffusion of Effective Behavioral Interventions Project: Development, Implementation, and Lessons Learned." *AIDS Education and Prevention* 18 (Suppl. A): 5–20.

CompassPoint. 2013. "About Us." http://www.compasspoint.org/about-us.

Connelly, Mark. 1980. *The Response to Prostitution in the Progressive Era.* Chapel Hill: University of North Carolina Press.

Courville, Sasha, and Nicola Piper. 2004. "Harnessing Hope Through NGO Activism." *Annals of the American Academy of Political Science* 592 (1): 39–61.

COYOTE. 2003. "Call Off Your Old Tired Ethics" (accessed 28 June 2013). http://www.walnet.org/csis/groups/coyote.html.

Cress, Daniel. 1997. "Nonprofit Incorporation Among Movements of the Poor: Pathways and Consequences for Homeless Social Movement Organizations." *Sociological Quarterly* 38 (2): 343–60.

Cruess, Richard, Sylvia Cruess, and Sharon Johnston. 2000. "Professionalism: An Ideal to Be Sustained." *Lancet* 356 (9224): 156–69.

Dalton, Russell. 2008. "Citizenship Norms and the Expansion of Political Participation." *Political Studies* 56 (1): 76–98.

Darrow, William. 1990. "Prostitution, Intravenous Drug Use, and HIV-1 in the United States." In *AIDS, Drugs and Prostitution*, edited by Martin Plant, 18–40. London: Routledge.

Davis, Fania. 1995. "Re: *Dotson v. Yee*." San Francisco: Moore and Moore, Attorneys at Law.

Delacoste, Frederique, and Priscilla Alexander. 1998. *Sex Work: Writings by Women in the Sex Industry*. San Francisco: Cleis.

DeLeon, Rich. 1992. "The Urban Anti-Regime: Progressive Politics in San Francisco." *Urban Affairs Quarterly* 27 (4): 555–79.

———. 2007. *Only in San Francisco?* San Francisco Politics and Urban Research Association (accessed 8 April 2007). http://www.spur.org.

D'Emilio, John, and Patricia Donat. 1992. "A Feminist Redefinition of Rape and Sexual Assault: Historical Foundations and Change." *Journal of Social Issues* 48 (1): 9–22.

D'Emilio, John, and Estelle Freedman. 1997. *Intimate Matters: A History of Sexuality in America*. Chicago: University of Chicago Press.

Department of Health and Human Services. 2010. *Fiscal Year 2010 Budget in Brief: Centers for Disease Control and Prevention*. DHHS 2010 (accessed 7 February 2011). http://dhhs.gov/asfr/ob/docbudget/2010budgetinbriefg.html.

Department of the Interior. 2012. *GPRA Strategic Plan: 2007–2012* (accessed 28 June 2013). http://www.doi.gov/pmb/ppp/upload/strat_plan_fy2007_2012.pdf.

Dobkin-Hall, Peter. 1987. "Abandoning the Rhetoric of Independence: Reflections on the Nonprofit Sector in the Post-Liberal Era." *Nonprofit and Voluntary Sector Quarterly* 16 (11): 11–28.

Donovan, B., and C. Harcourt. 2005. "The Many Faces of Sex Work." *Sexual Health* 81 (3): 201–6.

Dorfman, Lori. 1992. "Hey Girlfriend! An Evaluation of AIDS Prevention Among Women in the Sex Industry." *Health Education Quarterly* 19 (1): 24–40.

Dorfman, Lori, Susana Hennessy, Jane Lev, and Peg Reilly. 1988. "GIRLFRENS: A Study of Outreach to Street Prostitutes." San Francisco: California Prostitutes Education Project.

Dworkin, Shari, Rogerio Pinto, Joyce Hunter, Bruce Rapkin, and Robert Remien. 2008. "Keeping the Spirit of Community Partnerships Alive in the Scale Up of HIV/AIDS Prevention: Critical Reflections on the Roll Out of DEBI (Diffusion of Effective Behavioral Interventions)." *American Journal of Community Psychology* 42 (1–2): 51–59.

Ebaugh, Helen Rose, Paula Pipes, Janet Saltzman Chafetz, and Martha Daniels. 2003. "Where's the Religion? Distinguishing Faith-Based from Secular Social Service Agencies." *Journal for the Scientific Study of Religion* 42 (3): 411–26.

Economic Opportunity Act of 1964. (Public Law 88-452)

Edin, Kathryn, and Laura Lein. 1997. *Making Ends Meet: How Single Mothers Survive Welfare and Low-Wage Work*. New York: Russell Sage Foundation.

Eisenstein, Zillah. 1994. *The Color of Gender*. Berkeley: University of California Press.

Eisinger, Peter. 1973. "The Conditions of Protest Behavior in American Cities." *American Political Science Review* 67 (1): 11–28.

Epstein, Steven. 2006. "The New Attack on Sexualty Research: Morality and the Politics of Knowledge Production." *Sexuality Research and Social Policy* 3 (1): 1–62.

Evans, Peter B., Dietrich Rueschemeyer, and Theda Skocpol, (eds). 1985. *Bringing the State Back In*. Cambridge: Cambridge University Press.

Farley, Melissa. 2005. "Prostitution Harms Women Even If Indoors: Reply to Weitzer." *Violence Against Women* 11: 950–54.

———. 2007. *Prostitution and Trafficking in Nevada: Making the Connections*. San Francisco: Prostitution Research and Education.

———. 2010 *About Prostitution Research and Education*. Prostitution Research and Education 2010 (accessed December 2011). http://www.prostitutionresearch.com/about.html.

Farley, Melissa, Ann Cotton, Jacqueline Lynne, Sybille Zumbeck, Frida Spiwak, Maria Reyes, Dinorah Alvarez, and Ufuk Sezgin. 2003. "Prostitution and Trafficking in Nine Countries: An Update on Violence and Post-Traumatic Stress Disorder." In *Prostitution, Trafficking and Traumatic Stress*, edited by Melissa Farley, 33–74. Binghamton, N.Y.: Haworth.

Farley, Melissa, and Vanessa Kelly. 2000. "Prostitution: A Critical Review of the Medical and Social Science Literature." *Women and Criminal Justice* 11: 26–64.

Fecente, Shelley, Dale Gluth, Marise Rodriguez, Teri Dowling, and Nicolas Sheon. 2007. *Benefits of Electronic Data Collection for HIV Test Counseling*. AIDS Office, HIV Prevention Section, San Francisco Department of Public Health 2007 (accessed 21 February 2008). http://www.palmpal.org/facente_1_FINAL.pdf.

Ferree, Myra Marx, and Patricia Yancey Martin. 1995. *Feminist Organizations: Harvest of the New Women's Movement*. Philadelphia: Temple University Press.

Fiorina, Morris. 1999. "Extreme Voices: The Dark Side of Civic Engagement." In *Civic Engagement in American Democracy*, edited by Theda Skocpol and Morris Fiorina, 395–426. Washington, D.C.: Brookings Institution.

Franceschet, Susan. 2011. "Gendered Institutions and Women's Substantive Representation: Female Legislators in Argentina and Chile." In *Gender, Politics and Institutions: Towards a Feminist Institutionalism*, edited by Mona Lena Krook and Fiona Mackay, 58–79. Basingstoke: Palgrave Macmillan.

Galston, William. 2001. "Political Knowledge, Political Engagement, and Civic Education." *Annual Review of Political Science* 4: 217–34.

———. 2007. "Civic Knowledge, Civic Education, and Civic Engagement: A Summary of Recent Research." *International Journal of Public Administration* 30 (6–7): 623–42.

Gamson, Joshua 1995. "Must Identity Movements Self-Destruct? A Queer Dilemma." *Social Problems* 42 (3): 390–403.

Gamson, Joshua and David Meyer. 1996. "Framing Political Opportunity." In *Comparative Perspectives on Social Movements*, edited by Doug McAdam, John McCarthy, and Mayer Zald, 275–90. Cambridge: Cambridge University Press.

Gamson, William. 1990. *The Strategy of Social Protest*. 2nd ed. Belmont, Calif.: Wadsworth.

Ganahl, Jane. 1992. "Hookers Stage Rally at City Hall." *Examiner*, 14 November, A4.

Gerring, John. 2004. "What Is a Case Study and What Is It Good For?" *American Political Science Review* 98 (2): 342–54.

Gilmore, Ruth Wilson. 2007. "In the Shadow of the Shadow State." In *The Revolution Will Not Be Funded: Beyond the Nonprofit-Industrial Complex*, edited by Incite! Women of Color Against Violence, 41–52. Boston: South End Press.

Gil-Swedberg, Cecilia. 1993. Book review of "The New Institutionalism in Organizational Analysis." *Acta Sociologica* 36 (1): 70–73.

Giugni, Marco. 1998. "Was It Worth the Effort? The Outcomes and Consequences of Social Movements." *Annual Review of Sociology* 98: 371–93.

———. 1999. "How Social Movements Matter: Past Research, Present Problems, Future Developments." In *How Social Movements Matter: Social Movements, Protest, and Contention*, edited by Marco Giugni, Doug McAdam, and Charles Tilly, xiii–3. Minneapolis: University of Minnesota Press.

Godfrey, Brian. 1995. "Restructuring and Decentralization in a World City." *Geographical Review* 85 (4): 436–57.

Gordon, Linda. 2002. *The Moral Property of Women: A History of Birth Control Politics in America*. Urbana: University of Illinois Press.

Gozdziak, Elzbieta, and Elizabeth Collett. 2005. "Research on Human Trafficking in North America: A Review of the Literature." *International Migration* 43 (1-2): 99–128.

Gronbjerg, Kristen, and Steven R. Smith. 2006. "Scope and Theory of Government-Nonprofit Relations." In *The Nonprofit Sector: A Research Handbook*, edited by Walter Powell and Richard Steinberg, 221–42. New Haven, Conn.: Yale University Press.

Hall, Peter A., and Rosemary C. R. Taylor. 1996. "Political Science and the Three New Institutionalisms." *Political Studies* 44 (4): 936–57.

Halley, Janet, Prabha Kotiswaran, Hila Shamir, and Chantal Thomas. 2006. "From the International to the Local in Feminist Legal Responses to Rape, Prostitution/Sex Work, and Sex Trafficking: Four Studies in Contemporary Governance Feminism." *Harvard Journal of Law and Gender* 29 (2): 335–424.

Haraway, Donna. 1990. "A Cyborg Manifesto: Science, Technology and Socialist Feminism in the Late Twentieth Century." In *Simioans, Cyborgs and Women*, edited by Donna Haraway, 149–81. London: Routledge.

Harrington, Carol. 2010. *Politicization of Sexual Violence: From Abolitionism to Peacekeeping*. Farnham, U.K.: Ashgate.

Hathaway, Kimberly. 2004. "City of San Francisco Proclaims 'Erotic' Health Day, to Benefit St. James Infirmary November 13." San Francisco: Hathaway Public Relations.

Hausbeck, Kathryn, and Barbara Brents. 2000. "Inside Nevada's Brothel Industry." In *Sex for Sale: Prostitution, Pornography and the Sex Industry*, edited by Ronald Weitzer, 217–44. London: Routledge.

———. 2005. "Violence and Legalized Prostitution in Nevada: Examining Safety, Risk and Prostitution Policy." *Journal of Interpersonal Violence* 20 (3): 270–95.

Hausbeck, Kathryn, Barbara Brents, and Crystal Jackson. 2007. "Vegas and the Sex Industry." *Las Vegas Review Journal*, 16 September.

Heath, Melanie. 2009. "State of Our Unions: Marriage Promotion and the Contested Power of Heterosexuality." *Gender and Society* 23 (1): 27–48.

Helmke, Gretchen, and Steven Levitsky. 2004. "Informal Institutions and Comparative Politics: A Research Agenda." *Perspectives on Politics* 2 (4): 725–40.

Herbert, Steve, and Elizabeth Brown. 2006. "Conceptions of Space and Crime in the Punitive Neoliberal City." *Antipode* 38 (4): 755–77.

Hoover, Ken. 1992. "Targeting the Tenderloin: How SF Hopes to Curb Prostitution." *San Francisco Chronicle*, 25 October.

Hotaling, Norma. 2007. *San Francisco's Successful Strategies: Prevention Services for Girls and the First Offender Prostitution Program.* Madison, Wis.: Policy Institute for Family Impact Seminars.

Hotaling, Norma, Autumn Burris, Julie Johnson, Yoshi Bird, and Kirsten Melbye. 2003. "Been There, Done That: SAGE, a Peer Leadership Model Among Prostitution Survivors." In *Prostitution, Trafficking and Traumatic Stress*, edited by Melissa Farley, 255–66. Binghamton, N.Y.: Haworth.

Hotaling, Norma, N. Dutto, P. Gibson, J. Coleman, T. Jackson, D. Nothmann, A. Cassidy, S. Sawyer, and P. Grant. 1997. *Social Justice, Health Education, Program Planning for Prostitutes and Solicitors* (unpublished outline). Cited in Hughes, Donna. 2004. *Best Practices to Address the Demand Side of Trafficking.* Washington, D.C.: Department of State, (accessed 28 June 2013). http://www.uri.edu/artsci/hughes/demand_sex_trafficking.pdf.

Hubbard, Phil. 2004. "Revenge and Injustice in the Neoliberal City: Uncovering Masculinist Agendas." *Antipode* 36 (4): 665–86.

Hughes, Donna. 2003. "Accommodation or Abolition? Solutions to the Problem of Sexual Trafficking and Slavery." *National Review Online* (accessed 28 June 2013). http://www.nationalreview.com/comment/comment-hughes050103.asp.

Hughes, Donna, and Janice Raymond. 2001. *Sex Trafficking of Women into the United States.* Amherst, Mass.: Coalition Against Trafficking in Women.

Immergut, Ellen. 1998. "Theoretical Core of the New Institutionalism." *Politics and Society* 26 (5): 5–34.

Incite! Women of Color Against Violence, eds. 2007. *The Revolution Will Not Be Funded: Beyond the Non-Profit Industrial Complex.* Cambridge, Mass.: South End Press.

Internal Revenue Code of the United States, Section 501c4. 2013. http://www.irs.gov/irm/part7/irm_07-025-004.html.

Internal Revenue Service. 2006. "Political Activities Compliance Initiative." (accessed 28 June 2013). http://www.irs.gov/pub/irs-tege/2006paci_report_5-30-07.pdf

———. 2007. *Life Cycle of a Private Foundation—Political and Lobbying Activities.* (ac-

cessed 24 October 2007). http://www.irs.gov/charities/foundations/article/0,,id=
149683,00.html.

———. 2009. "Form 990 Redesign for Tax Year 2008 (Filed in 2009)" (accessed 28 June
2013). http://www.irs.gov/charities-&-nonprofits/.

———. 2008 *Governance and Related Topics—501c3 Organizations* (accessed 1 March
2010). http://www.irs.gov/pub/irs-tege/governance_practices.pdf.

Isaac, Jeffrey C. 2003. *The Poverty of Progressivism: The Future of American Democracy in
a Time of Liberal Decline*. Lanham, Md.: Rowman and Littlefield.

———. 2010. "Perestroika and the Journals? A Brief Reply to My Friend Greg Kasza." *PS:
Political Science and Politics* 43 (4): 735–37.

Jackson-Elmoore, Cynthia, and Richard Hula. 2001. "Emerging Roles of Nonprofit
Organizations: An Introduction." *Policy Studies Review* 18 (4): 1–5.

Jeffreys, Elena. 2005. "In Defense of Prostitution." *Social Alternatives* 24 (2): 20–21.

Jenness, Valerie. 1990. "From Sex as Sin to Sex as Work: COYOTE and the Reorganiza-
tion of Prostitution as a Social Problem." *Social Problems* 37 (3): 403–20.

———. 1993. *Making It Work: The Prostitutes' Rights Movement in Perspective*. New York:
Aldine De Gruyter.

Jennings, Anne. 1976. "The Victim as Criminal: A Consideration of Prostitution Law."
California Law Review 64 (5): 1235–84.

Jolin, Annette. 1994. "On the Backs of Working Prostitutes: Feminist Theory and Pros-
titution Policy." *Crime and Delinquency* 40 (1): 69–83.

Kasza, Gregory. 2010. "Perestroika and the Journals." *PS: Political Science and Politics* 43
(4): 733–34.

Katzenstein, Mary Fainsod. 1998a. *Faithful and Fearless: Moving Feminist Protest Inside
the Church and Military*. Princeton, N.J.: Princeton University Press.

———. 1998b. "Stepsisters: Feminist Movement Activism in Different Institutional
Spaces." In *The Social Movement Society*, edited by David Meyer and Sidney Tarrow,
195–216. Lanham, Md.: Rowman and Littlefield.

Kayal, Philip. 1993. *Bearing Witness: Gay Men's Health Crisis and the Politics of AIDS*.
Boulder, Colo.: Westview.

Keck, Margaret, and Kathryn Sikkink. 1999. "Transnational Advocacy Networks in
International and Regional Politics." *International Social Science Journal* 51 (1):
89–103.

Keefe, Robert, Sandra Lane, and Heidi Swarts. 2006. "From the Bottom Up: Tracing
the Impact of Four Health-Based Social Movements and Social Policies." *Journal of
Health and Social Policy* 21 (3): 55–69.

Kempadoo, Kamala. 1998. "The Exotic Dancers Alliance: An Interview with Dawn Pas-
sar and Johanna Breyer." In *Global Sex Workers: Rights, Redefinition and Resistance*,
edited by Kamala Kempadoo and Jo Doezema, 182–92. New York: Routledge.

———. 2005. "From Moral Panic to Global Justice: Changing Perspectives on Traffick-
ing." In *Trafficking and Prostitution Reconsidered: New Perspectives on Migration, Sex*

Work and Human Rights, edited by Kamala Kempadoo, Jyoti Sanghera, and Barbara Pattanaik, vii–xxxiv. Boulder, Colo.: Paradigm.

Kempadoo, Kamala, and Jo Doezema. 1998. *Global Sex Workers: Rights, Resistance and Redefinition.* New York: Routledge.

Kennedy, Maureen, and Paul Leonard. 2001. *Dealing with Neighborhood Change: A Primer on Gentrification and Policy Choices.* Washington, D.C.: Brookings Institution Center on Urban and Metropolitan Policy.

Kerr, Courtney. 1994. "A Geographic History of Prostitution in San Francisco." *Urban Action: San Francisco State University's Journal of Urban Affairs,* 29–34.

Kessler, Kari. 2002. "Is a Feminist Stance in Support of Prostitution Possible? An Exploration of Current Trends." *Sexualities* 5 (2): 219–35.

Kivel, Paul. 2007. "Social Service or Social Change?" In *The Revolution Will Not Be Funded: Beyond the Nonprofit-Industrial Complex,* edited by Incite! Women of Color Against Violence, 129–50. Boston: South End.

Kristof, Nicholas. 2009. "Sex Trafficking: Time to Launch a Twenty-First-Century Abolitionist Movement." *Seattle Times,* 8 January.

Kuo, Lenore. 2002. *Prostitution Policy: Revolutionizing Practice Through a Gendered Perspective.* New York: New York University Press.

Lazzarini, Zita. 2004. "Should HIV Be Jailed? HIV Criminal Exposure Statutes and Their Effects in the United States and South Africa." *Washington University Global Studies Law Review* 3 (177): 177–98.

Lee, Raymond M., and Claire Renzetti. 1990. "The Problems of Researching Sensitive Topics." *American Behavioral Scientist* 33 (5): 510–28.

Leigh, Carol. 1996. *A Brief History of Government Policies Toward Prostitution in San Francisco.* San Francisco: San Francisco Task Force on Prostitution.

———. 1997. "Inventing Sex Work." In *Whores and Other Feminists,* edited by Jill Nagle, 225–31. New York: Routledge.

Lelchuk, Illene. 1999. "Tenderloin Clinic Treats Sex Workers' Aches and Pains." *Examiner,* 10 August.

Lerman, Amy, and Vesla Weaver. 2010. "Political Consequences of the Carceral State." *American Political Science Review* 104 (4): 817–33.

Lipsky, Michael. 1980. *Street-Level Bureaucracy.* New York: Russell Sage Foundation.

Lockett, Gloria. 1994. "CAL-PEP: The Struggle to Survive." In *Women Resisting AIDS: Feminist Strategies of Empowerment,* edited by Beth Schneider and Nancy Stoller, 208–18. Philadelphia: Temple University Press.

Lockett, Gloria, Carla Dillard-Smith, and Ben Bowser. 2004. "Preventing AIDS Among Injectors and Sex Workers." In *Preventing AIDS: Community-Science Collaborations,* edited by Ben Bowser, Mishra Shiraz, Cathy Reiback and George Lemp, 45–68. London: Haworth Press.

Luker, Kristin. 1998. "Sex, Social Hygiene, and the State: The Double-Edged Sword of Social Reform." *Theory and Society* 27 (1): 601–34.

Lunder, Erika. 2006. *Tax-Exempt Organizations: Political Activity Restrictions and Disclosure Requirements*. Washington, D.C.: Congressional Research Service.

Lustig, Jessica. 2007. "The 13-Year-Old Prostitute." *New York Times Magazine*, 1 April.

Lutnick, Alexandra. 2006. "The St. James Infirmary: A History." *Sexuality and Culture* 10 (2): 56–75.

———. 2011. *Beyond Prescientific Reasoning: The Sex Worker Environmental Assessment Team Study*. San Francisco: Research Triangle Institute International.

Lutnick, Alexandra, and Deb Cohan. 2009. "Criminalization, Legalization or Decriminalization of Sex Work: What Female Sex Workers Say." *Reproductive Health Matters* 17 (33): 38–46.

Mackay, Fiona, Meryl Kenny, and Louise Chappell. (2010). "New Institutionalism Through a Gender Lens: Towards a Feminist Institutionalism?" *International Political Science Review* 31 (5): 573–588.

MacKinnon, Catharine. 1989. *Towards a Feminist Theory of the State*. Cambridge, Mass.: Harvard University Press.

Magno, C. 2008. "Refuge from Crisis: Refugee Women Build Political Capital." *Globalisation, Societies and Education* 6 (2): 119–30.

Maier, Shana. 2011. "'We Belong to Them': The Costs of Funding for Rape Crisis Centers." *Violence Against Women* 17 (11): 1383–408.

Majic, Samantha. 2011. "Serving Sex Workers and Promoting Democratic Engagement: Rethinking Nonprofits' Role in American Civic and Political Life." *Perspectives on Politics* 9 (4): 821–40.

March, James G., and Johan P. Olsen. 1984. "The New Institutionalism: Organizational Factors in Political Life." *American Political Science Review* 78 (3): 734–49.

———. 2006a. "Elaborating the 'New Institutionalism.'" In *The Oxford Handbook of Political Institutions*, edited by Rod Rhodes, Sarah Binder, and Bert Rockman, 3–20. Oxford: Oxford University Press.

———. 2006b. "'The New Institutionalism': Organizational Factors in Political Life." *American Political Science Review* 100 (4): 675–75.

Markon, Jerry. 2007. "Human Trafficking Evokes Outrage, Little Evidence." *Washington Post*, 23 September.

Marshall, Carolyn. 2004. "Bid to Decriminalize Prostitution in Berkeley." *New York Times*, 14 September.

Marwell, Nicole. 2004. "Privatizing the Welfare State: Nonprofit Community-Based Organizations as Political Actors." *American Sociological Review* 69 (2): 265–91.

Mathieu, Lilian. 2003. "The Emergence and Uncertain Outcomes of Prostitutes' Social Movements." *European Journal of Women's Studies* 10 (1): 29–50.

McAdam, Doug. 1982. *Political Process and the Development of Black Insurgency 1930–1970*. Chicago: University of Chicago Press.

McCormick, Erin. 1993. "Giving Green Light to Red Light District." *Examiner*, 5 December, A1

McGoldrick, Jake. 2006. *Anonymous Phone Venue Established as Part of Needs Assess-*

ment for Sex Worker Community. Press release from the office of Supervisor Jake McGoldrick, District 1. San Francisco: Board of Supervisors.

McGovern, Patrick. 2010. "Perestroika in Political Science: Past, Present and Future." *PS: Political Science and Politics* 43 (4): 725–27.

Meil-Hobson, Barbara. 1987. *Uneasy Virtue: The Politics of Prostitution and the American Reform Tradition.* New York: Basic.

Mettler, Suzanne. 1998. *Gender and Federalism in New Deal Public Policy.* Ithaca, N.Y.: Cornell University Press.

———. 2005. *Soldiers to Citizens.* Oxford: Oxford University Press.

Meyer, David. 1993. "Institutionalizing Protest: The United States Structure of Political Opportunity and the End of the Nuclear Freeze Movement." *Sociological Forum* 8 (2): 157–79.

———. 2004. "Protest and Political Opportunities." *Annual Review of Sociology* 30: 124–45.

———. 2005. "Social Movements and Public Policy: Eggs, Chicken and Theory." In *Routing the Opposition: Social Movements, Public Policy, and Democracy*, edited by David Meyer, Valerie Jenness, and Helen Ingram, 1–27. Minneapolis: University of Minnesota Press.

Meyer, David, and Debra Minkoff. 2004. "Conceptualizing Political Opportunity." *Social Forces* 82 (4): 1457–92.

Meyer, David, and Suzanne Staggenborg. 1996. "Movements, Countermovements, and the Structure of Political Opportunity." *American Journal of Sociology* 101 (6): 1628–55.

Meyer, David, and Nancy Whittier. 1994. "Social Movement Spillover." *Social Problems* 41 (2): 277–98.

Mink, Gwendolyn. 2001. "Faith in Government?" *Social Justice* 28 (1): 5–10.

Minkoff, Debra. 1997. "Producing Social Capital: National Social Movements and Civil Society." *American Behavioral Scientist* 40 (5): 606–19.

Minkoff, Debra, and Walter Powell. 2006. "Nonprofit Mission: Constancy, Responsiveness, or Deflection?" In *The Nonprofit Sector: A Research Handbook*, edited by Walter Powell and Richard Steinberg, 591–611. New Haven, Conn.: Yale University Press.

Mitchell, John. 2002. "Prostitute's HIV-Related Charge Dropped in Plea Bargain." *Los Angeles Times*, 13 September, 3.

Monto, M. 2004. "Female Prostitution, Customers and Violence." *Violence Against Women* 10 (2): 160–88.

Morgen, Sandra. 2002. *Into Our Own Hands: The Women's Health Movement in the United States, 1969–1990.* New Brunswick, N.J.: Rutgers University Press.

Morse, Anita. 1997. "Pandora's Box: An Essay Review of American Law and Literature on Prostitution." In *Gender and American Law: Pornography, Sex Work and Hate Speech*, edited by Karen Maschke, 99–141. New York: Garland.

Naples, Nancy. 1991a. "Contradictions in the Gender Subtext of the War on Poverty: The Community Work and Resistance of Women from Low Income Communities." *Social Problems* 38 (3): 316–32.

——. 1991b. "'Just What Needed to Be Done': The Political Practice of Women Community Workers in Low-Income Neighborhoods." *Gender and Society* 5 (4): 478–94.

——. 1998. *Grassroots Warriors: Activist Mothering, Community Work, and the War on Poverty.* New York: Routledge.

NBC News. 2008. "Voters Choose Not to Legalize Prostitution in San Francisco." *NBC-Bay Area News.* http://www.nbcbayarea.com/news/elections/local/Voters_Choose_Not_to_Legalize_Prostitution_in_San_Francisco.html.

Nonprofit Action. 2005. "Can 501(c)(3) Nonprofit Organizations Receiving Federal Grants Lobby?" http://www.npaction.org/article/articleview/100/1/248.

Norton-Hawk, Maureen. 2001. "The Counterproductivity of Incarcerating Female Street Prostitutes." *Deviant Behavior* 22 (5): 403–17.

——. 2003. "Social Class, Drugs, Gender and the Limitations of the Law: Contrasting the Elite Prostitute with the Street Prostitute." *Studies in Law, Politics and Society* 29 (1): 123–39.

Network of Sex Worker Projects (NSWP). 2012. *Our Work 2011* (accessed 15 January 2012). http://www.nswp.org/page/our-work.

O'Connell-Davison, Julia. 2002. "The Rights and Wrongs of Prostitution." *Hypatia* 17 (2): 84–98.

Oliva, Geraldine, Jennifer Rienks, Ifeoma Udoh, and Carla Dillard Smith. 2005. "A University and Community-Based Organization Collaboration to Build Capacity to Develop, Implement, and Evaluate an Innovative HIV Prevention Intervention for an Urban African American Population." *AIDS Education and Prevention* 17 (4): 300–17.

Olszewski, Lori. 1988. "Former Hookers Help Their Own." *San Francisco Chronicle*, 4 April, D5.

Orleck, Annelise. 2005. *Storming Caesar's Palace: How Black Mothers Fought Their Own War on Poverty.* Boston: Beacon.

Owczarzak, Jill, and Julia Dickson-Gomez. 2011. "Providers' Perceptions of and Receptivity Toward Evidence-Based HIV Prevention Interventions." *AIDS Education and Prevention* 23 (2): 105–17.

Penner, Susan. 1995. "A Study of Coalitions Among HIV/AIDS Service Organizations." *Sociologial Perspectives* 39 (2): 217–39.

Peters, B. Guy. 2005. *Institutional Theory in Political Science: The "New Institutionalism."* 2nd ed. London: Continuum.

Peters, Jeanne, Anushka Fernandopulle, Jan Masaoka, Christine Chan, and Tim Wolfred. 2002. *Help Wanted: Turnover and Vacancy in Non-Profits.* San Francisco: Compass Point Non-Profit Services.

Peterson, Paul. 1995. *The Price of Federalism.* Washington, D.C.: Brookings Institution.

Pheterson, Gail. 1989. *A Vindication of the Rights of Whores.* Seattle: Seal.

Phlebotomy Certification Center. 2011. "Phlebotomy Certification and Training Schools." http://www.phlebotomycertificationcenter.com.

Pierson, Paul. 2001. "Investigating the Welfare State at Century's End." In *The New Politics of the Welfare State*, edited by Paul Pierson, 1–17. Oxford: Oxford University Press.

Pierson, Paul, and Theda Skocpol. 2002. "Historical Institutionalism in Contemporary Political Science." In *Political Science: The State of the Discipline*, edited by Helen Milner and Ira Katznelson, 693–721. New York: W. W. Norton.

Pinto, Nick. 2011. "Women's Funding Network Sex Trafficking Study Is Junk Science." *Village Voice*, 23 March.

Piven, Frances Fox, and Richard Cloward. 1977. *Poor Peoples' Movements: Why They Succeed, How They Fail*. New York: Pantheon.

Plumridge, Libby, and Gillian Abel. 2001. "A Segmented Sex Industry in New Zealand: Sexual and Personal Safety of Female Sex Workers." *Australian and New Zealand Journal of Public Health* 25 (1): 78–83.

Popp, Robert. 1991. "SF Neighborhood Groups Want Prostitution Stopped." *San Francisco Chronicle*, 23 September.

Powell, Walter W., and Paul DiMaggio. 1991. *The New Institutionalism in Organizational Analysis*. Chicago: University of Chicago Press.

Preston, Pamela, and Alan Brown-Hart. 2005. "John Court: Comparison of Characteristics, Sexual Behavior and Sexual Attitudes of Clients of Prostitutes." *Journal of Ethnicity in Criminal Justice* 3 (4): 49–68.

Prostitutes' Education Network. 2004. *Prostitution in the United States: The Statistics*. Prostitutes' Education Network 2004 (accessed 10 March 2004). http://www.bayswan.org/stats.html.

Putnam, Robert. 1995. "Tuning In, Tuning Out: The Strange Disappearance of Social Capital in America." *Political Science and Politics* 28 (4): 664–83.

———. 2000. *Bowling Alone: The Collapse and Revival of American Community*. New York: Simon and Schuster.

Quadagno, Jill. 1994. *The Color of Welfare*. New York: Oxford University Press.

Queen, Carol. 2000. "Sex in the Çity." *San Francisco Chronicle*, 19 November, E1.

Reckless, Walter Cade. 1933. *Vice in Chicago*. Chicago: University of Chicago Press.

Reilly, John, Carter Hull, and Barbara Briag-Allen. 2003. "IRC 501(c)(4) Organizations." Washington, D.C.: Internal Revenue Service.

Reinharz, Shulamit. 1992. *Feminist Methods in Social Research*. New York: Oxford University Press.

Rhomberg, Chris. 2004. *No There There: Race, Class and Political Community in Oakland*. Berkeley: University of California Press.

Rosenstirn, Julius. 1913. *Our Nation's Health Endangered by Poisonous Infection Through the Social Malady*. San Francisco: Advisory Committee Municipal Clinic.

Roth, N., and K. Hogan. (1998). "Gendered Epidemic." In *Gendered Epidemic: Representations of Women in the Age of AIDS*, edited by N. Roth and K. Hogan, xv–2. New York: Routledge.

Ruzek, Sheryl, and Julie Becker. 1999. "The Women's Health Movement in the United

States: From Grass-Roots Activism to Professional Agendas." *Journal of the American Medical Women's Association* 54 (1): 4–8.

Salamon, Lester. 2003. *The Resilient Sector: The State of Nonprofit America*. Washington, D.C.: Brookings Institution Press.

San Francisco Task Force on Prostitution. 1996. *The San Francisco Task Force on Prostitution: Final Report*. San Francisco: Submitted to the Board of Supervisors of the City and County of San Francisco.

Sassen, Saskia. 1999. "Making the Global Economy Run: The Role of Nation-States and Private Agents." *International Social Science Journal* 51 (161): 409–16.

Sawer, Marian. 2010. "Premature Obituaries: How Can We Tell if the Women's Movement Is Over?" *Politics and Gender* 6 (4): 602–9.

Schechter, Susan. 1982. *Women and Male Violence: The Visions and Struggles of the Battered Women's Movement*. Boston: South End Press.

Schiller, Lucy. 2011. "Period Piece: The San Francisco Prostitute March of 1917." *San Francisco Bay Guardian*, 26 October.

Schmidt, Vivien. 2006. "Institutionalism and the State." In *The State: Theories and Issues*, edited by Colin Hay, Michael Lister, and David Marsh, 98–117. Houndmills, U.K.: Palgrave Macmillan.

———. 2008. "Discursive Institutionalism: The Explanatory Power of Ideas and Discourse." *Annual Review of Political Science* 11 (1): 303–26.

Schneider, Joseph. 1985. "Social Problems Theory: The Constructionist View." *Annual Review of Sociology* 11: 209–29.

Schotten, C. Heike. 2005. "Men, Masculinity, and Male Domination: Reframing Feminist Analyses of Sex Work." *Politics and Gender* 1 (2): 211–40.

Schram, Sanford. 2002. *Praxis for the Poor: Piven and Cloward and the Future of Social Science in Social Welfare*. New York: New York University Press.

Schram, Sanford, and Joe Soss. 1998. "Making Something out of Nothing: Welfare Reform and a New Race to the Bottom." *Publius* 28 (3): 67–88.

Schwarzer, Michael. 2001. "San Francisco by the Numbers: Planning After the 2000 Census." *SPUR Newsletter* 7 (1). Available at http://www.spur.org/publications/library/article/SFbynumbers07012001.

Scoular, Jane. 2010. "What's Law Got to DO with It? How and Why Law Matters in the Regulation of Sex Work." *Journal of Law and Society* 37 (1): 12–39.

Scrivener, Gary. 2001. "A Brief History of Tax Policy Changes Affecting Charitable Organizations." In *The Nature of the Nonprofit Sector*, edited by Steven Ott, 126–47. Boulder, Colo.: Westview.

Sex Workers Outreach Project. 2007. "About SWOP." Available at http://www.swop-usa.org/about.php.

Shaver, Francis. 2005. "Sex Work Research: Methodological and Ethical Challenges." *Journal of Interpersonal Violence* 20 (3): 296–319.

Shively, Michael, Sarah Jalbert, Ryan Kling, William Rhodes, Chris Flygare, Laura Tierney, Dana Hunt, David Squires, Christina Dyous, and Kristin Wheeler. 2008. *Final*

Report on the Evaluation of the First Offender Prostitution Program. Cambridge, Mass.: Abt Associates.

Showden, Carisa Renae. 2011. *Choices Women Make: Agency in Domestic Violence, Assisted Reproduction, and Sex Work.* Minneapolis: University of Minnesota Press.

Shumsky, Neil, and Larry Springer. 1981. "San Francisco's Zone of Prostitution: 1880–1934." *Journal of Historical Geography* 7 (1): 71–89.

Sirianni, Carmen. 2009. *Investing in Democracy: Engaging Citizens in Collaborative Governance.* Washington, D.C.: Brookings Institution Press.

Sirianni, Carmen, and Lewis A. Friedland. 2001. *Civic Innovation in America: Community Empowerment, Public Policy, and the Movement for Civic Renewal.* Berkeley: University of California Press.

Skocpol, Theda. 1996. "Unraveling from Above." *American Prospect* (25): 20–26.

———. 2003. *Diminished Democracy: From Membership to Management in American Civic Life.* Norman: University of Oklahoma Press.

———. 2004. "Voice and Equality: The Transformation of American Civic Democracy." *Perspectives on Politics* 2 (1): 3–20.

Skocpol, Theda, and Morris Fiorina. 1999. *Civic Engagement in American Democracy.* Washington, D.C.: Brookings Institution Press.

Smith, R. Drew. 2004. *Long March Ahead: African American Churches and Public Policy in Post-Civil Rights America—The Public Influences of African American Churches.* Durham, N.C.: Duke University Press.

Smith, Steven R. 2006. "Government Financing of Nonprofit Activity." In *Nonprofits and Government: Collaboration and Conflict,* edited by Elizabeth Boris and Eugene Steuerle, 219–56. Washington, D.C.: Urban Institute Press.

Smith, Steven R., and Michael Lipsky. 1993. *Nonprofits for Hire: The Welfare State in the Age of Contracting.* Cambridge, Mass.: Harvard University Press.

———. 2001. "Nonprofit Organizations and Community." In *The Nature of the Nonprofit Sector,* edited by Steven Ott, 251–57. Boulder, Colo.: Westview.

Snow, David A., Sarah Anne Soule, and Hanspeter Kriesi. 2004. *The Blackwell Companion to Social Movements, Blackwell Companions to Sociology.* Malden, Mass.: Blackwell.

Soderlund, Gretchen. 2005. "Running from the Rescuers: New U.S. Crusades Against Sex Trafficking and the Rhetoric of Abolition." *NWSA Journal* 17 (3): 64–87.

Sokolowski, Wojciech, and Lester Salamon. 1999. "The United States." In *Global Civil Society: Dimensions of the Nonprofit Sector,* edited by Lester M. Salamon, Helmut K. Anheier, Regina List, Stefan Toepler, and S. Wojciech Sokolowski, 261–83. Baltimore: Johns Hopkins Center for Civil Studies.

Soss, Joe. 1999. "Lessons of Welfare: Policy Design, Political Learning and Political Action." *American Political Science Review* 93 (2): 363–80.

———. 2000. *Unwanted Claims: The Politics of Participation in the U.S. Welfare System.* Ann Arbor: University of Michigan Press.

State of Emergency Taskforce. 2003. *Taskforce Newsletter.* Alameda County.

St. James Infirmary. 2008. *St. James Infirmary*. San Francisco: SJI.

―――. 2009a. *Employee Handbook*. San Francisco: SJI.

―――. 2009b. *Programs Manual*. San Francisco: SJI.

―――. 2009c. *Annual Report 2009*. San Francisco: SJI.

―――. 2010. *St. James Infirmary Report on the Global Working Group on Sex Work and HIV Policy to UNAIDS*. San Francisco: SJI.

―――. 2012a. Media campaign: "Someone You Know Is a Sex Worker." SJI 2012 (accessed 8 January 2012). http://stjamesinfirmary.org/?page_id=1673.

_____. 2012b. Who We Are. http://stjamesinfirmary.org/wordpress/?page_id=2.

Stolle, Dietlind, and Marc Howard. 2008. "Civic Engagement and Civic Attitudes in Cross-National Perspective: Introduction to the Symposium." *Political Studies* 56: 1–11.

Stolle, Dietlind, and Thomas Rochon. 1998. "Are All Assocations Alike?" *American Behavioral Scientist* 42 (1): 47–65.

Stoller, Nancy. 1998. *Lessons from the Damned: Queers, Whores, and Junkies Respond to AIDS*. New York: Routledge.

Stricker, Frank. 2007. *Why America Lost the War on Poverty—and How to Win It*. Chapel Hill: University of North Carolina Press.

Strupp, Joe. 1994a. "Prostitution Crackdown Under Fire." *Independent*, 3 April, 1.

―――. 1994b. "Prostitution Panel Ripped by Debate." *Independent*, 21 January, 1.

―――. 1995. "6 Members Quit City Task Force in Protest." *Independent*, 7 February, 1.

Sullivan, Barbara. 2010. "When (Some) Prostitution Is Legal: The Impact of Law Reform on Sex Work in Australia." *Journal of Law and Society* 37 (1): 85–104.

Tamir, Yael. 1998. "Revisiting the Civic Sphere." In *Freedom of Association*, edited by Amy Gutmann, 214–38. Princeton: Princeton University Press.

Tarrow, Sidney. 1989. *Struggle, Politics, and Reform: Collective Action, Social Movements, and Cycles of Protest*. Ithaca, N.Y.: Cornell Center for International Studies.

―――. 1996. "Social Movements in Contentions Politics: A Review Article." *American Political Science Review* 4 (90): 874–83.

―――. 1998. *Power in Movement: Social Movements and Contentious Politics*. 2nd ed. Cambridge: Cambridge University Press.

Terry, Martha Ann, Jon Liebman, Bobbie Person, Lisa Bond, Carla Dillard Smith, and Chrystal Tunstall. 1999. "The Women and Infants Demonstration Project: An Integrated Approach to AIDS Prevention and Research." *AIDS Education and Prevention* 11 (2): 107–21.

Theiss-Morse, Elizabeth, and John Hibbing. 2005. "Citizenship and Civic Engagement." *Annual Review of Political Science* 8: 227–49.

Third Wave Foundation. 2012. *Our Work: Reproductive Health and Justice Initiative*. (accessed 2 March 2012). http://www.thirdwavefoundation.org/our-work/reproductive -health-justice-initiative/.

Thomas, Craig, Bryce Smith, and Linda Wright-DeAgüero. 2006. "The Program Evaluation and Monitoring System: A Key Source of Data for Monitoring Evidence-Based

HIV Prevention Program Processes and Outcomes." *AIDS Education and Prevention* 18 (Supp.): 74–80.

Thomas, George. 2005. "The Qualitative Foundations of Political Science Methodology." *Perspectives on Politics* 3 (4): 855–66.

Thompson, Susan E. 2000. "Prostitution: A Choice Ignored." *Women's Rights Law Reporter* 21: 217-248.

Tilly, Charles. 1978. *From Mobilization to Revolution*. Columbus, Ohio: McGraw Hill.

_____. 2004. *Social Movements: 1768-2004*. Boulder: Paradigm Publishers.

Todd, Linda Bales. 2009. "The U.S. Takes on Trafficking." *Christian Century* 126 (16): 25-25.

Trafficking Victims Protection Reauthorization Act of 2003 (H.R. 2620).

Trafficking Victims Protection Reauthorization Act of 2005 (H.R. 972).

Trafficking Victims Protection Reauthorization Act of 2008 (H.R. 7311).

Transgender Law Center. 2006. "Good Jobs NOW! A Snapshot of the Economic Health of San Francisco's Transgender Communities." San Francisco: Transgender Law Center.

Traugott, Mark. 1995. *Repertoires and Cycles of Collective Action*. Durham, N.C.: Duke University Press.

UNAIDS. 2007. *UNAIDS Guidance Note on HIV and Sex Work*. Geneva: UNAIDS.

United States Agency for International Development v. Alliance for Open Society International. 2011. 2nd Circuit, U.S. Court of Appeals.

United States of America v. Ralph H. Washington, no. 84-1024. 1984. 9th Circuit, U.S. Court of Appeals.

University of California, San Francisco. 2011a. *AHP Trainings for Risk Reduction*. http://ahp04.ucsf.edu/trainingtypes.php?a=AUDN05.

_____. 2011b. *HIV Counseling and Testing Programs*. UCSF. http://ahp04.ucsf.edu/trainingtypes.php?a=AUDN01.

U.S. Department of State. 2010. *Trafficking in Persons Report 2010*. Undersecretary for Democracy and Global Affairs, Office to Monitor and Combat Trafficking in Persons. Washington, D.C.: U.S. Department of State.

Van Dyke, Nella, Sarah Soule, and Verta Taylor. 2004. "The Targets of Social Movements: Beyond a Focus on the State." *Research in Social Movements: Conflicts and Change* 25: 27–51.

Vanwesenbeck, Ine. 2001. "Another Decade of Social Scientific Work on Sex Work: A Review of Research 1990–2000." *Annual Review of Sex Research* 12 (1): 242–89.

Vega, Miriam. 2009. "The Change Approach to Capacity-Building Assistance." *AIDS Education and Prevention* 21 (Suppl. B): 137–51.

Verba, Sidney, Kay Scholzman, and Henry Brady. 1993. *Voice and Equality*. Cambridge, Mass.: Harvard University Press.

Volden, Craig. 2003. "States as Policy Laboratories: Experimenting with the Children's Health Insurance Program." Presented at the Summer Political Methodology Meetings, Minneapolis, 17-19 July.

Wahab, Stephanie. 2006. "Evaluating the Usefulness of a Prostitution Diversion Program." *Qualitative Social Work* 5 (1): 67–92.

Warren, Mark. 1998. "Community Building and Political Power." *American Behavioral Scientist* 42 (1): 78–92.

Weingast, Barry. 2002. "Rational Choice Institutionalism." In *Political Science: The State of the Discipline*, edited by Helen Milner and Ira Katznelson, 660-692. New York: W. W. Norton.

Weir, Margaret. 2010. "Collaborative Governance and Civic Empowerment: A Discussion of Investing in Democracy—Engaging Citizens in Collaborative Governance." *Perspectives on Politics* 8 (2): 595–98.

Weitzer, Ronald. 1991. "Prostitutes Rights in the United States: The Failure of a Movement." *Sociological Quarterly* 32 (1): 23–41.

———. 1999. "Prostitution Control in America: Rethinking Public Policy." *Crime, Law and Social Change* 32 (1): 83–102.

———. 2000. "Why We Need More Research on Sex Work." In *Sex for Sale: Prostitution, Pornography and the Sex Industry*, edited by Ronald Weitzer, 1–16. New York: Routledge.

———. 2005. "Flawed Theory and Method in Studies of Prostitution." *Violence Against Women* 11 (7): 1–16.

———. 2007. "The Social Construction of Sex Trafficking: Ideology and Institutionalization of a Moral Crusade." *Politics and Society* 35: 447–75.

———. 2010a. "The Movement to Criminalize Sex Work in the United States." *Journal of Law and Society* 37 (1): 61–84.

———. 2010b. "The Mythology of Prostitution: Advocacy Research and Public Policy." *Sexuality Research and Social Policy* 7: 15–29.

———. 2010c. *Sex for Sale: Prostitution, Pornography, and the Sex Industry*. 2nd ed. New York: Routledge.

———. 2011. *Legalizing Prostitution: From Illicit Vice to Lawful Business*. New York: New York University Press.

West, Jackie. 2000. "Prostitution: Collectives and the Politics of Regulation." *Gender, Work and Organization* 7 (2): 106–18.

White House. 2003. "Trafficking in Persons: National Security Presidential Directive." White House, Office of the Press Secretary. Washington, D.C.: White House.

———. 2012. "Federal Funding Ban on Needle Exchange Programs." Office of National Drug Control Policy. Washington, D.C.: White House.

Whiteis, David. 2000. "Poverty, Policy and Pathogenesis: Economic Justice and Public Health in the U.S." *Critical Public Health* 10 (2): 257–71.

Williams, Elisa. 2003. "Reaching Out to the High-Risk." *Newsweek*, 12 December.

Wing, Kennard, Katie Roeger, and Thomas Pollack. 2010. *The Nonprofit Sector in Brief: Public Charities, Giving and Volunteering, 2010*. Washington, D.C.: Urban Institute, National Center for Charitable Statistics.

Winokur, Scott. 1992a. "Cops vs. Hookers." *Examiner*, 7 December, A1.

———. 1992b. "The Cost of Crime." *Examiner*, 7 December, A17.

———. 1992c. "Playground for Prostitutes, Nuisance for a Neighborhood." *Examiner*, 6 December, D1.

———. 1993. "Secret Crackdown to Get Hookers off Street." *Examiner*, 17 January, B1.

Wolch, Jennifer R. 1990. *The Shadow State: Government and Voluntary Sector in Transition*. New York: Foundation Center.

Wolf, Leslie, and Richard Vezina. 2004. "Crime and Punishment: Is There a Role for Criminal Law in HIV Prevention Policy?" *Whittier Law Review* 25: 821-886.

Wolfson, Mark. 1995. "The Legislative Impact of Social Movement Organizations: The Anti-Drunken-Driving Movement and the 21-Year-Old Drinking Age." *Social Science Quarterly* 76 (2): 311-27.

Wolitski, R. J., K. O. Henny, C. M. Lyles, D. W. Purcell, J. W. Carey, N. Crepaz, A. O'Leary, T. D. Mastro, J. C. Cleveland, A. K. Nakashima, and R. S. Janssen. 2006. "Evolution of HIV/AIDS Prevention Programs—United States, 1981-2006." *Morbidity and Mortality Weekly Report* 55 (21): 597-603.

Yancey-Martin, Patricia. 2009. "Rape Crisis Centers: Helping Victims, Changing Society." In *Human Service Organizations as Complex Organizations*, 2nd edition, edited by Yeheskel Hasenfeld, 207-27. Thousand Oaks, Calif.: Sage.

Yanow, Dvora, and Peregrine Schwartz-Shea. 2010. "Perestroika Ten Years After: Reflections on Methodological Diversity." *PS: Political Science and Politics* 43 (4): 741-45.

YesOnPropK.org. 2009. "Worker Safety Is Public Safety 2009" (accessed 16 February 2009). http://www.yesonpropk.org/.

Young, Iris. 1992. "Social Groups in Associative Democracy." *Politics and Society* 20 (4): 529-34.

Young, Stephanie. 2009. "Freedom to Sell Sex? Prostitution Debate Continues." *Harvard Law Record*, 4 December.

Zalduondo, Barbara, Mauricio Hernandez-Avila, and Patricia Uribe-Zuniga. 1991. "Intervention Research Needs for AIDS Prevention among Commercial Sex Workers and their Clients." In *AIDS and Women's Reproductive Health*, edited by L. C. Chen, 165-178. New York: Plenum Press.

Zucker, Lynne. 1987. "Institutional Theories of Organization." *Annual Review of Sociology* 13: 443-64.

Zweig, Janine, and Martha Burt. 2003. "Effects of Interactions Among Community Agencies on Legal System Responses to Domestic Violence and Sexual Assault in Stop-Funded Communities." *Criminal Justice Policy Review* 14 (2): 249-72.

INDEX

Page numbers in italics refer to tables and illustrations.

ACKNOWLEDGMENTS

Although this is a single-author book, I could not have finished it without the support and generosity of so many people. First, I am eternally grateful to CAL-PEP's and the SJI's leadership for providing me with so much access to these phenomenal organizations. Gloria Lockett and Carla Dillard Smith at CAL-PEP, and Naomi Akers and Johanna Breyer at the SJI: you are some of the most formidable women I have ever met. Thank you for introducing me to your incredible staff and for sharing all the fantastic work that you do.

Second, this book would also not have been possible without the support of my mentor, Mary Fainsod Katzenstein, who is a model of a scholar and a human being. She, along with Anna Marie Smith, Ted Lowi, and Suzanne Mettler, read many drafts and provided me with the intellectual direction that shaped this work. I also benefited from the support and guidance of Peter Agree, the editor in chief at the University of Pennsylvania Press, and Rick Vallely, the series editor. Thank you for finding such thoughtful reviewers and for patiently reading and commenting on my drafts. I also want to thank Noreen O'Connor-Abel and Rachel Taube at the Press for their invaluable assistance with the production process. And I owe a very special thanks to my dear friend and colleague Shannon Mariotti: without you, I could never have navigated this whole experience.

A number of brilliant people also read and provided invaluable feedback on various parts of this manuscript, including Jeffrey Isaac at *Perspectives on Politics*, Jeffrey Berry at Tufts University, fellow panelists at multiple meetings of the Western Political Science Association, and my colleagues in the political science department at John Jay College (especially Andrew Sidman, Jack Jacobs, Monica Varsanyi, Janice Bockmeyer, and Dan Pinello). I was also fortunate to receive a year-long fellowship at the Center for Place, Culture and Politics at the City University of New York (CUNY) Graduate Center in

2011–12, which provided me with time away from teaching and a supportive group of colleagues to help me finish (and improve) my work—a special thanks here goes out to Laura Liu, Charity Scribner, Ujju Aggarwal, Susan Fisher, Marisa Lerer, and Ruthie Gilmore.

I am also eternally grateful to the many, many individuals—including sex workers, sex-worker rights activists, San Francisco and Oakland public-health officials, politicians, police officers, and community-organization representatives—who gave their time to speak to me over the years about their work and provide research interviews. A very special thanks goes to Ben Bowser for helping me understand the political economy of Oakland; to Charles Cloniger, for insights about the public-health landscape in San Francisco; and to Alexandra Lutnick, for introducing me to the SJI, sharing her brilliance, and being a dear friend along the way.

This work would also not have been possible without financial support from the Mellon Foundation, the Walter and Sandra LaFeber Collaborative Research Fund, the John L. Senior Chair in American Institutions, and the Departments of American Studies and Feminist, Gender and Sexuality Studies (all at Cornell University). I was fortunate as well to receive funding from the Office for the Advancement of Research at John Jay College and from the Professional Staff Congress at CUNY (research award #60072-40 41) for completing this project. Without these resources, I would not have been able to complete the required travel or hire the fantastic research and editorial assistants—Katy Kleis, Stephanie Polito, Kelley Burke, Steven Koskela, and Holly Knowles—that made this work possible.

I am also very fortunate to have wonderful friends and family who have supported this book in so many ways. Jennifer Trickett, Mary Sum, Brooke Wells, Glenn Cohen, Hilary Walker, Melanie Martin-Griem, Jenna Slotin, Erica Mott, Loren Kolar, Preeti Chauhan, Deryn Strange, Alexa Capeloto, and Elspeth Tory: thank you for letting me talk about the process, for asking smart questions, and for being such good company. Elizabeth Majic, my dear (little!) sister, thank you for reading and critiquing so much of my work. And to my cousin Xavier Majic and to Dr. Julie Djie Majic, thank you for opening your home and sharing your life with me in San Francisco over the years: none of this would be possible without you.

Finally, my deepest and most heartfelt thanks goes out to my partner in life, John Rasmussen. Since we met, you have supported my work every day, in more ways than you will ever know. For this—and for making me laugh every day—this book is for you.